Fifty Years of Illustration

Fifty Years of Illustration

Lawrence Zeegen and Caroline Roberts

Laurence King Publishing

60s 70s 80s

90s 00s

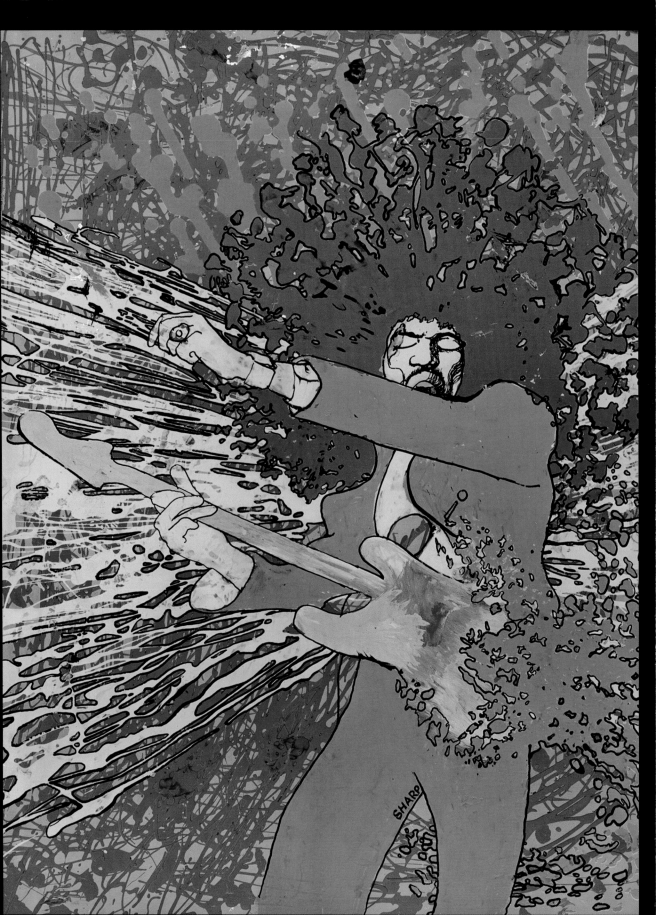

Introduction:
Fifty Years of Illustration

Illustration is the 'people's art'; it reflects the lives we lead. Illustration plays a part in our personal histories and a major role in determining how we comprehend our world. Illustration communicates, educates, entertains, informs, inspires and persuades. Man's first marks, probably drawn with a finger or a stick in the sand or dirt, played as vital a role as speech in initial communication between people. The single method of recording stories, prior to the emergence of the written word, was the drawn image. The oldest form of art, illustration came into existence to help us make sense of our world, enabling man to record, describe and communicate the intricacies of life. Illustration remains critical in aiding our understanding of the complexities of modern life.

While its roots may go back to the origins of mankind, illustration in the twenty-first century remains one of the most direct forms of visual communication, and the very best of the medium today has something to say: a message to articulate, a meaning to enunciate, a feeling to evoke. The world's top illustrators do this with clarity and vision from a personal perspective using unique stylistic approaches.

Our bond with illustration goes back to the playroom, in children's picture books and classics; it goes back to the classroom in the encyclopaedia and text books; and it goes back to the bedroom of our youth and the living room of our parents in the record sleeves and CD cases of the popular music that defines each generation. We are connected to illustration through the comics and cartoon characters of our childhood, through the psychedelic and pop posters and pin-ups of our teens, through the advertising campaigns and promotional graphics pouring from the printed page of newspapers and magazines and from the digital screens of our televisions, laptops, tablets and smartphones. Illustration is deeply embedded in popular culture.

Looking back upon 50 years of illustration is to recognise a mere slice of the discipline's rich heritage. Reviewing half a century of illustration misses any opportunity, of course, to revisit the engravings of eighteenth-century artists; the realistic and comic tradition set by the great Victorian illustrators; the academically sound drawing skills of those producing the stylistically avant-garde work of the 1920s and 1930s, informed by painters and sculptors of the day; the wealth of campaign posters during World War II; and even the birth of consumerism in the 1950s and illustration's role in the advertising and promotion of the decade's products and services.

This book begins in the 1960s, a time of cultural revolution in the West and China's Great Proletarian Cultural Revolution in the East. The Swinging Sixties, fuelled by unprecedented changes socially and politically, witnessed post-war baby boomers approach life with an enthusiasm and optimism not seen before. Teenagers came of age, the sexual revolution exploded, feminism emerged, youth movements sprang up and music, drugs and the Civil Rights Movement and the birth of environmentalism defined the decade, notably described in shorthand as the era of miniskirts, flower power and a space race to the moon.

And, illustration was in at the start – capturing the zeitgeist of the 1960s, recording the decade, reflecting the moment.

01 Martin Sharp, *Jimi Hendrix, Explosion*, poster, 1967
02 Milton Glaser, *The Poppy Foundation*, poster, watercolour & offset lithography, 1968

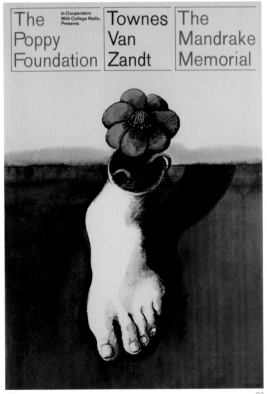

◄01 02

Illustration began to be truly democratic and truly accessible to both artists and audience. With the birth of the counterculture's underground press, artists were able to express themselves away from the confines and constraints of purely commercial art, while an understanding of the importance of marketing by record-company executives led to the first genuine artistic experimentation in album art. Illustration provided the decade with images of lasting impact – from Klaus Voormann's album sleeve for the Beatles' *Revolver* in 1965 in the UK (see p.68) and Milton Glaser's portrait of Bob Dylan in 1967 in the USA (see p.19) to Martin Sharp's cover illustrations for *Oz* magazine (see p.34) and Rick Griffin's images for California's Grateful Dead (see p.36).

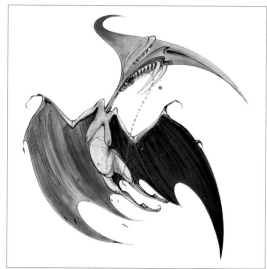

03

As the utopian idealism of the 1960s faded and the 1970s erupted, a generation enjoyed a carefree hedonism, until an economic recession in the USA and UK started to take a stranglehold. The bleak realism of the 1970s – mass unemployment, the three-day week, blackouts and power cuts as well as political unrest in Angola, police gunfire in Soweto and near nuclear disaster (the Three Mile Island Accident) in Pennsylvania – ensured that the optimism of the previous decade was over. A new subculture, inspired by realism and negativity, took hold: glam rock was out, punk rock was in. With its origins in the hippy mantra of peace and love, glam rock was surpassed by punk rock's rhetoric of hate and war in a decade of discontent. Hollywood, in on the nihilism of the era, delivered movies depicting raw urban life, such as Martin Scorsese's *Mean Streets* (1973) and *Taxi Driver* (1976).

Illustration was to undergo massive flux during the 1970s, as artists began to emerge across the planet, from Japan to Germany and from France to Poland. A new graphic sensibility began to take shape as the 1960s-influenced psychedelic images eventually dissipated and flower power was finally killed off. The fantasy and sci-fi illustrations by Roger Dean for albums by Yes and Steve Howe (see opposite and p.114) and Guy Peellaert's image of David Bowie for *Diamond Dogs* (right) during the early 1970s were replaced by images depicting a harder-edged gritty visual aesthetic. In the UK, Gerald Scarfe's visuals coupled manically drawn characters with open political and satirical bite (see above and p.110), while Japan's Shigeo Fukuda (see p.92) displayed his distaste for war through politically charged images with a graphic edge.

The 1980s, nicknamed the designer decade, saw the arrival of the yuppie as a new middle class emerged. The baby boomers of the 1960s gave birth to a youth with aspirations for power dressing and trend setting, and an appetite for luxury goods and extravagant living. As designer labels grew in popularity so did a desire for designer objects, from the newly launched mobile phone to the ultimate diary, the Filofax, and even designer bottled water. Oliver Stone's *Wall Street* (1987) played at the cinema and Bret Easton Ellis's *Less Than Zero* was on sale in the book shops, while *The Face*, the original style bible of the 1980s, and a champion for emerging illustration, sat on the coffee tables of the best-dressed apartments. The outward consumerism of the decade, however, was set against a backdrop of floods in Bangladesh, the Chernobyl nuclear disaster, the explosion of Space Shuttle Challenger, the discovery of AIDS and

04

03 Gerald Scarfe, *Thatcher – Torydactyl*, book illustration
 from *Scarfeland*, personal project, ink & watercolour, 1979
04 Guy Peellaert, *Diamond Dogs*, record sleeve, David Bowie
 & RCA Records, photography/collage/paint on paper, 1974
05 Roger Dean, *Relayer*, record sleeve, Yes, watercolour/ink/
 acrylic, 1976

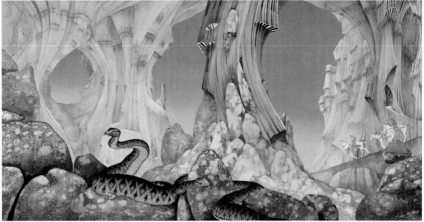

05

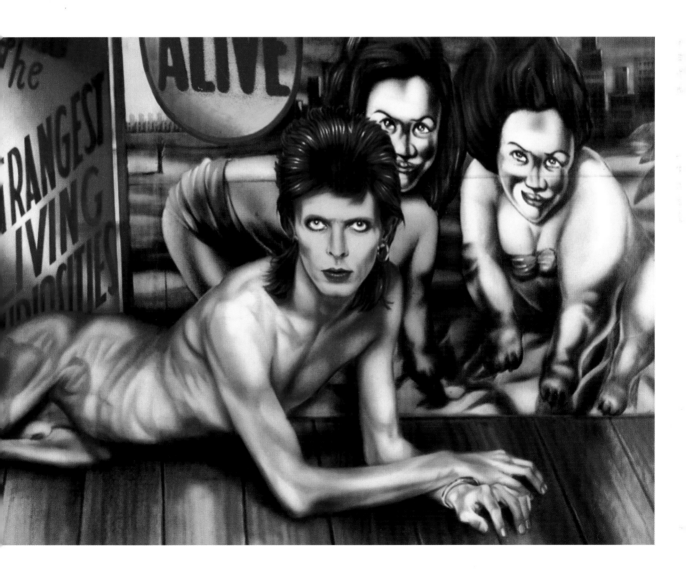

o6

IAN DVRY

SPASTICVS AVTISTICVS

09 Alex Trochut, *Fila*, print campaign, FILA (Japan), 2010
10 Anthony Burrill, *Rainbow Landscape*, screen print, 2009

the end of the Cold War. With the soundtrack to the decade shifting from Michael Jackson's *Thriller* to Duran Duran's *Rio*, the 1980s saw Modernism rejected and a riot of colour, ornamentation and superfluous style became the calling card for designers of every persuasion. Life might be tough in some parts of the world, but that was not going to stop the designer party.

Illustration was suddenly in huge demand and was systematically being applied to every surface imaginable. Illustrators soon became the design world's elite as they worked on advertising campaigns, interiors, packaging, animations and products. With the launch of the Apple Macintosh in 1984, it was to be the final years of an analogue design world, but the illustrators of the 1980s were to enjoy the party to the bitter end.

A digital dawn emerged slowly in the 1990s for the world of illustration. Unsurprisingly reluctant to embrace new technologies, the old-school, die-hard illustrator continued to reject the mouse, holding firmly on to the pencil, pen and brush. As media channels exploded during the early part of the decade – CNN broadcast the Gulf War live and direct and MTV charted the rise and fall of Britpop – the PC became incredibly popular among home users, and with the rise of the Internet, the global village started to become a reality.

During the 1990s, race riots in LA, war in Bosnia, conflict in Rwanda, the break-up of the Soviet Union and the deaths of Princess Diana and Mother Teresa contrasted with the end of apartheid and an historic peace agreement signed in Northern Ireland. The

09

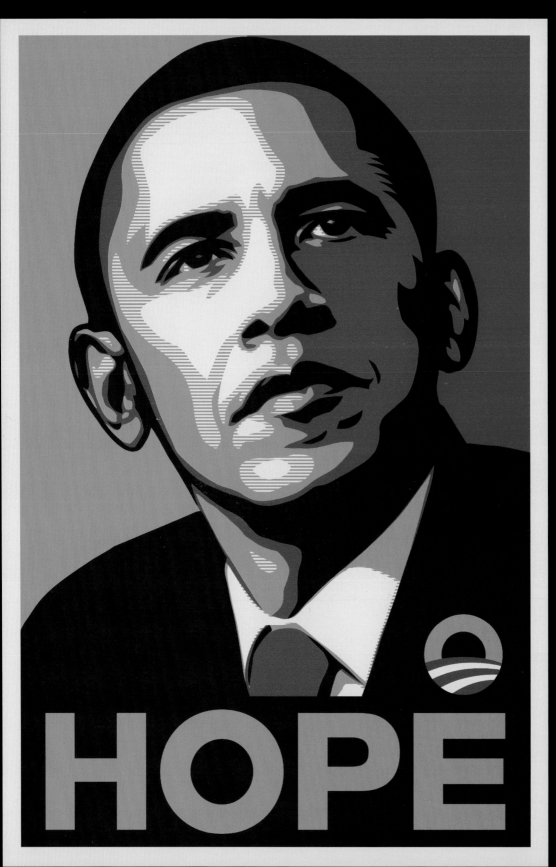

11 Shepard Fairey, *Obama Hope*, personal project, offset lithography, 2008

12 Sara Fanelli, *First Flight*, book spread, Jonathan Cape, collage, created 1999, published 2002

13 Gary Baseman, *Direct Communication*, editorial illustration, *The New York Times Magazine*, mixed media on paper, 1994

discipline of illustration finally came in from the cold and the new practitioners warmed to digital techniques, with Gary Baseman in the USA (see below and p.212), Sara Fanelli (see below and p.226) and Andy Martin (see p.200) in the UK mixing and merging the analogue and digital to great effect.

The opening decade of the twenty-first century saw issues of global proportions: international terrorism, with the destruction of the World Trade Center in New York, and global warming, with the devastation of South American rainforests and the melting of the polar ice caps, took headline news. War and violence in Afghanistan and the Middle East threatened world order, even after the deaths of Saddam Hussein and Colonel Gaddafi. And, with Asia's expansion and the economic industrialisation of China and India, the continent ably demonstrated how a shift in the power struggle for global supremacy could be undertaken.

Illustration played a key role in shaping the future of the USA in 2008, when Shepard Fairey's self-published HOPE posters and stickers backing Barack Obama's presidential campaign were widely recognised for bringing his image into the public's perception ahead of the election (see opposite and p.274). Having funded, produced and disseminated over 300,000 stickers and 500,000 posters, Fairey proved the power of the illustrated image.

Against a backdrop of global issues and an era of diminishing opportunities in traditional illustration outlets, most illustrators were simply content to concentrate on diversification. For the new wave of illustrator, working in the digital domain was second nature, having grown up with a computer in the bedroom, playroom and classroom, and having trained in the studios of art schools where digital and analogue technologies sat alongside each other. For these new practitioners, the challenge was in the crossing of boundaries and territories, working in advertising, design, music, fashion and publishing as well as traversing from the commercial to the non-commercial and self-initiated, self-publishing projects. This new breed of illustrator works globally, yet lives locally. No longer required to live where the work is, illustrators can work anywhere, anytime and for anyone.

As the artform for the people, illustration continues to contribute to and reflect global popular culture. As the broadcast, blogged, published and screened visual messages and pictures vying for attention across our increasingly media-saturated planet testify, illustrators continue to use progressively sophisticated methods to innovate and inspire. The desire to communicate using a visual language is as crucial today as it was at the dawn of mankind.

12

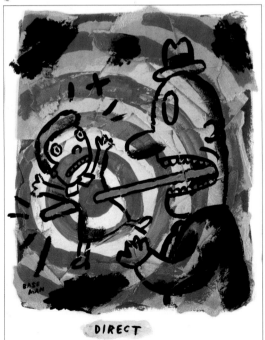

13

Chapter 1:
1960s

An Era of Utopian Idealism

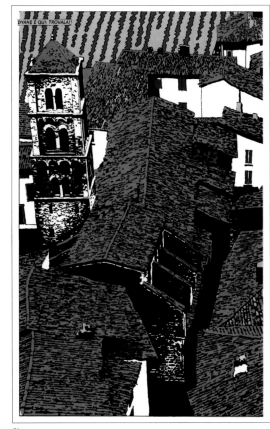

01

01 Michel Quarez, *La Vita Privata di Dyane*, comic book
illustration, Citroën, 1968

'The thing that the sixties did was to show us the possibilities and the responsibility that we all had. It wasn't the answer. It just gave us a glimpse of the possibility,' explained John Lennon in a radio interview on the day of his death on 8 December 1980. The birth of the 1960s was fuelled by new possibilities and new hope. In the USA, most Americans believed that they were standing at the dawn of a new age, and in Europe, too, the long recovery from World War II during the 1950s had given way to a sense of a new beginning.

The decade's optimism began on 2 January 1960, with the initiation by John Fitzgerald Kennedy of his campaign for presidency in the Democratic primary election. JFK, sworn in as the 35th president of the United States at midday on 20 January 1961, became the figurehead for an era of hope and idealism. The world during the preceding decade had been divided: in the aftermath of World War II, much of Europe and Asia had been devastated, whereas the USA had not suffered any physical damage. But, the hardships of the post-war period were slowly dissolving as the global economy began to prosper, with priority given to rebuilding and healing wounds. The international power of the USA grew, too, through increased industrial capacity. The country would lead the world with its economic edge – the production lines of General Motors provided cars for the masses, William Levitt mass-produced suburban housing for a new whites-only middle class and television came of age in time for the first televised presidential election.

While industrial and technological advances were significant, so too were political and social changes. In February of 1960, the month following JFK's presidential campaign launch, four black students sat down at a whites-only lunch counter in Greensboro, North Carolina, and refused to leave. A movement spread as hundreds of demonstrators returned to the same restaurant every day, and within weeks tens of thousands blocked segregated restaurants and shops in the southern states. The fight for civil rights had begun.

Across the USA, UK and Europe, other groups, impatient with incremental reforms, became more militant: student activists organised anti-war demonstrations and women protested for equal pay and rights. Following the development of the first contraceptive pill, which came to market in 1960, there was a new beginning in sexual freedom and women's liberation. A decade of change was underway, with a radical shift in people's expectations, but the era continued with marked contrasts – social reform was in progress, with varying degrees of success, and tensions across the global political landscape were evident. Cuban exiles mounted an invasion on the Bay of Pigs in April 1961, unofficially supported by the USA in the hope of overthrowing Fidel Castro, but just a few short months later a network of concrete blocks and electric fences were erected to divide East and West Berlin, which would remain in place until 1989.

Society, too, was in flux. In the UK, following a decade of slavishly emulating USA popular culture, a new youth-led phenomenon was emerging. Swinging London, and later the Swinging Sixties, became the catch-all terms to describe a new modern fashion and cultural scene that flourished in London and

was spreading across the UK. As hair grew longer and skirts got shorter, pop music became the most important driving force in society. The Beatles released 'Love Me Do', their first single, in 1962 and, by 1963, Beatlemania was gripping the nation. Arriving at JFK Airport, New York, in February 1964, the successful exportation of the Fab Four had commenced.

Robert Allen Zimmerman, having dropped out of college at the end of his first year in May 1960, had also travelled to New York. Gigging in clubs and bars around Greenwich Village from February 1961, Zimmerman made an important career decision when he legally changed his name to Bob Dylan in 1962. In contrast to the Beatles' Merseybeat sound, Bob Dylan's protest tunes, showcased on his landmark album *The Freewheelin' Bob Dylan* released in May 1963, were folk-inspired, solidifying his early reputation and impressing many listeners, including George Harrison of the Beatles: 'the content of the song lyrics and just the attitude – it was incredibly original and wonderful'.

A new generation of image-makers were listening to the sounds of the Beatles, Bob Dylan and the plethora of popular music on both sides of the Atlantic. Born before, during or just after World War II, these artists and designers had first-hand experience of the radical social changes that marked the 1950s and early 1960s and many were entrenched in the new ideological commitments and political battles of the time. The illustrators among them were to look towards the social upheavals and the gradual changes in attitude for inspiration and an opportunity to comment.

French-born Tomi Ungerer (see p.56) relocated to New York in 1956 to work as an illustrator for *Harper's Bazaar*, *The New York Times*, *Esquire* and *Life*, before finally settling in Ireland in 1976. Ungerer, a passionate campaigner, created political images protesting racism and fascism and promoting nuclear disarmament, ecological and humanitarian causes.

Push Pin Studios in New York, originally founded in 1954 by Seymour Chwast, Milton Glaser, Reynold Ruffins and Edward Sorel, was one of a number of independent design companies to come to attention during the 1960s.

Rejecting Modernism, the protagonists of 1960s' graphic design and illustration explored new and expressive forms of graphic image-making using Victorian typography, Edwardian influences and Art Nouveau. While Pop Art, which borrowed images from everyday life, exploded in New York following Andy Warhol's controversial exhibition of paintings of Campbell's soup cans in 1962 and Roy Lichtenstein's giant comic-strip cartoon paintings in 1961, graphic image-makers plundered the past for influence and inspiration.

On the West Coast of the USA in San Francisco in 1965 a group of poster artists, many of them without any formal artistic training, began to experiment with design and print, developing an expressionist and free-flowing visual language. A counterculture, resistant to mainstream views and driven to break free from outmoded values, found expression in music and, for many, inspiration in hallucinogenic drugs such as LSD. In California, where drugs were legal until 1966, young artists and designers took stimulus from the acid trips they encountered – the resulting

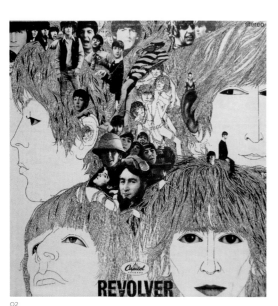

02

02 Klaus Voormann, *Revolver*, record sleeve, EMI Records, collage & pen & ink on paper, 1965
03 Milton Glaser, *Dylan*, colour offset lithograph, 1967

MILTON GLASER

DYLAN

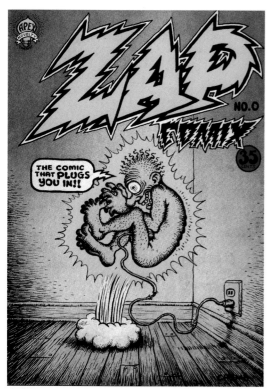

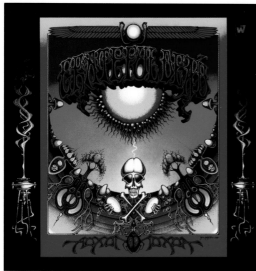

flamboyant and psychedelic images in stark contrast to the modernist international design style so prominent in commercial art and corporate design at the time.

The graphic arts were undergoing change; young counterculture artists, designers and illustrators influenced their peers through posters promoting rock concerts and political events, sleeve designs for rock and pop bands and influential publications such as *Rolling Stone* and *Oz* magazines.

In 1967, New York–based Push Pin Studios' Milton Glaser created what was to become an iconic poster portrait of Bob Dylan for inclusion in the original album package of *Bob Dylan's Greatest Hits*. It is often described as an example of psychedelic artwork and associated with the rock posters being produced in San Francisco, but Glaser denied this, admitting that he had tapped into an earlier art movement. 'I was interested in Art Nouveau at the time,' he recalled, 'that was an influence for the colours and shapes in the picture.'[1] The composition was in fact inspired by Marcel Duchamp's 1957 self-portrait, but the transformation of Dylan's hair into a tangled rainbow of colours was Glaser's own invention.

During 1965, the mop-top hairstyles of the Beatles would be immortalised in print, too, on the cover of *Revolver*, their seventh studio album. It is considered to be one of the very first psychedelic albums for its innovative manipulation of amplification and electronics to create new sounds on guitars and other instruments and for the apparent influence of drugs on the sound and lyrics. The name of the album, a play on the handgun of the same name and the act of a turntable spinning a record, derives from time spent in their Tokyo Hilton hotel room working collaboratively on a large psychedelic painting while on a tour of Japan.

Klaus Voormann (see p.68), a German-born artist and fellow musician, whom the Beatles had met and befriended during their time playing small gigs in Hamburg, created the artwork for the *Revolver* sleeve. Voormann's illustration – part line drawing and part collage of photographs of the band – captured the mood of the moment. His monochrome rendering of John, George, Paul and Ringo's hair was in stark contrast to Glaser's multicoloured interpretation of Dylan's.

Elsewhere in Europe, Jan Lenica (see p.39) and Roman Cieślewicz (see p.38), both from Poland, were demonstrating how an Eastern European aesthetic could hold sway and influence a wider audience. Strong, vivid and vibrant colours, from folk-art origins, mixed with hand-lettered or typographically bold slogans and the use of creative metaphors typified their work. And, in France, both Robert Massin (see p.46) and Romanian-born André François (see p.47) were leading contemporary illustration into new areas. Massin designed book covers with a uniquely typographic approach and François created darkly humorous covers for *Punch* magazine, while maintaining commercial projects for clients as diverse as Pirelli and Kodak.

Martin Sharp (see p.34) and Richard Neville had moved from Sydney in early 1967, relocating *Oz*, a satirical humour magazine, to London and, with fellow Australian Jim Anderson, led in the reincarnation of the publication. *Oz* became a psychedelic hippy

04 Robert Crumb, *Zap 0*, comic book cover, *Zap Comix*, offset print, 1967

05 Rick Griffin, *Aoxomoxoa*, album artwork, Grateful Dead/ Warner Bros. Records, 1969

magazine, the most recognised publication of the underground press until its demise in 1973. It was a hard-line advocate for counterculture views and opinions, promoting anti-establishment values while using a radical design aesthetic. With the new freedom of design layout afforded by offset printing and with access to fluorescent inks, metallic foils and new print stocks, Martin Sharp's artistic sensibility was given free rein. Sharp, recognised now as one of Australia's foremost pop artists, went on to create the seminal psychedelic cover art for Cream's album *Disraeli Gears* in 1967. In the same year, Michael English (see p.28), a British-born artist known for collaborating on psychedelic artworks with Nigel Waymouth under the moniker Hapshash and the Coloured Coat, created an iconic poster to promote the Love Festival, a climatic event for the British psychedelic scene. Psychedelic art and design had become a global phenomenon.

In the USA during the latter years of the 1960s, a succession of artwork and images would come to define the decade. In 1968, the year after the Summer of Love, Seymour Chwast created one of his most provocative works – *End Bad Breath* – an anti-war poster protesting the USA bombing of Hanoi (left). The poster depicts a sick and angry-looking Uncle Sam standing in front of exploding rays of blue and white with a gaping mouth filled with bombs and bombers.

The following year, *Zap Comix*, the first of the counterculture comics, with the label 'Fair Warning: For Adult Intellectuals Only', was published in San Francisco (opposite). On the day of publication, the print run of 3,500 copies was distributed around Haight-Ashbury from a baby's buggy by the wife of Robert Crumb. Crumb (see p.29) was *Zap*'s satirical cartoonist and illustrator responsible for much of the publication's radical input. He introduced to the pages of *Zap* two of the foremost psychedelic artists: Victor Moscoso (see p.48), best known for his poster artwork for rock venues and bands across San Francisco, and Rick Griffin (see opposite and p.36), acclaimed album-sleeve artist for the Grateful Dead.

However, by the end of 1968, the utopian dream had turned sour. The Vietnam War looked impossible to win due to the Viet Cong and North Vietnamese Tet Offensive; Martin Luther King, Jr. and Robert F. Kennedy, two of the most prominent left-wing politicians, had been assassinated; Richard Nixon was elected President; the Soviet Union invaded Czechoslovakia; and student protests and riots were rife in Paris. The decade had started with huge optimism and had witnessed the birth of a cultural revolution fuelled by massive changes socially and politically.

Following the conservatism of the 1950s, music, fashion, drugs, the Civil Rights Movement, feminism, the sexual revolution and the birth of environmentalism characterised the decade. The 1960s was a period of dreams and of revolt; it was a time of hope, struggle, disillusionment and unpredictable events. There were profound developments in ideas and attitudes, influencing behavioural change over the following decades, and a melting pot of new and experimental avant-garde practitioners of graphic design, illustration and comic art recorded, reflected and depicted the 1960s.

End Bad Breath.

06

06 Seymour Chwast, *End Bad Breath*, Push Pin Studios, pen/ink/ colour film, 1968

1. *Sign of the Times: Bob Dylan*, Owen Edwards for *Smithsonian Magazine*, June 2010.

MILTON GLASER

b.1929

After studying at The Cooper Union and the Academy of Fine Arts in Bologna, Milton Glaser founded the groundbreaking Push Pin Studios with Seymour Chwast, Reynold Ruffins and Edward Sorel in 1954 in New York. He was president for 20 years until setting up Milton Glaser Inc. in 1974. A prolific designer, in addition to his revered commercial work, he has designed hundreds of posters and prints that have been exhibited in museums and galleries worldwide. His reworked iconic 'I ♥ New York' logo (originally designed in 1977) became a symbol of unity after the September 11 terrorist attacks.

www.miltonglaser.com

01

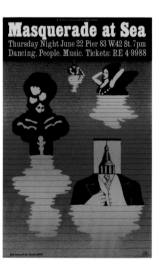

02

01 *Poppy Gives Thanks*, poster, black ink/colour overlays/colour offset lithograph, 1968
02 *Masquerade at Sea*, poster, black ink/colour overlays/colour offset lithograph, 1967
03 *The Poppy Foundation*, poster, watercolour & offset lithograph, 1968

The Poppy Foundation

In Cooperation With College Radio, Presents

Townes Van Zandt

The Mandrake Memorial

PAUL DAVIS

b.1938

Raised in Oklahoma, Paul Davis won a
scholarship to New York's School of Visual
Arts aged 17. While still studying he was
commissioned to create illustrations
for *Playboy* magazine and, shortly after
graduating, he joined Push Pin Studios.
Davis opened his own studio in 1963, going
on to have his work published in *Time,
Esquire, Sports Illustrated* and *Life*. His 1967
Che Guevara poster for *Evergreen* magazine
provoked a strong response, and led to the
magazine's offices being bombed by Cuban
dissidents. Davis was art director of the
Shakespeare Festival for several years
and of the cultural magazines *Wigwag* and
Normal, and he is renowned for his theatre
posters. His paintings have been exhibited
extensively, and his famous poster for
The Threepenny Opera can be found in the
permanent collection at the Museum of
Modern Art in New York.

01 *Clown Target*, editorial illustration,
Push Pin Graphic, oil paint on wood &
collage, 1961
02 *Mrs. Phipps*, editorial illustration, *Sports
Illustrated*, tempera paint on wood, 1963
03 *Leadbelly*, record sleeve, Columbia
Records, acrylic paint on wood, 1969
04 *Delta Queen*, editorial illustration, *Holiday*
magazine, acrylic paint on canvas, 1965
05 *Viva La Huelga*, poster, California Grape
Workers, acrylic paint on paper, 1968
06 *Bouquet*, book cover, Amsco Music
Publishing Company, tempera paint on
paper, 1962

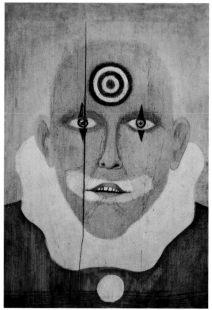

O1

O2

03

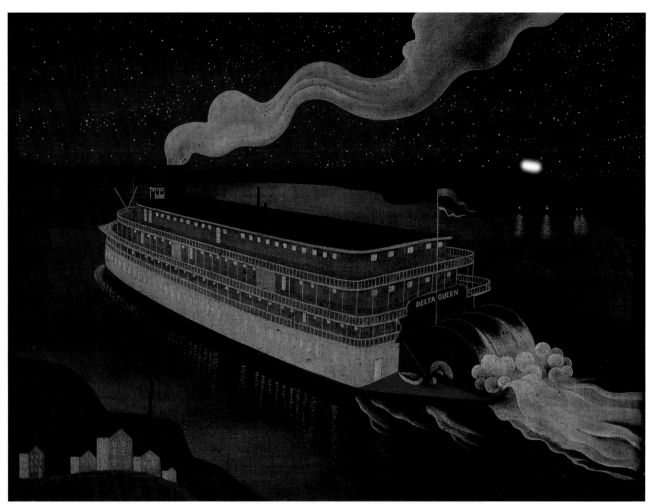

04

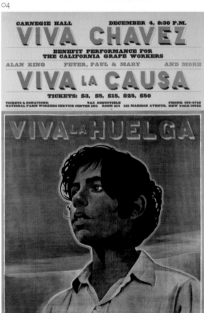

05

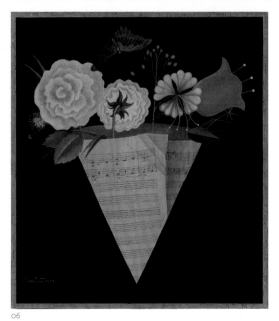

06

SEYMOUR CHWAST

b.1931

A native of the Bronx in New York, Seymour
Chwast studied at The Cooper Union.
After graduating, he set up Push Pin Studios
with Milton Glaser, Reynold Ruffins and
Edward Sorel. Chwast continued Push Pin
after Glaser left in 1974, and his playful
illustrations have been used extensively for
advertising, editorial, film and environmental
graphics. He has created several typefaces,
many children's books and over 100 posters.
Push Pin Studios published an eponymous
magazine until 1981, and Chwast has carried
on the self-publishing tradition with his
own magazine *The Nose*.
www.pushpininc.com

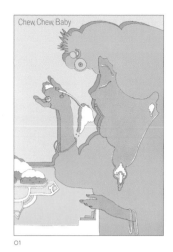

01

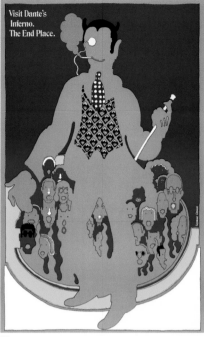

02

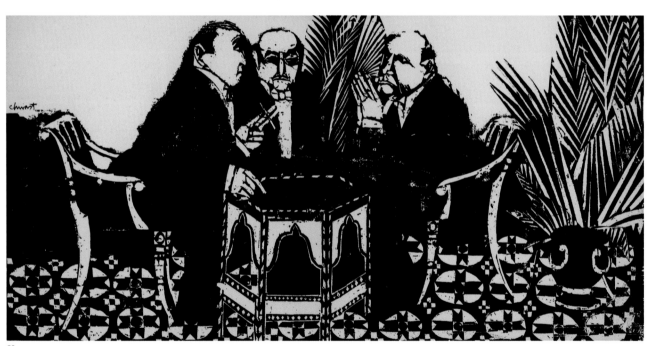

03

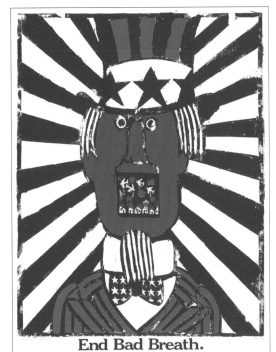

End Bad Breath.

05

04

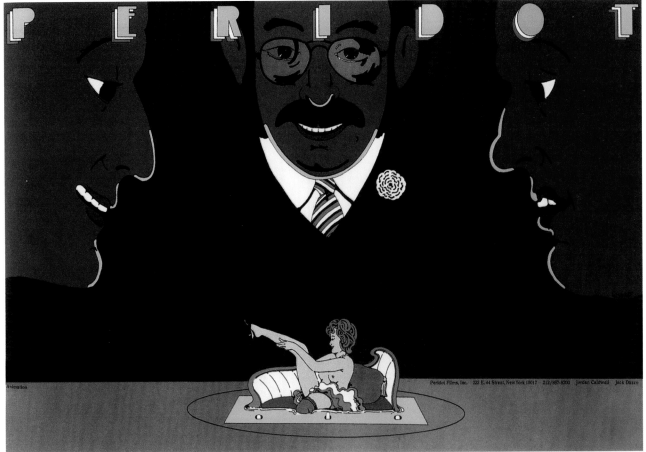

06

MICHAEL ENGLISH

1941–2009

Born in Oxfordshire, Michael English attended Ealing Art College in 1962, where he studied under the tutor Roy Ascott on his highly experimental Ground Course programme. After graduating in 1966, English contributed to the underground magazine *International Times*, and decorated the shopfronts of two of the most fashionable Chelsea boutiques of the time: Granny Takes a Trip and Hung on You. With Nigel Waymouth, English produced numerous posters under the name Hapshash and the Coloured Coat for musicians including Jimi Hendrix and Pink Floyd. These colourful, psychedelic screen-printed posters epitomised the emerging hippy scene of the time. Abandoning the psychedelic imagery in the early 1970s in favour of a hyper-realist approach, English found commercial success working for high-profile advertising clients. *michaelenglishart.co.uk*

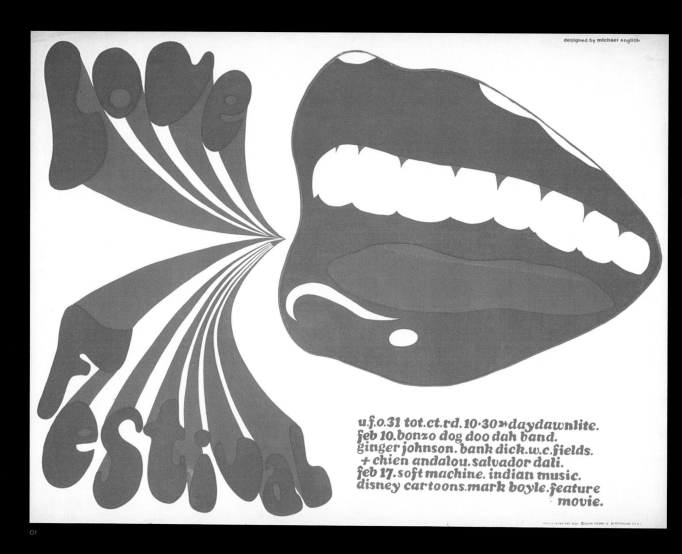

01

01 *Love Festival*, poster, Osiris Visions Ltd, colour screen print, 1967

ROBERT CRUMB

b.1943

Born in Philadelphia, cartoonist Robert Crumb moved to San Francisco in 1967, placing himself at the heart of the city's counterculture movement. One of the founders of the underground *Zap Comix*, Crumb contributed to all of its 16 issues.

His characters Fritz the Cat and Mr Natural soon became cult figures, with his often-controversial work attracting much attention. He also contributed to the British magazine *Nasty Tales*, which was involved in an obscenity trial in 1972 (the first involving a comic). Crumb designed numerous LP covers for bands

including Big Brother and the Holding Company and the Grateful Dead, contributed to *Weirdo* magazine in the 1980s and collaborated with writers including Charles Bukowski. In 2003, Crumb was immortalised in Shari Springer Berman's film *American Splendour*.

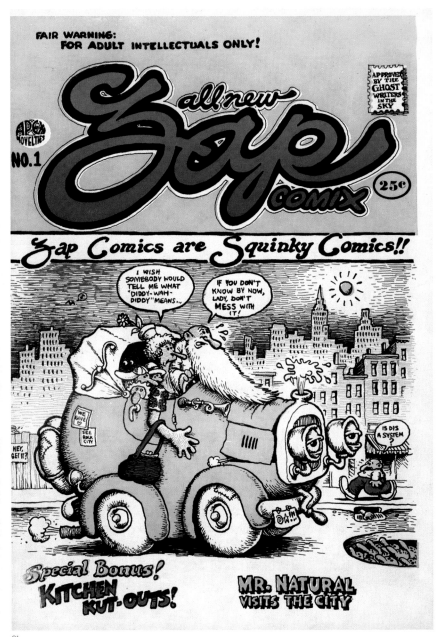

01

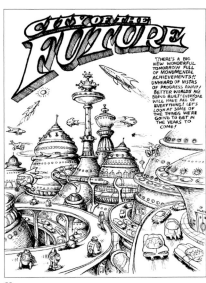

02

01 *Zap 1*, comic book cover, *Zap Comix*, offset printing, 1967
02 *City of the Future*, comic-strip illustration from *Zap 1*, *Zap Comix*, ink on paper, 1967

BERNIE FUCHS

1932–2009

On leaving Washington University in St. Louis, Bernie Fuchs went to work for a commercial art studio in Detroit, where he painted aspirational scenes featuring the latest car models for clients in the automotive industry. His narrative style and refined technique appealed to companies such as Seagram's and Coca-Cola, and commissions for postage stamps and children's books followed. Fuchs undertook considerable editorial work for magazines such as *TV Guide* and *Sports Illustrated*, for which he drew numerous covers. He painted portraits of many famous sports stars, as well as historic figures including John F. Kennedy, Lyndon B. Johnson and Martin Luther King.

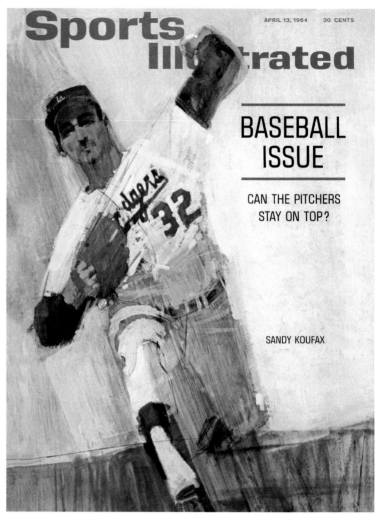

01

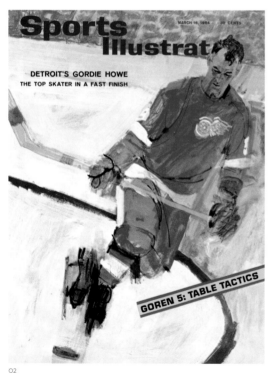

02

01 *Los Angeles Dodgers Sandy Koufax,* editorial cover, *Sports Illustrated,* 1964
02 *Detroit Red Wings Gordie Howe,* editorial cover, *Sports Illustrated,* 1964

JOE DEMERS

1910–84

Specialising in the depiction of the modern American girl, Joe DeMers attended Chouinard Art Institute in Los Angeles and then Brooklyn Museum Art School in New York. For about ten years he was a film-production illustrator and designer, working primarily for Warner Bros. Studios. He illustrated his first piece for *Fortune* magazine in 1937, going on to work for *Esquire*, *McCall's Magazine*, *The Saturday Evening Post* and *Ladies' Home Journal*.

01 *He was there when she was. The Relationship was natural, unplanned. It flowed,* editorial illustration, *McCall's Magazine,* mixed media on Masonite board, 1960

01

HEINZ EDELMANN

1934–2009

Born in Czechoslovakia, Heinz Edelmann studied at the Düsseldorf Academy of Fine Arts. After graduating, he became well known as a designer, in particular for his work on avant-garde German magazine *Twen*. In 1967, Edelmann was invited to submit designs for a full-length animated film featuring the Beatles, and he was duly appointed art director of *Yellow Submarine* (1968). The first British feature-length animation since *Animal Farm* (1954), it proved to be hugely influential, although for Edelmann – who went on to design posters for plays and films, book jackets and the mascot for the Expo '92 World's Fair in Seville, Spain – it became, as he remarked, somewhat of an albatross around his neck.

01 *The Wind in the Branches*, poster, Kammerspiele Düsseldorf, 1960s
02 *Monsters, Beatles und Edelmann*, poster, Modern Art Museum München, c.1968
03 *Nekrassow* by Jean-Paul Sartre, poster, Atlas Film, 1960s

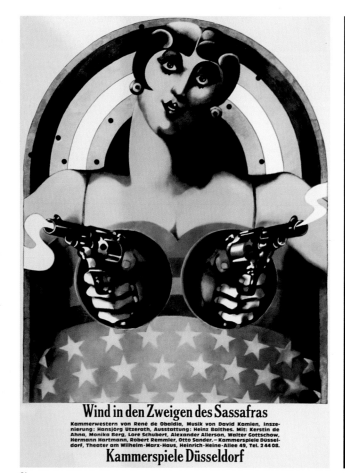

01

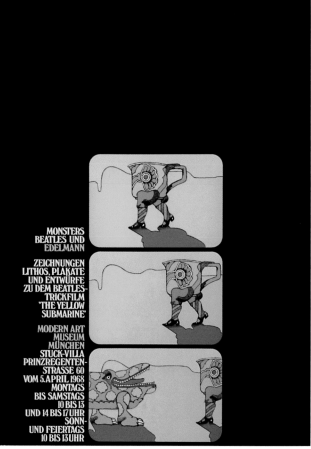

02

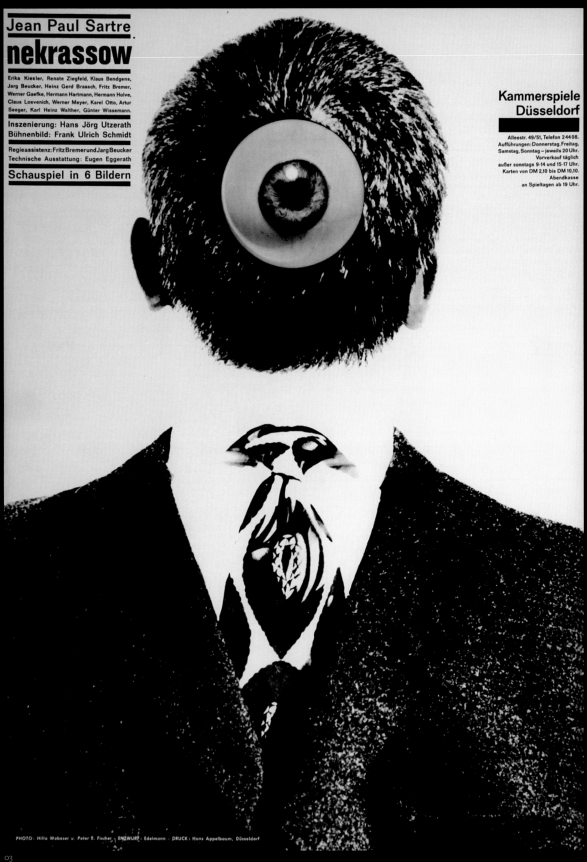

Jean Paul Sartre

nekrassow

Erika Kiesler, Renate Ziegfeld, Klaus Bendgens,
Jarg Beucker, Heinz Gerd Braasch, Fritz Bremer,
Werner Gaefke, Hermann Hartmann, Hermann Holve,
Claus Loevenich, Werner Meyer, Karel Otto, Artur
Seeger, Karl Heinz Walther, Günter Wissemann.

Inszenierung: Hans Jörg Utzerath
Bühnenbild: Frank Ulrich Schmidt

Regieassistenz: Fritz Bremer und Jarg Beucker
Technische Ausstattung: Eugen Eggerath

Schauspiel in 6 Bildern

Kammerspiele
Düsseldorf

Alleestr. 49/51, Telefon 24408.
Aufführungen: Donnerstag, Freitag,
Samstag, Sonntag – jeweils 20 Uhr.
Vorverkauf täglich
außer sonntags 9-14 und 15-17 Uhr.
Karten von DM 2,10 bis DM 10,10.
Abendkasse
an Spieltagen ab 19 Uhr.

PHOTO: Hilla Webeser u. Peter R. Fischer. ENTWURF: Edelmann. DRUCK: Hans Appelbaum, Düsseldorf.

03

MARTIN SHARP

1942–2013

Martin Sharp studied in his native Sydney at the National Art School, and his cartoons were published in many of the Australian national newspapers while he was a student. In 1963, with student editors Richard Neville and Richard Walsh, he art-directed the first incarnation of controversial satirical underground magazine *Oz*. A talented illustrator with a vibrant psychedelic style, Sharp created iconic posters of Bob Dylan, Donovan and Jimi Hendrix, and designed album covers for artists such as Cream and Eric Clapton. Often described as 'Australia's foremost pop artist', Sharp founded Sydney's first art-performance space Yellow House, and was responsible for giving the Luna Park theme park its distinctive identity.
www.martin-sharp.com

01 *Max 'The Birdman' Ernst*, poster, 1967
02 *Bob Dylan, Blowin' in the Mind*, poster, 1966

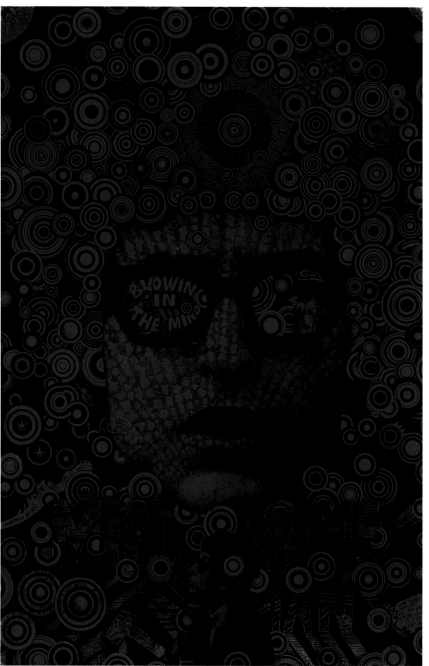

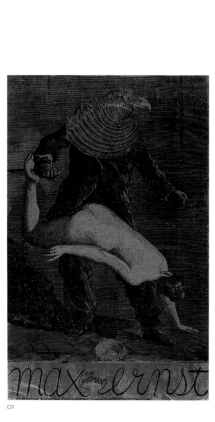

01

02

BERNARD BUFFET

1928–99

Bernard Buffet was born in Paris and studied at the École Nationale Supérieure des Beaux-Arts, graduating in 1945. In his early career, he worked in the studio of painter Eugène Narbonne, before art dealers Emmanuel David and Maurice Garnier became his patrons. Buffet's often melancholy work was exhibited widely, and, in 1955, he was declared by the magazine *Connaissance des Arts* as one of the top-ten post-war artists. In 1957, he illustrated Jean Cocteau's *La Voix Humaine*, and his first retrospective was held at the Galerie Charpentier in Paris in 1958 when he was just 30 years old. A prolific artist, he created more than 8,000 paintings throughout his lifetime, and a museum dedicated to his work was opened in Surugadaira, Japan, in 1973.

www.museebernardbuffet.com

01 *Femmes Déshabillées – Trois Femmes*, oil on canvas, 1965
02 *Le Museum – Le Condor*, oil on canvas, 1963
03 *Le Museum – Le Papillon Rouge*, oil on canvas, 1963

01

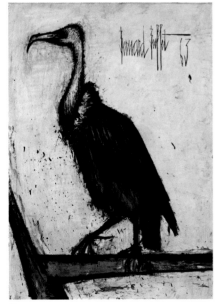

02

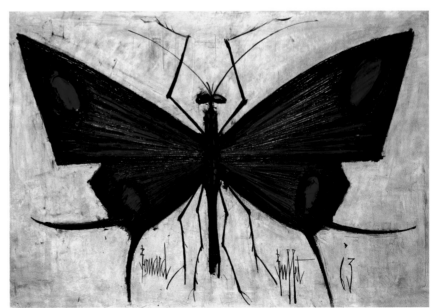

03

RICK GRIFFIN
1944–91

Born in California and a keen surfer from the age of 14, Rick Griffin chose his first job based on his lifelong passion, becoming a staff artist at *Surfer* magazine in 1961. It was here that he created the comic-strip character Murphy, which later became a mascot for surfers. He briefly attended the Chouinard Art Institute in Los Angeles before participating in Ken Kesey's famous Acid Test parties. Then, in late 1966, he moved to San Francisco. Griffin's intricate, psychedelic style epitomised the spirit of the times, and he was soon invited to design what were to become iconic posters for Chet Helms's Family Dog events at the Avalon Ballroom, and for gigs at The Fillmore. Griffin regularly contributed to the underground magazine *Zap Comix* and had a long-standing relationship with the band the Grateful Dead, for whom he designed numerous LP covers and posters.

01 *Aoxomoxoa*, album artwork, Grateful Dead/ Warner Bros. Records, 1969

02 *Alohaoahola*, comic-strip illustration from *Zap 2*, *Zap Comix*, 1968

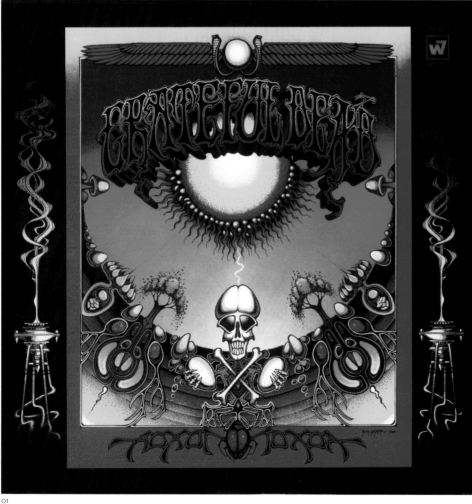

01

02▶

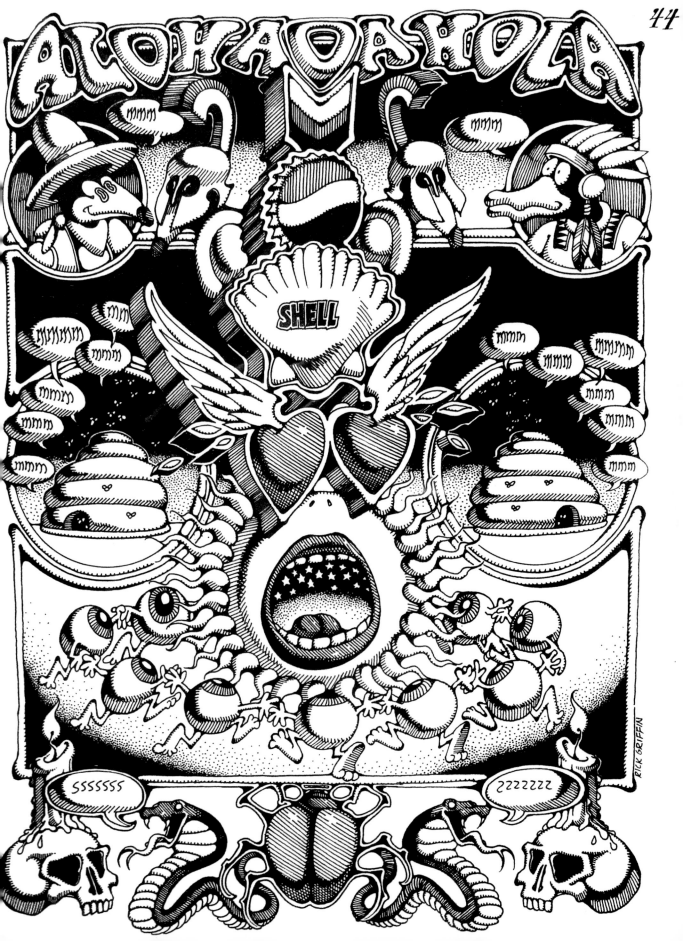

ROMAN CIESLEWICZ
1930–96

Roman Cieślewicz studied at the Krakow Academy of Fine Arts and, after graduating, designed the successful magazine *Ty i Ja* (*You and Me*). He left Poland in 1963 for Italy, then Paris, where he worked as art director for *Elle*, contributed to *Vogue* and worked for the ad agency Mafia. A member of Panique, the so-called 'last surrealist group in France', he is credited with having introduced the Polish poster to the country. His work spans cinema posters, books and magazine covers, as well as publicity material for the Centre Georges Pompidou, Paris. Cieślewicz uses collage to great effect and his bold and political work has appeared in over 100 solo exhibitions around the globe.

01 *Ksiadz Marek (Friar Marek)*, poster for the production of the 1843 drama by Juliusz Slowacki, Teatr Dramatyczny, offset lithograph, 1963

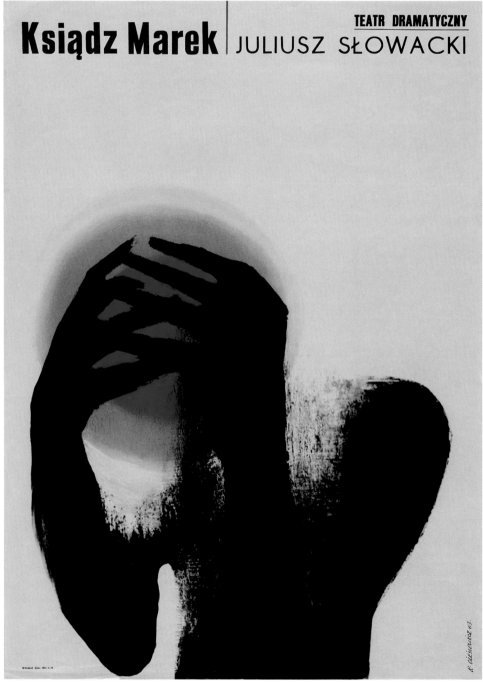

01

JAN LENICA
1928–2001

Award-winning Polish poster designer and cartoonist Jan Lenica studied architecture at Warsaw University of Technology, and on graduating collaborated with film director Walerian Borowczyk on some of his early animated films. Lenica went on to make many films using his trademark stop-frame animation technique. He designed book jackets, illustrations and numerous posters, all of which display his distinctive take on surrealism. Lenica taught extensively – he lectured on poster art at Harvard University in 1974 and was Professor of Poster and Graphic Arts at the Academy of Fine Arts in Berlin between 1986 and 1994.

01 *Polnische Filmtage*, poster, Constantin Film, silk screen, 1964

01

TOM MCNEELY

b.1935

Tom McNeely was born in Toronto, Canada, where he continues to live and work. A keen artist from a very early age, on graduating from the Danforth Collegiate and Technical Institute, McNeely went to work for the studio Rapid Grip and Batten. A spell at Bomac Studios followed, where McNeely created work that appeared in magazines, advertising and books, as well as for the country's fast-growing automotive industry in the form of catalogues, newspaper advertisements and posters. McNeely's beautifully precise watercolour work often featured Canadian themes such as national heroes, military uniforms and native peoples. He established his own studio in 1968, and his work has continued to be much in demand, appearing on everything from stamps and calendars to annual reports.

DODGE/63

01

02

03

04

05

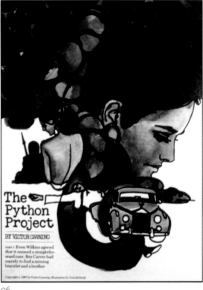

06

a long and fruitful relationship with *The New Yorker* as well as a career in exhibiting in galleries and museums. Steinberg's witty approach and economy of line were instantly recognisable to magazine readers as well as exhibition viewers throughout the world, as were his political and social commentaries, which ran from the acerbic to the affectionate. His much-loved 1976 *New Yorker* cover *View of the World from 9th Avenue* depicted the mental geography of Manhattanites.
www.saulsteinbergfoundation.org

01 *Artists and War*, 1969. Rubber stamp/pencil/coloured pencil
on paper, 58 x 73.5 cms (23 x 29 inches). The Saul Steinberg
Foundation.

02 *Untitled*, 1964. Pen and ink/brush and ink/graphite/
watercolour on paper, 56 x 58 cms (22 x 23 inches).
Reworked from a drawing published in *The New Yorker*,
11 August 1962. The Saul Steinberg Foundation.

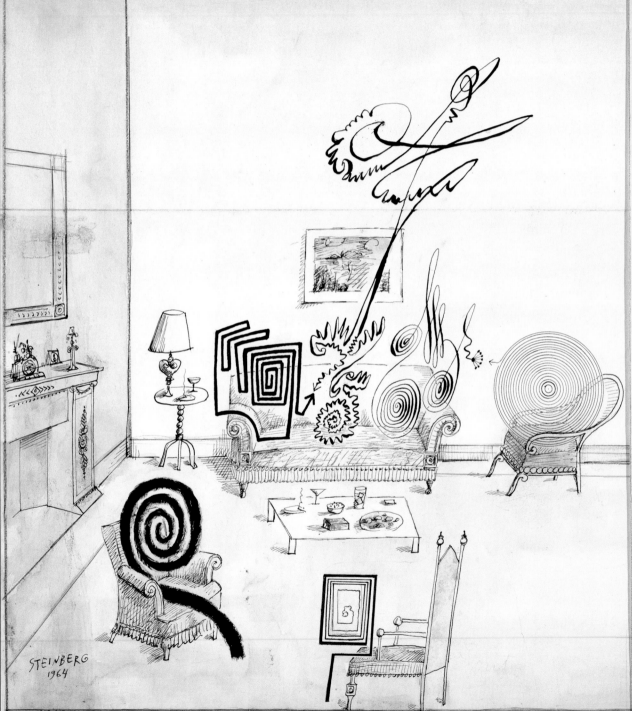

BRIAN LOVE

Print maker, artist and author, Brian Love graduated from the Royal College of Art, London, in 1966. His working method embraces mixed media, consolidating drawing, print, montage and sculptural elements. He has created editorial illustrations for many publications, including *Town Magazine*, *The Radio Times*, *NOVA* and *Vogue*. With the emergence of colour supplements in the mid-1960s, Love was commissioned for many features, his key focus being on the portrayal of celebrities from popular culture. His work has been exhibited worldwide, and he created and managed the illustration courses at Kingston University, London, for 25 years, after which the university appointed him Honorary Fellow for Illustration & Animation.

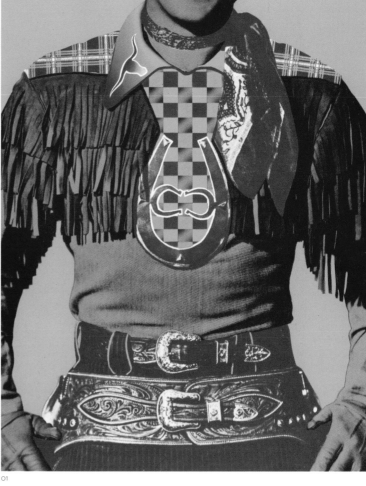

01

02

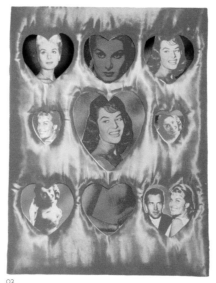

03

01 *Roy Rogers, Screen Cowboy,* silk screen for 1000 *Makers of the Twentieth Century, The Sunday Times,* mixed media, 1968
02 *Tendril Scarf,* editorial cover, *Ambassador* magazine, lithograph drawn, 1966
03 *Belinda Lee, British Beauty in Hollywood,* silk screen for 1000 *Makers of the Twentieth Century, The Sunday Times,* mixed print process/photography/drawing, 1968
04 *Malcolm X, True Revolutionary,* lithograph collage for 1000 *Makers of the Twentieth Century, The Sunday Times,* mixed print process/photography/drawing, 1968
05 *Duncan Edwards, Manchester United Superstar,* artwork for 1000 *Makers of the Twentieth Century, The Sunday Times,* mixed print process/photography/drawing, 1968
06 *Jim Reeves, Songster,* artwork for 1000 *Makers of the Twentieth Century, The Sunday Times,* mixed print process/ photography/drawing, 1968

04

05

06

ROBERT MASSIN

b.1925

Born in Eure-et-Loir in northern France,
Robert Massin played a major part in the
French book design revolution of the 1950s.
As art director of Éditions Gallimard, he
was responsible for the pocket-book series
Folio and L'Imaginaire. Massin designed
thousands of book covers and layouts, all
with his unique typographic slant. His work
has been exhibited extensively and he has
written over 30 books, one in particular,
entitled *Letter and Image*, has been updated
and reissued continually since it was first
published in 1970.

01

02

03

01 *Crocodile 1 – 2*, book illustration from *The Bald Soprano*,
Grove Press, 1965
02 *Délireàdeux*, Éditions Gallimard, 1966
03 *Mémoires de Chirico*, La Table Ronde, 1966

ANDRÉ FRANÇOIS

1915–2005

Born in Romania, André François studied at the Academy of Fine Arts in Budapest. He moved to Paris in 1934 and worked in the atelier of the famous poster artist Cassandre, eventually becoming a French citizen in 1939. He cut his teeth drawing political cartoons for satirical magazine *Le Rire*, before going on to contribute extensively to *Punch*, for whom he designed many darkly humorous covers. François was a hugely influential figure; as well as his prolific cartoon output he was commissioned by commercial clients including Citroën, Pirelli and Kodak. He designed stage sets for the Royal Shakespeare Company and provided numerous illustrations for *The New Yorker* and *Sports Illustrated*.

01 *Untitled*, editorial cover, *Punch*, 1963
02 *Mr Punch in a Punch and Judy show protecting Toby the dog*, editorial cover, *Punch*, 1962

01

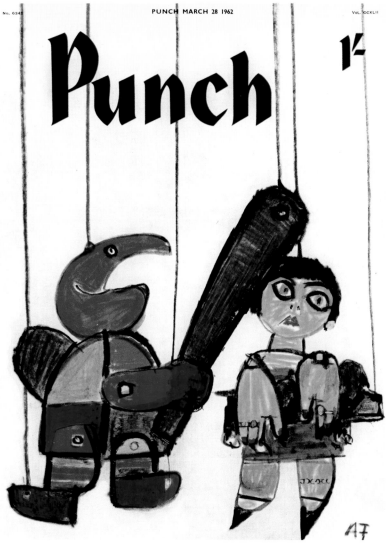

02

VICTOR MOSCOSO

b.1936

Originally from Spain, Victor Moscoso studied at The Cooper Union in New York and Yale University, before attending San Francisco Art Institute in 1959. His psychedelic posters for concerts in the city's clubs and dance halls, particularly the high-profile Family Dog events at the Avalon Ballroom and Neon Rose at The Matrix, were seen as the graphic representation of the legendary Summer of Love and brought him international acclaim. Moscoso also contributed extensively to the underground *Zap Comix* and designed ad campaigns, posters and album artwork for musicians including Jerry Garcia and Herbie Hancock. *www.victormoscoso.com*

01 *Neon Rose #12*, The Matrix, standard printing ink on rag paper & offset lithography, 1967
02 *Neon Rose #2*, The Matrix, standard printing ink on rag paper & offset lithography, 1967

01

O2

EDWARD GOREY

1925–2000

Author and artist Edward St. John Gorey was born in Chicago and attended the Art Institute of Chicago before enrolling at Harvard University. In 1952, he went to work in the art department of Doubleday Publishers in New York, publishing his first book, *The Unstrung Harp*, in 1953. Gorey has illustrated over 100 books, designed sets and costumes for many theatre productions, and created artwork for such publications as *The New Yorker* and *The New York Times* and for such authors as John Updike, Samuel Beckett and Charles Dickens. Gorey died in Cape Cod on 15 April 2000. He was inducted into the Society of Illustrators Hall of Fame in 2012.

www.edwardgoreyhouse.org

01

01 *Untitled*, editorial cover, *The Kenyon Review*, pen & ink, 1966

BEN SHAHN

1898–1969

Lithuanian-born illustrator, graphic artist and painter Ben Shahn moved to New York City in 1906. He attended New York University, City College of New York and the National Academy of Design in New York. Best known for his work on social or political themes, in 1954 Shahn represented the USA at the Venice Biennale. He worked as a commercial artist for CBS and for magazines *Fortune* and *Harper's Bazaar*, while his well-known 1965 portrait of Martin Luther King, Jr. appeared on the cover of *Time*. He was elected to the National Institute of Arts and Letters and the Accademia delle Arti e del Disegno in Florence. Shahn died aged 70 in New York.

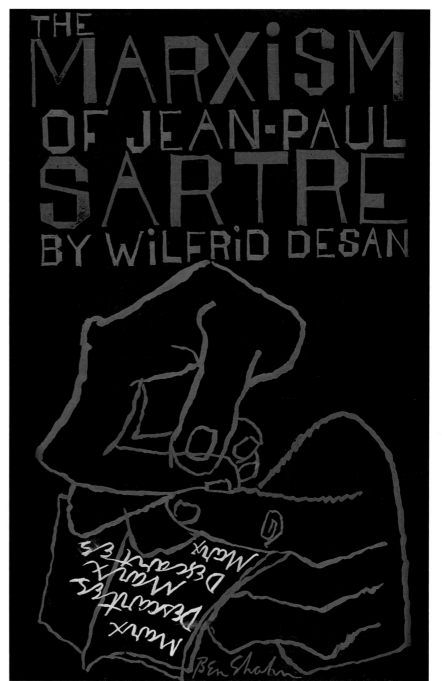

01

01 *The Marxism of Jean-Paul Sartre*, book cover, Doubleday, tempera on acetate, 1965

TAKASHI KONO

1906–99

Takashi Kono graduated from the Tokyo National University of Fine Arts and Music in 1929. An important figure in Japanese graphic design in the post-war period, he is well known for his poster design for the 1972 Winter Olympics in Sapporo and for his politically motivated poster *Sheltered Weaklings – Japan*, depicting a shark-like fish bearing the stars and stripes of the American flag being trailed by a shoal of tiny red-eyed 'Japanese' fish. In the early part of his career, Kono worked for Japan's first fringe theatre, Tsukiji Shogekijo; he designed numerous film posters for the major film production company Shochiku Kinema, eventually going on to open the Gallery 5610 space in Tokyo in 1972.

01, 02 *Untitled*, exhibition piece for 'Variation on a Fish', personal project, silk-screen print, 1967
03 *Untitled*, editorial cover for *Design no. 76*, Bijutsu Shuppan-Sha Co., Ltd, intaglio photogravure, 1965
04 *Untitled*, editorial cover for *Design no. 78*, Bijutsu Shuppan-Sha Co., Ltd, intaglio photogravure, 1965
05 *Untitled*, editorial cover for *Design no. 77*, Bijutsu Shuppan-Sha Co., Ltd, intaglio photogravure, 1965
06 *Untitled*, editorial cover for *Design no. 75*, Bijutsu Shuppan-Sha Co., Ltd, intaglio photogravure, 1965

01

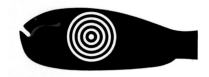

02

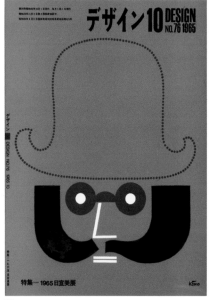

03

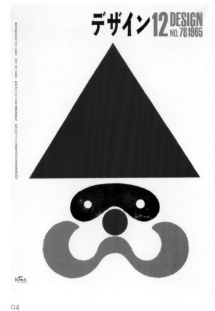

04

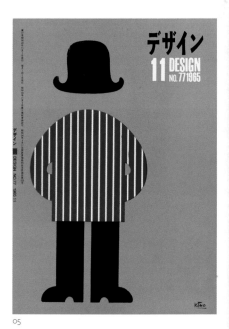

05

第75号昭和40年9月1日発行　毎月1回1日発行　昭和34年11月2日第3種郵便物認可　昭和34年9月11日　国鉄東局特別扱承認雑誌第625号

デザイン 9 DESIGN
NO.75 1965

デザイン DESIGN NO.75 1965 9

KONO

ROY SCHNACKENBERG
b.1934

Roy Schnackenberg studied graphics with Edwin Fulwider at Miami University in Oxford, Ohio. Graduating in 1956, Schnackenberg was art director at advertising agency Foote, Cone & Belding between 1959 and 1960, before leaving to pursue a career as a painter. At that time, Art Paul, creator of the Playboy Bunny logo and look, decided to start a collection of commissioned works from fine artists for *Playboy*. Schnackenberg was one such artist and he went on to create two dozen canvases for the magazine over the following 25 years. His work appears in the permanent collections of the Art Institute of Chicago and the Whitney Museum of Art, New York. Schnackenberg lives and works in Chicago.
www.royschnackenberg.com

01 *Playmate as Fine Art*, editorial illustration, *Playboy*, wood & plastic oil-painted relief, 1967
02 *The Good Blonde*, editorial illustration, *Playboy*, oil on canvas, 1965

01

02

AL PARKER

1906–85

Alfred Charles Parker was born in St. Louis, Missouri, and went on to study at Washington University's School of Fine Arts from 1923 to 1928. On graduation, Parker set up an advertising agency with fellow students before moving to New York in 1935. In 1938, he began a 13-year collaboration with *Ladies' Home Journal* to illustrate a series of over 40 'Mother and Daughter' covers. He has worked for countless magazines, including *Vogue*, *Cosmopolitan*, *Good Housekeeping* and *The American Weekly*. He even secretly illustrated an entire issue of *Cosmopolitan*, using different names, styles and media for each story. Elected to the Society of Illustrators Hall of Fame in 1965, Parker was also one of the founding faculty members of the Famous Artists School in Westport, Connecticut.

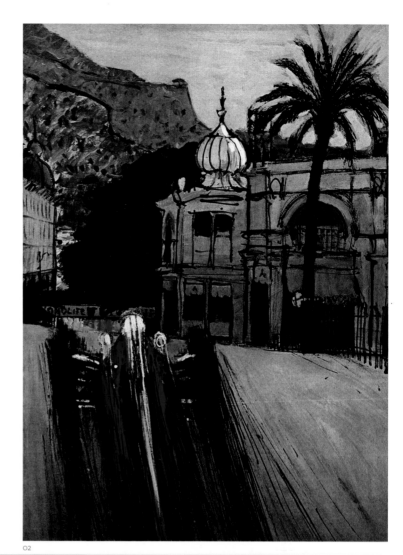

O2

O1

O3

O4

01 *Untitled*, editorial illustration, *Sports Illustrated*, acrylic, 1964
02 *Untitled*, editorial illustration, *Sports Illustrated*, acrylic, 1964
03 *Untitled*, editorial illustration, *Cosmopolitan*, 1968
04 *Untitled*, editorial illustration, *Ladies' Home Journal*, 1960

TOMI UNGERER

b.1931
Born in the French town of Strasbourg, trilingual illustrator Tomi Ungerer moved to the USA in 1956. He published his first children's book a year later, the first of over 140 publications for adults and children to date. His witty illustrations were subsequently commissioned by numerous publications including *Harper's Bazaar* and *The New York Times*, and it was during this time that he started designing posters against the Vietnam War. In 2000, he was named as the first Ambassador for Childhood and Education by the Council of Europe, and in 2007 the Musée Tomi Ungerer was opened in his birth town of Strasbourg. *www.tomiungerer.com*

01 *Colour on Friday*, editorial illustration, *The Daily Telegraph*, Pelikan ink, 1966
02 *Ice Capades*, poster, Ice Capades, Pelikan ink, 1965
03 *Choice not Chance*, poster, personal project, Pelikan ink, 1967

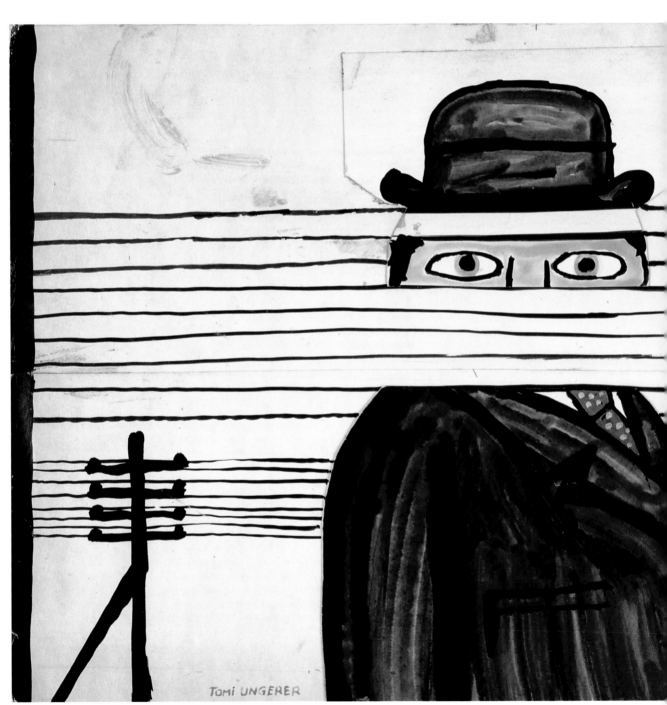

01

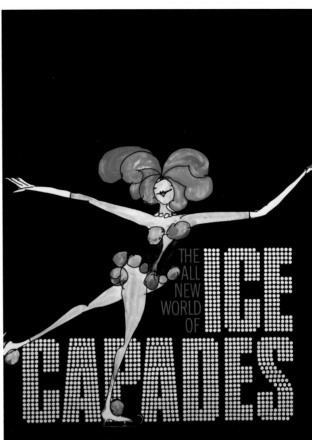

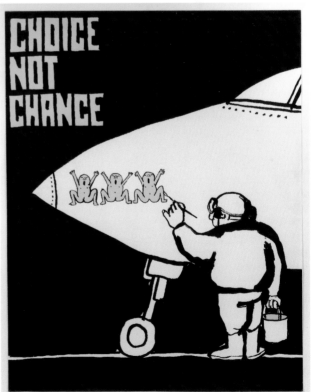

MICHEL QUAREZ

b.1938

Born in Syria, Michel Quarez studied at the École Nationale Supérieure des Arts Décoratifs in Paris. After graduating in 1961, he moved to Warsaw, where he worked for a year with the famous poster designer Henryk Tomaszewski – this was at a time when the poster was the only art form in Poland that remained uncensored. Quarez went on to work in New York, where he created the comic strip *Mode Love*, before returning to Paris to work as a freelance illustrator. Taking inspiration from his local area of St. Denis, Quarez has won many awards for his bold style. A retrospective of his work was held at the Stedelijk Museum, Amsterdam, in 2006.

01, 02, 03 *La Vita Privata di Dyane*, comic book spread, Citroën, 1968

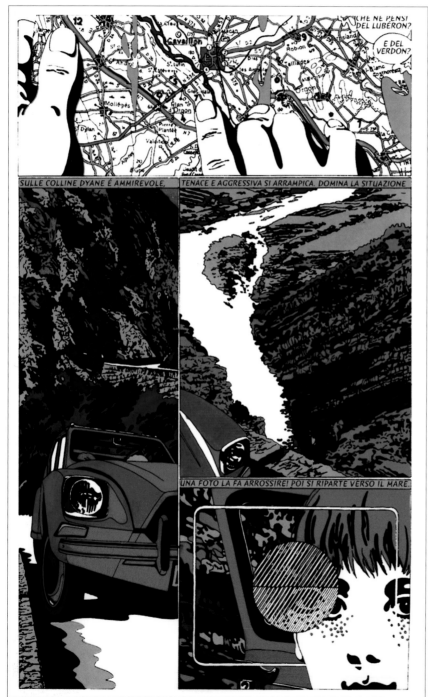

01

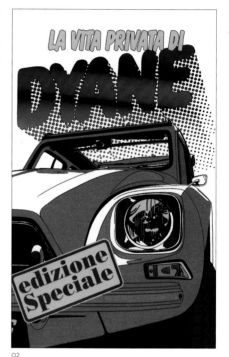

02

03

ROLAND TOPOR
1938–97

An illustrator, painter, writer, film maker and actor, Roland Topor spent the first years of his life as a refugee in Savoy. During the 1960s, Topor was part of the Paris-based Dada movement Panique, and in 1964 he wrote and illustrated *The Tenant* (which was later made into a film by Roman Polanski in 1976). A prolific artist, he went on to create posters, books, an animated feature film and screenplays, even appearing in films himself. Surrealism was a key theme running through all of his work and this, combined with dark humour, resulted in many memorable and often macabre images.

01 *Untitled*, book illustration from *Stories and Drawings* by Roland Topor, Peter Owen Ltd, pen & ink, 1968

01

MAURICE SENDAK

1928–2012

Rich and complex, Maurice Bernard Sendak's illustration work graces the pages of more than 90 books. Born on 10 June in New York, Sendak enjoyed drawing from an early age, working for *All-American Comics* on backgrounds for comic strips while still at high school. His first professional illustrations appeared in a physics book in 1947, with his first children's book following soon after in 1951. With a career spanning over six decades, and which also included set and costume design, Sendak cited various influences, from Herman Melville to Emily Dickinson and Mozart. Perhaps his most famous book, *Where the Wild Things Are*, was first published in 1963 and won the Caldecott Medal in 1964. He was the recipient of the Hans Christian Andersen Award for Illustration in 1970 and, in 1983, the Laura Ingalls Wilder Award for his contributions to children's literature. He died on 8 May 2012 in Danbury, Connecticut.

01 *Where the Wild Things Are*, book cover, HarperCollins Publishers, pen and ink line with watercolour on WhatmanTM watercolour paper, 1963

02 *In the Night Kitchen*, book cover, HarperCollins Publishers, pen and ink line with watercolour on WhatmanTM watercolour paper, created 1960s, published 1970

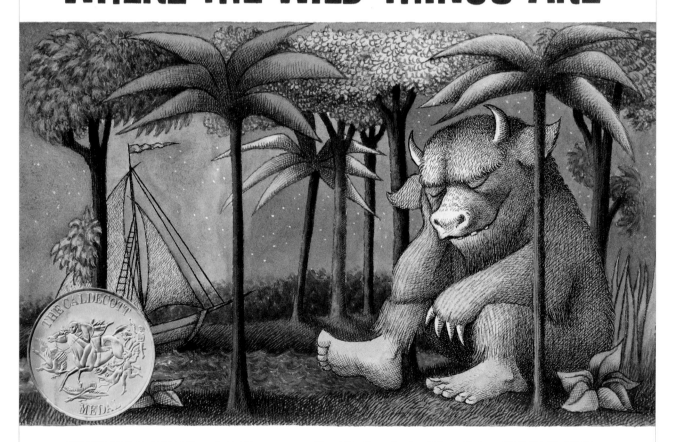

01

PHILIP HAYS
1931–2005

Philip Hays was born in Texas, raised in Louisiana and attended the Art Center College of Design in Pasadena. He moved to New York after graduating and embarked on a very successful career as an illustrator: his pop-art-influenced work was commissioned by publications including *Sports Illustrated*, *Rolling Stone* and *Esquire*, and as cover artwork for artists including Jerry Lee Lewis, Muddy Waters and Billie Holiday. The desire for a change of pace prompted Hays to quit at the height of his success to become Chairman of the Illustration Department at the Art Center College of Design. It was a position he held for 24 years, making a huge impact on his students and completely transforming the department.

www.philhays.com

01

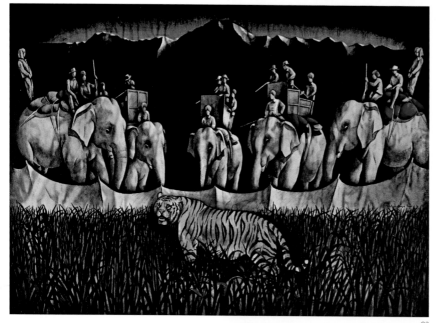

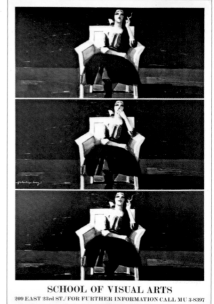

02 03

01 *The Kiss*, editorial illustration, *Esquire*, watercolour & pencil, 1965

02 *Tiger Hunt*, editorial illustration, *Playboy*, watercolour & pencil, c.1966

03 Poster, School of Visual Arts, watercolour & pencil, c.1964

04 *Race Car Driver*, editorial illustration, *Esquire*, acrylic, c.1967

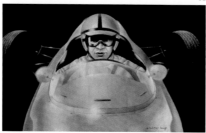

04

YUSAKU KAMEKURA

1915–97

Often referred to as 'the Godfather of Japanese design', Yusaku Kamekura studied at the Institute of New Architecture and Industrial Arts, Tokyo, a unique design school heavily influenced by the teachings of the Bauhaus. After graduating, he went on to work in publishing for Nippon Kobo, and in 1960 he was one of the founders of the Nippon Design Center. Throughout his career Kamekura designed many notable posters, for example, those to promote the Tokyo 1964 Olympic Games and Japan Expo '70, as well as the message-driven works *Atoms for Peace* and *Hiroshima Appeals*. In 1989, he took over as publisher of *Creation*, a limited-edition design magazine for which he was designer, editor and publisher.

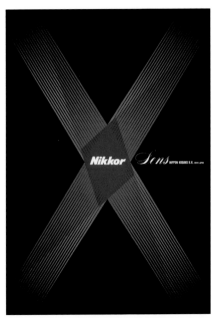

01

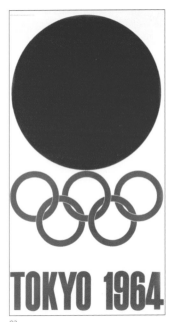

02

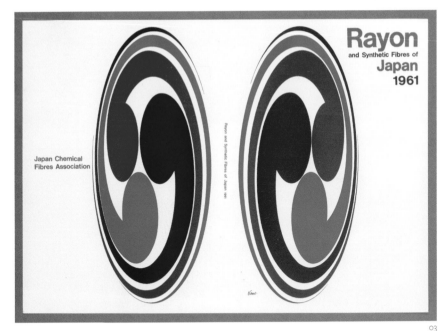

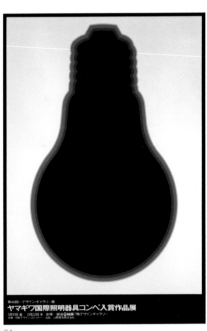

03 04

01 *Poster for Nikkor Lens,*
 Nikon Corporation, 1960
02 *Poster for 1964 Tokyo*
 Olympics, Japan Olympic
 Committee, 1961

03 *Brochure Cover for*
 Rayon and Synthetic
 Fibres of Japan, 1961
04 *Untitled,* poster,
 Yamagiwa International
 Competition for Lighting
 Fixtures Exhibition, 1968

ROBERT WEAVER

1924–94

Born in Pittsburgh, Pennsylvania, Robert Weaver studied at the city's Carnegie Institute, The Art Students League of New York and the Accademia di Belle Arti in Venice. He is credited with creating a new approach to visual storytelling akin to that of a photojournalist, creating his own narratives and often dealing with hard-hitting subject matter. Weaver's visual essays appeared in publications including *Life*, *The New York Times* and *Sports Illustrated*, and he covered events such as the Kennedy election and the Vietnam War. In an acknowledgement of his genre, a master's course entitled 'Illustration as Visual Essay' was established at the School of Visual Arts in New York (where Weaver taught for many years) in 1983.

01 *The Man Who Said 'Control the Ball'*, editorial illustration, *Sports Illustrated*, paint & four-colour printing, 1967

02 *Belmont Park and Max Hirsch Are Off and Running Strong*, editorial illustration, *New York* magazine, drawing & four-colour printing, 1968

03, 04 *All-Century Football Team*, editorial illustration, *Sports Illustrated*, painting & four-colour printing, 1969

05 *Report Communicated to the Nearest Patrol Car*, editorial illustration, *New York* magazine, drawing & four-colour printing, 1968

01

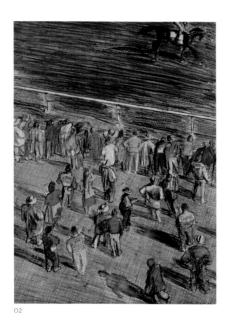

02

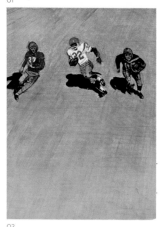

03

04

05

RONALD SEARLE

1920–2011

Cartoonist and satirist Ronald William Fordham Searle was born on 3 March in Cambridge, UK. He trained at Cambridge College of Arts and Technology before enlisting in 1939. The Imperial War Museum in London holds some of the work he created while being held as a Japanese prisoner of war during World War II. The fictional girls' school St. Trinian's is one of Searle's best-known creations, the first cartoons of which were published in 1941. His work also regularly appeared in magazines and newspapers, including *Punch*, *Life* and *The New Yorker*. After moving to Paris in 1961, Searle began designing for the cinema. He was appointed Commander of the Order of the British Empire in 2004. In 2007, he was decorated with the Chevalier de la Légion d'honneur, and, in 2009, the German Order of Merit. He died on 30 December 2011 in France.

01 *Status by Possession*, editorial illustration, *Punch*, 1960
02 *After Picasso: London le 6.4.60*, editorial cover, *Punch*, 1960

II—STATUS BY POSSESSION
The emphasis here is on the low, long and sleek. Somebody has obviously bothered a good deal.

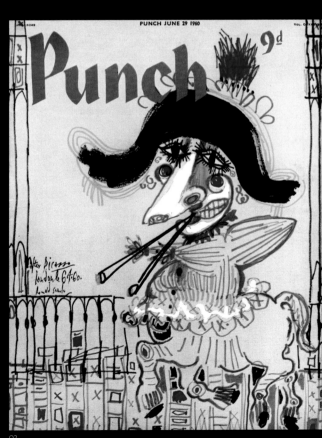

PAULINE BAYNES
1922–2008

The illustrator of more than 100 books, Pauline Baynes was born in Brighton, UK. She attended Farnham School of Art to study design, before going briefly to the Slade School of Fine Art, London, but was largely self-taught. She began her career in 1942, producing illustrations for publishers, magazines and advertising agencies. Baynes's most famous work was for C. S. Lewis and J. R. R. Tolkien. Her slipcase design for the three volumes of *The Lord of the Rings* was later adapted as a cover for the original one-volume paperback edition (shown here). Baynes contributed to various genres, from fantasy to religion and from history to cooking. She was awarded the Kate Greenaway Medal in 1968 for *A Dictionary of Chivalry*. With a career spanning more than 60 years, Baynes worked up to her death on 1 August 2008 in Surrey.

chapin.williams.edu/collect/baynes.html

01 *Meat*, book illustration for *Lady Jekyll, Kitchen Essays*, Collins, pen & ink, 1969
02, 03 *Middle-Earth Landscape*, book jacket, George Allen & Unwin, gouache, 1963

01

02

03

KLAUS VOORMANN

b.1938

Illustrator, artist, musician and producer, Klaus Voormann was born in Berlin on 29 April. He studied commercial art in the city before moving to Hamburg to continue his education. In 1960, Voormann first heard the Beatles and developed a friendship and working collaboration that would lead to his move to London. In 1965, he designed the black-and-white *Revolver* sleeve for the group, a revolutionary move at a time when everyone else was working in full colour. A year later, Voormann's artwork won a Grammy for 'Best Album Cover, Graphic Arts', and, in 2007, the design appeared on Royal Mail stamps. The designer of over 100 album covers, Voormann has led an equally impressive career in music. Returning to Germany in 1980, he lives and works near Munich. *www.voormann.com*

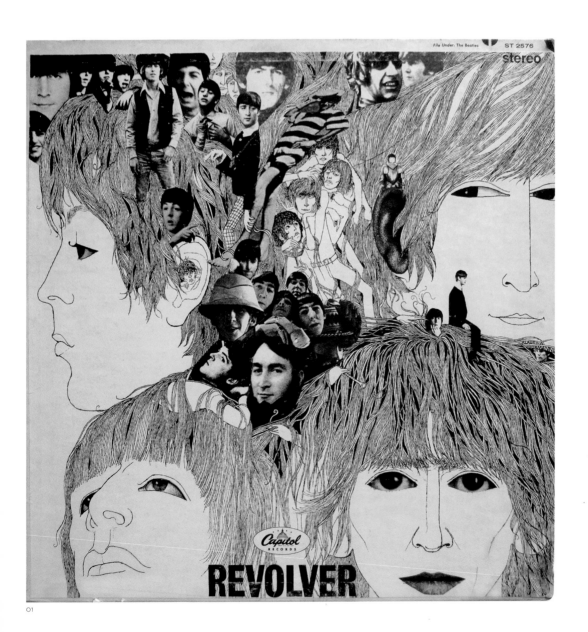

01

02

01 *Revolver*, record sleeve, EMI Records,
collage & pen & ink on paper, 1965
02, 03 *Twiggy*, editorial illustration, *Vogue*,
pencil on photo paper, 1967
04 *Bee Gees Idea*, record sleeve, Bee Gees,
collage & pen & ink on paper, 1966

03

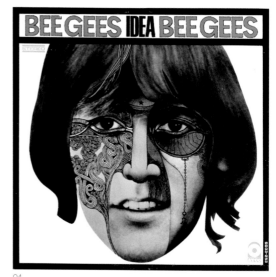

04

Chapter 2:
1970s

A Decade of Discontent

American novelist Tom Wolfe famously christened the 1970s the 'Me Decade' in an essay for *New York* magazine in August 1976. As a generation enjoyed carefree hedonism, dancing to disco music and listening to 'concept' albums, an economic recession in the USA and UK was taking a firm grip. The bleak realism of the 1970s was of global decline, but the Me Generation, with its preoccupation with self-absorbed navel-gazing, hid in self-help and self-therapy programmes directly evolved from the hippy ethos of the late 1960s.

The counterculture of the previous decade had given way to blunt opposition to the Vietnam War, nuclear weapons, corporate business and the authority of government. With the demise of the Beatles, following Paul McCartney's writ in the UK to dissolve the group in April of 1970, and Jimi Hendrix's death from a drug overdose in September of the same year, here were the visible signals of an end to hippiedom and the era of utopian idealism.

Conflicts, coups and international terrorism were rife in the 1970s. From coups in Syria, Uganda, Chile, Ethiopia and Argentina and conflicts such as the Yom Kippur War in 1973 and the start of the Lebanese Civil War in 1975, to the end of the Vietnam War in 1975, this was a decade scarred by death and destruction. With martial law declared in the Philippines in 1972, Tito's dictatorship in Yugoslavia between 1971 and 1974 escalating ethnic tensions, the Soweto Uprising in 1976, where black men, women and school children were killed by South Africa's security police, and the Khmer Rouge in Cambodia engaged in the death of millions of people up until 1979, struggles within countries and continents were widespread.

International terrorist attacks were on the increase, highlighted by the Munich Massacre at the 1972 Olympic Games, where Palestinian guerrillas from the Black September movement kidnapped eleven Israeli Olympic team members and, in the events that followed, all were to lose their lives. The rise in the use of terrorism by militant organisations was significant, from the Marxist-Leninist Red Brigade (Brigate Rosse) in Italy to the Baader-Meinhof Gang in Germany and the IRA from Northern Ireland active in mainland Britain. Terrorist events were occurring with shocking regularity.

The economic performance of the world's industrialised countries was at its lowest since the Great Depression of the 1930s. Annual inflation in the USA was at a record high during the decade, having moved from an average of 2.5% between 1960 and 1970 to a 6% average in the 1970s, rising to a staggering high of 13.3% by 1979. If life was tough at the start of the decade it was to become tougher still as the decade wore on. In the UK, mass unemployment, the three-day week, blackouts and power cuts, as the oil crisis peaked in 1973 and again in 1979, became the norm. Across Europe, the energy crisis meant that many countries introduced car-free days and weekends to absorb the problems of undersupply. In Eastern Europe, economies began to slow and show signs of stagnation, resulting in a growing dependence on imported food. But, four major Asian countries – Hong Kong, South Korea, Singapore and Taiwan – began to thrive and underwent an economic transformation and industrialisation fuelled by cheap labour costs and educational and policy reforms.

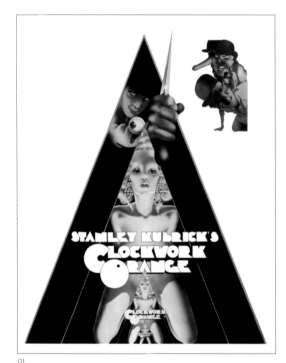

01

01 Philip Castle, *Clockwork Orange*, poster, Stanley Kubrick & Warner Bros. Entertainment Inc., 1971

Against a backdrop of a planet in change, disarray and chaos, social movements that challenged the status quo grew in popularity in the 1970s: anti-war protests increased against the Vietnam War, environmentalism became a more mainstream concern, women's rights and feminism took a more prominent role in society and the Civil Rights Movement and the Gay Rights Movement finally became more accepted.

As the 1970s marched on to the anthem of prog-rock concept albums, pop icons of the past were departing this world. Within weeks of Hendrix's death at the start of the decade, Janis Joplin also died. Then, in 1977, Elvis Presley passed away, followed two months' later by Bing Crosby. The world had lost some of popular music's most successful artists. In New York and London, almost simultaneously, a new sound and a new look were emerging in the form of punk rock. With an anti-establishment stance, informed and inspired by hate and war as a reaction against the love and peace of a previous generation, punk rock was uncompromising in igniting a renaissance in music, fashion and design.

Eighteen-year-olds had gained the vote in 1970, and by the time that Malcolm McLaren had launched The Sex Pistols in 1975, the mood of a disaffected youth was to be heard loud and clear. Stanley Kubrick's *Clockwork Orange* (1971), the film of the book by Anthony Burgess, was to become the cinematic vision that depicted the mood of the decade, heavily assisted by Philip Castle's influential illustrated marketing materials and iconic poster (see p.87). The anti-authoritarian voice of youth was to be captured in the sounds of Richard Hell and the Voidoids, and the Ramones in the USA, and The Sex Pistols, The Damned and The Clash in the UK. And, with the sounds of punk, came the graphics of punk.

The underlying punk ethos of 'do-it-yourself' and 'anyone can do it' was visible in the arts – from Gilbert & George performing living sculptures to Bruce McLean (their contemporary at Saint Martin's School of Art, London) making openly subversive work through simple visual statements, such as placing 1,000 catalogues on a gallery floor and inviting visitors to pick and take them away as artwork. With Francis Bacon's brutal and violent images juxtaposed against German-born F. H. K. Henrion's stencil logotype for the National Theatre, art and design were capturing the anxieties of the moment. By the time that Jamie Reid's infamous cut-up ransom-style newspaper lettering appeared on the yellow fluorescent sleeve for The Sex Pistols' album *Never Mind the Bollocks*, released in 1977 and coinciding with the Queen's Silver Jubilee, the doors had been firmly kicked down to allow in a new visual aesthetic.

Across the discipline of illustration, a stylistic and conceptual shift was to take place. Fashion-led illustrative approaches, most notable in the output of those illustrators working for women's fashion magazines and record companies by creating sleeve designs for the rock stars of the early-to-mid 1970s, would be derided by a younger, angrier generation of illustrators towards the end of the decade.

The pastel shades of Ian Beck's album-sleeve illustration for Elton John's *Goodbye Yellow Brick Road* in 1973 (see top left and p.82) and George Hardie's images for Pink Floyd's *Wish You Were*

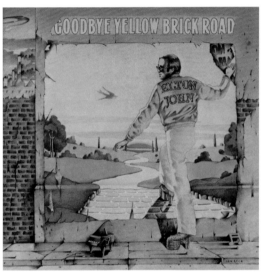

02

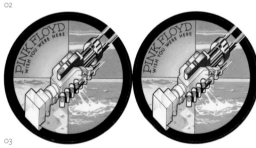

03

02 Ian Beck, *Goodbye Yellow Brick Road*, record sleeve, Rocket Records, 1973

03 George Hardie, *Wish You Were Here*, sticker, Hipgnosis for Pink Floyd, ink & airbrush, 1975

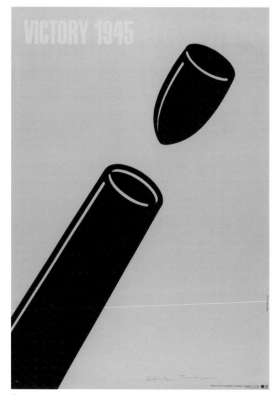

04

05

Here in 1975 (see opposite below and p.98) were representative of the visual mood of the early years of the decade. Prog rock and pop music were inoffensive, inward looking and inane; out of touch with the realism of the period, over-blown and over produced. A wind of change was coming and David Bowie would ring in those changes. Guy Peellaert's wrap-around album sleeve illustration for Bowie's *Diamond Dogs* in 1974 (see p.8) was a controversial game-changer. Bowie's depiction as half-dog and half-human was a disturbing image and while stylistically it was hyperrealistic, as much of the illustration work of the period was, conceptually it demonstrated a shift. Just as Bowie's music was changing the sounds of the 1970s, the graphic illustrations were altering the look of the era; here were new rawer visuals to accompany a new rawer sound.

As the sounds and visuals were shifting, so too were attitudes; social awareness and responsibilities came into focus as the Me Generation was replaced by a new set keen for reform. Illustrators looked to raise awareness of contemporary issues – through their work they aimed to protest, to elicit change, to highlight injustices and to reflect an evolving society.

In Japan, Shigeo Fukuda, the son of a family involved in manufacturing toys, created playful graphic illustrations that highlighted international issues and concerns. Fukuda, inducted into the Art Directors Club Hall of Fame in New York, describing him as 'Japan's consummate visual commentator', created an iconic anti-war image. His poster *Victory 1945* depicted a bullet re-entering the gun from which it had been fired (see left and p.93). The poster's powerfully simple aesthetic and equally potent visual message ensured that it won the grand prize at the Warsaw International Poster Contest in 1975.

Another artist who used the platform of illustration to make political statements was illustrator and cartoonist Gerald Scarfe (see p.110). Born and based in the UK, Scarfe created satirical caricatures of political figures for *Private Eye*, *Punch*, *The Evening Standard* and *The Daily Sketch*, beginning in the 1960s. He came to further prominence in the late 1970s for his work with Pink Floyd designing the album-sleeve artwork for *The Wall* in 1979, going on to create the animated film version of the album. Alan Aldridge, another British-born illustrator, also worked closely with a global pop group, producing *The Beatles Illustrated Lyrics* in 1969, before publishing possibly his most famous book *The Butterfly Ball and the Grasshopper's Feast* in 1973 (see p.122). The artworks featured anthropomorphic insects and surreal creatures, demonstrating Aldridge's craftsmanship and ability to create images from the subtle merging of imagination and realism.

Aside from informing and reflecting growing public opinion in overtly political works by such artists as Fukuda, illustration also came of age stylistically during the 1970s. Artists were beginning to experiment with different forms of image-making: Aldridge used the influences of psychedelic art in his work; Roger Dean, through his famous album sleeves for Uriah Heep and Yes, created otherworldly dreamlike landscapes (see p.114); and Janosch (see left and p.102) mixed folk-art references with naïve drawing styles to great effect.

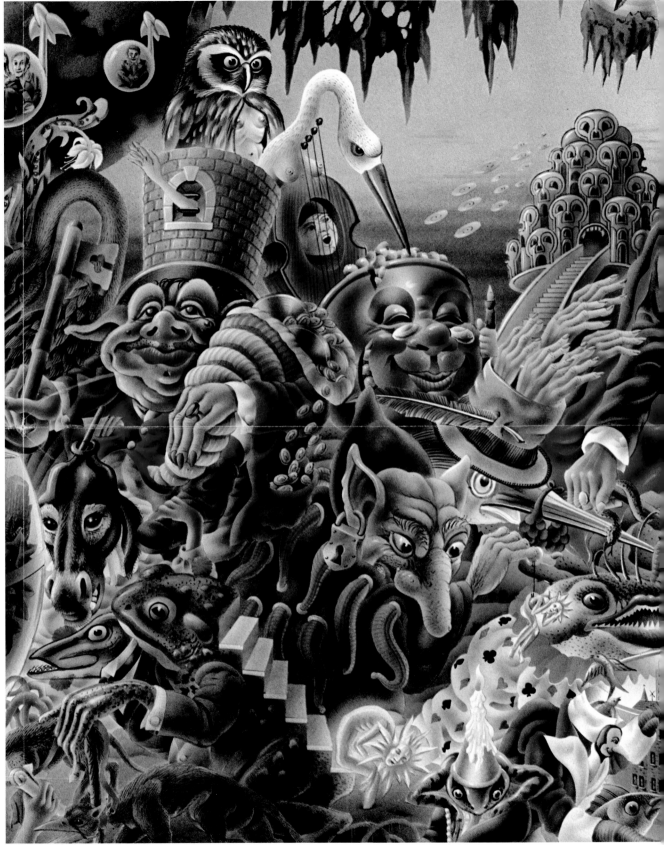

06

The decade was a period of visual experimentation in contemporary illustration. With war and violence, political radicalism, economic downturn and the end of the idealism of the previous decade, the 1970s were a wake-up call. Illustration was seemingly split down the middle. There were those from the first half of the decade motivated by fantasy, by prog rock and the visuals of the hallucinogenic drugs that fuelled the sound and vision of rock and pop. And there were those, from the latter half of the decade, grounded in the gritty realism, the speed of change and the urban nihilism of punk and protest. The new wave DIY aesthetic encouraged a more experimental cut-and-paste approach to creating images – artists explored collage techniques, began to use technology such as photocopiers in their work and brought both new and found elements into their images through printmaking techniques.

The decade of discontent threw up constant challenges for a world in violent flux. Illustration was instrumental in reflecting and visualising the realities and certainties of real-life issues, as well as the fantasies and escapism of rock dreams. Illustration, as the people's art, spoke to audiences of fantasy and of truth; the age of innocence, however, was over and a new age of hard-line realism stood proud.

FRED OTNES

b.1930

Born in Junction City, Kansas, and raised
in the Midwest, Fred Otnes trained at
the Art Institute of Chicago. He began his
career in the field of traditional illustration,
first in Chicago and then, from 1953, in New
York, working for national magazines and
advertising clients, such as United Airlines
and *The Saturday Post*. In the mid-1960s,
Otnes boldly changed his working method
using printing, photo-transfer and collage
techniques to create a unique look: multiple
images across a one-dimensional plane.
For three decades, Otnes's illustrations
appeared in *Penthouse*; he has also designed
stamps for the United States Postal Service
and created posters for 34 films. His stylish
solutions to many illustration problems
garnered Otnes more than 200 awards. The
Society of Illustrators in the USA includes
him in its Hall of Fame.
www.fredotnes.com

01 *Bill Tilden*, editorial
cover, *Sports Illustrated*,
mixed print and acrylic
on canvas, 1975
02 *Play Ball*, editorial
illustration, *Sports
Illustrated*, mixed media/
unique print/collage
elements, 1977

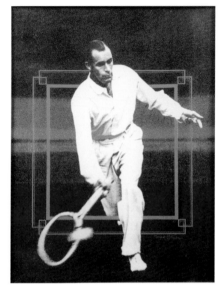

01

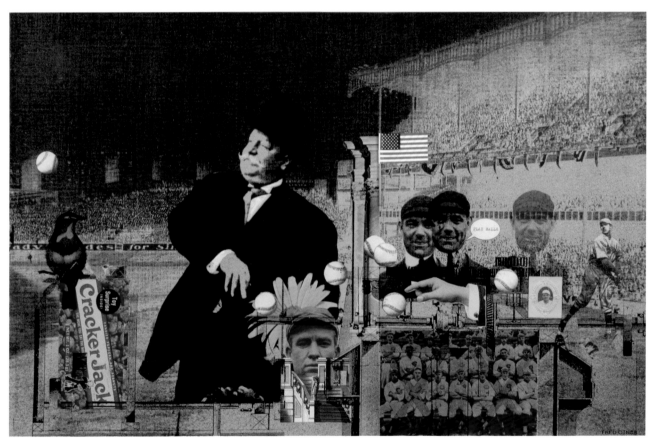

02

VIRGINIE THEVENET

Born in Paris, Virginie Thevenet received no formal art training, but after returning from an inspirational trip to London, her first illustrations, featuring playful images of girls on Chromolux paper, were published by magazines including *Jardin des Modes*, *Marie Claire* and *Vogue* when she was only 17. Work for the Centre Georges Pompidou followed, as well as an exhibition at the Axis Gallery on the rue Guénégaud in Paris. A successful actress since the age of 14, she divided her time between film acting and illustration, and was often commissioned by the directors she was working with, such as Eric Rohmer and François Truffaut, to create posters for their films. A move into directing followed, but Thevenet continues to paint and draw, holding numerous exhibitions in Paris.

01 *Footballeuses*, personal project, acrylic gouache on Chromolux paper, 1976
02 *Cowgirls*, personal project, acrylic gouache on Chromolux paper, 1976
03 *Motardes*, personal project, acrylic gouache on Chromolux paper, 1976
04 *Femmes d'un Jour*, poster, Centre Georges Pompidou – Le Centre de Création Industrielle (CCI), acrylic gouache on Chromolux paper, 1977

01

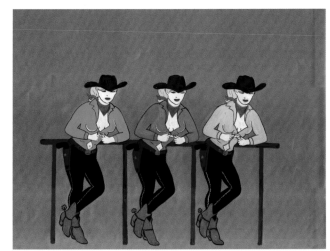

02

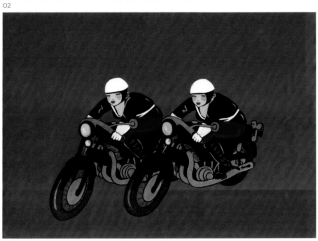

03

04

LOU BEACH

b.1947

Born in Germany, Lou Beach moved to New York when he was four. It was when he first moved to Hollywood that he started making his intriguing hand-crafted collages. After stints in Boston (where he had a one-man show) and Martha's Vineyard, Beach returned to Los Angeles and a successful career creating editorial illustrations and LP covers for Weather Report, Yellow Magic Orchestra and Brian Eno. Beach now writes as well as illustrates; his book of short stories, *420 Characters*, began as a daily post on Facebook in 2009 and was published in 2012.
www.loubeach.com

01

02

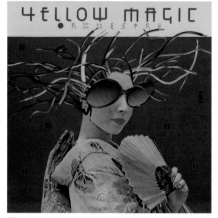
03

04

05

06

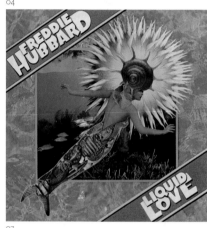
07

08

09

10

02 *Mr. Gone*, record sleeve, Columbia Records, 1977

03 *Yellow Magic Orchestra*, record sleeve, A&M Records, collage, 1979

04 *Charlie Haden*, record sleeve, A&M Records, collage, 1977

05 *Foreplay*, record sleeve, A&M Records, collage, 1977

06 *Ewan MacColl and Peggy Seeger*, record sleeve, Rounder Records, collage, 1973

07 *Liquid Love*, record sleeve, Columbia Records, collage, 1977

08 *Heavy Weather*, record sleeve, Columbia Records, collage, 1977

09 *No Wave*, record sleeve, A&M Records, collage, 1978

10 *The Flying Burrito Brothers*, record sleeve, Columbia Records, collage, 1975

79

FRITZ EICHENBERG

1901–90

Born on 24 October in Cologne, Fritz Eichenberg studied at the Municipal School of Applied Arts in Cologne and the Academy of Visual Arts in Leipzig before moving to Berlin in 1923, where he produced illustrations for books and newspapers. He left Berlin for the USA when Hitler came to power in 1933, teaching at the New School for Social Research in New York. He worked on the Federal Art Project and his prints and illustrations graced many of the great classics by such authors as Leo Tolstoy and the Brontë sisters. His best-known works are concerned with religion, social justice and non-violence. After teaching at the Pratt Institute from 1947 to 1966, he became chairman of the art department at the University of Rhode Island. He died aged 89 in Rhode Island.

01 *The Donkey in the Lion Skin*, wood engraving, 1976

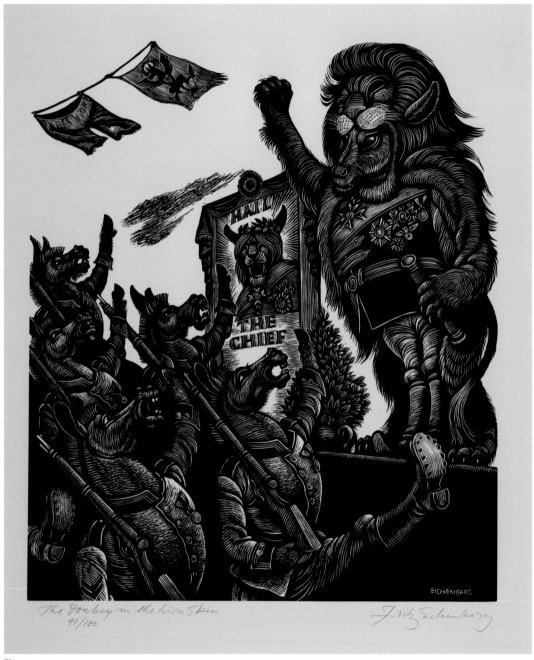

01

Great Bardfield in Essex. She studied art at Cambridge Art School and then at the Royal College of Art, graduating in 1976. She has exhibited worldwide and has pieces in such public collections as the Victoria and Albert Museum, London, and Tate Britain. At the start of her career as a freelance

the Eagle pub and restaurant in London. Now operating mainly as a printmaker, Cheese was commissioned by the House of Commons to make a lithograph for the Queen's Jubilee in 2012.
chloecheese.co.uk

Sunday Times Wine Club, editorial illustration, *The Sunday Times Magazine*, ink/coloured pencil/pencil, 1979
03 *Red Spread*, poster, The Thumb Gallery, ink & coloured pencil, 1978

02

03

01

IAN BECK

b.1947

Born on 31 July in Hove, Sussex, Ian Beck was encouraged by his school teachers to attend classes at Brighton College of Art, where he became a full-time student under Raymond Briggs and John Vernon Lord in 1963, studying illustration and graphic design. Graduating in 1968, Beck moved to London as a freelance illustrator, working on such magazines as *Good Housekeeping* and *Cosmopolitan*, and making drawings for the recording industry. In the early 1970s, he began designing and illustrating album covers, perhaps the best known of which is the triple gatefold album *Goodbye Yellow Brick Road* for Sir Elton John. Since the 1980s, Beck has had many commissions from the Conran Design Group and written and illustrated a number of books for children. He was Master of the Art Workers Guild in 1999.

ianbeck.wordpress.com

01

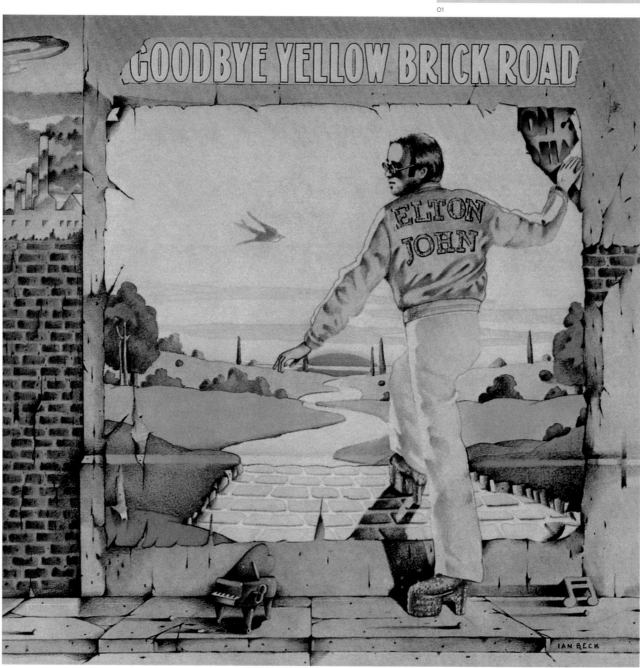

02

03

04

05

ROBERT ANDREW PARKER

b.1927

Hailing from Norfolk, Virginia, Robert Andrew Parker studied at the Art Institute of Chicago before moving to New York. Parker's first solo exhibition at the Roko Gallery in New York was a big success, and it was here that he was discovered by the art director Cipe Pineles, who commissioned him to create illustrations for the magazine *Seventeen*. Parker was subsequently commissioned by a raft of publications including *Fortune, Time, Playboy, The New Yorker* and *Sports Illustrated*, and his work has been exhibited at the Museum of Modern Art, the Whitney Museum of American Art and The Metropolitan Museum of Art. Using mainly acrylic and watercolour, Parker has also illustrated over 100 children's books. His work can be spotted in the 1956 Vincent van Gogh biopic *Lust for Life*, for which he copied many paintings and was employed as Kirk Douglas's hand double.

01 *The Great Jazz Artists*, book illustration, Simon & Schuster, monotype, 1977
02 *Two Knights Riding Horses Dragging a Man*, book illustration from *The Green Isle*, Dial Books, watercolour, 1974
03 *The Trees Stand Shining*, book illustration, Dial Books, watercolour, 1971

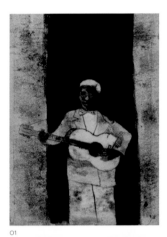

01

02

03

FRANCISZEK STAROWIEYSKI

1930–2009

Franciszek Starowieyski studied painting at the Academy of Fine Arts in Krakow and at the Warsaw Academy of Fine Arts. A prolific designer and one of Poland's most significant post-war artists, he created over 300 posters, illustrated numerous books, designed over 20 theatre productions, and also acted in two films. Starowieyski's powerful take on surrealism has featured in over 200 exhibitions around the globe, and in 1986 he was the first Polish designer to have a solo show at New York's Museum of Modern Art.

01

02

03

04

01 *Metafora '76 (Metaphor '76)*, poster, Muzeum Lubelskie, offset print, 1976

02 *Skorpion, Panna I Łucznik (Scorpio, Virgo and Sagittarius)*, poster, offset print, 1973

03 *Dyskretny urok burzuazji (Le charme discret de la bourgeoisie)*, poster, offset print, 1975

04 *Kochanek, Lekki ból (The Lover, A Slight Ache)*, poster, Teatr Dramatyczny, offset print, 1970

PHILIP CASTLE

b.1942

Born in Huddersfield, Philip Castle studied painting at Huddersfield School of Art before winning a place at the Royal College of Art, London, where he transferred to illustration. While studying there, he discovered an abandoned airbrush, and developed a startling new technique. By the time he left college, he had become a pioneer in this creative art form and was immediately commissioned by *The Sunday Times* to illustrate its 1967 'Motor Show Issue'. Next, he produced fashion illustrations for *Vogue*, *Elle* and *Jardin des Modes*, combining a flourishing career working for glossy magazines with numerous advertising accounts. By the early 1970s, his work had been spotted by Stanley Kubrick, for whom he produced the poster and other publicity materials for *Clockwork Orange*. From the 1980s to the present day, Castle has illustrated record covers, film posters and advertising campaigns for such clients as Wings, The Rolling Stones and Tim Burton.

01 *Elvis Jukebox* (*Thinking*), book jacket illustrations, Music Sales Publishing, 1971
02 *Truly Trionic*, exhibition piece, personal project, airbrush, 1977
03 *Wings over the World*, poster, Paul McCartney & MPL Communications Inc., 1978
04 *Clockwork Orange*, poster, Stanley Kubrick & Warner Bros. Entertainment Inc., 1971

01

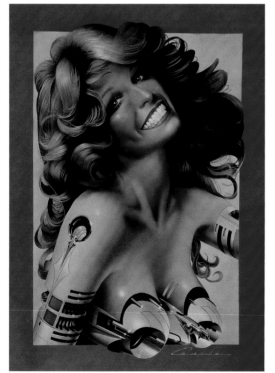

02

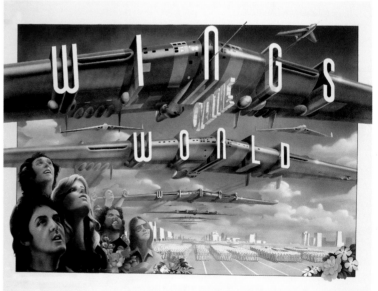

03

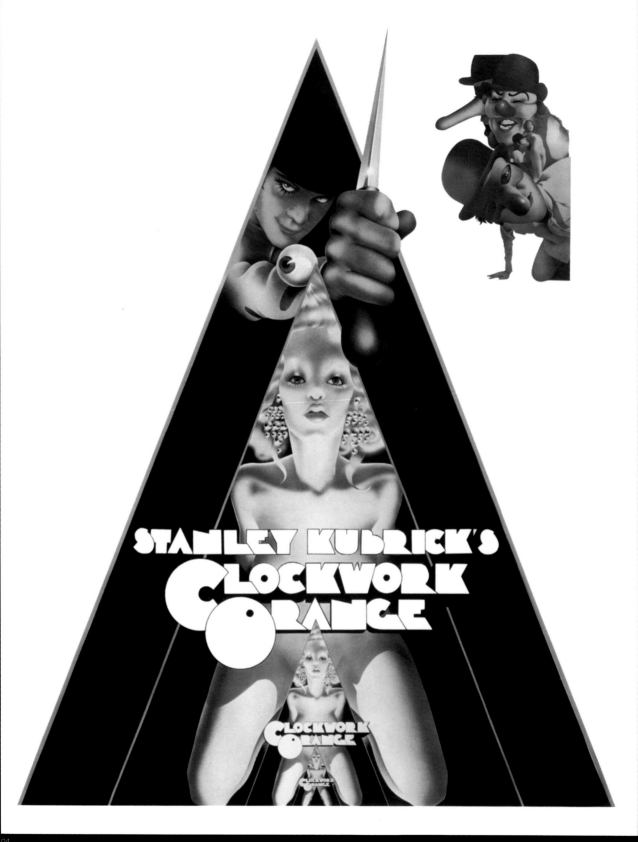

WENDELL MINOR

b.1944

Wendell Minor is the award-winning illustrator of over 50 picture books, including Robert Burleigh's *Night Flight* and Buzz Aldrin's *Reaching for the Moon*. Born in Aurora, Illinois, Minor graduated from Ringling College of Art and Design in 1966. Freelancing since 1970, Minor has illustrated nearly 2,000 book jackets. In 1988, he made the transition into children's book writing and illustrating about nature and history. His many awards include the National Green Earth Book Award for *The Wolves are Back*. Minor's work can be found in the permanent collections of the Eric Carle Museum of Picture Book Art and the Norman Rockwell Museum, both in Massachusetts. He has an honorary doctorate from the University of Connecticut, and is a past President of the Society of Illustrators in New York. Minor lives and works in rural Connecticut.
www.minorart.com

01

02

03

04

01 *Truck*, book illustration, Houghton Mifflin, 1976
02 *The Great Santini*, book cover, Houghton Mifflin, 1976
03 *The Auctioneer*, book illustration, Simon & Schuster, 1975
04 *The Illustrated Man*, book illustration, Doubleday, 1975

JACQUI MORGAN

1939–2013

A contemporary of Barbara Nessim (see p.106), Jacqui Morgan also graduated from the Pratt Institute in New York in 1960, going on to receive a master's in fine art from Hunter College in 1977. In the late 1960s, there were few female freelance illustrators. Her double-image psychedelic style was quickly picked up on, especially her iconic posters for The Electric Circus nightclub and the American Optometric Association, as well as her numerous commissions for billboards for Exxon, Celanese Corporation and 7UP. A successful silk-screen airbrush range of clothing called Mag-Jacs followed, and a foray into painting directly on to objects such as chairs and sofas. Morgan has designed animations and packaging for such clients as VO5 hair products and General Mills, as well as illustrating many children's books.
www.jacquimorgan.com

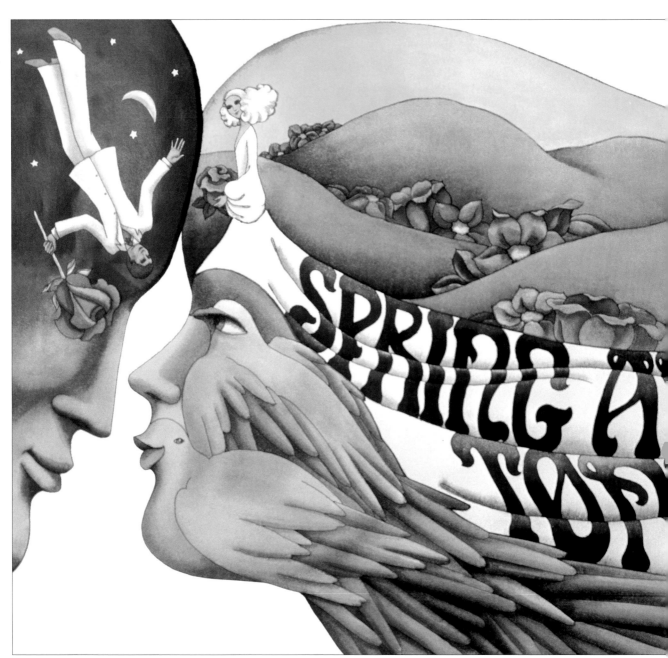

01

02

04

03

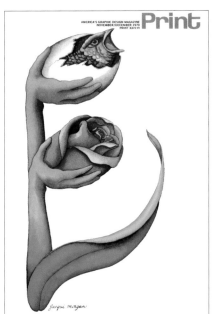

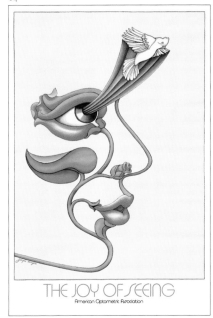

05

SHIGEO FUKUDA

1932–2009

Shigeo Fukuda graduated from the Tokyo National University of Fine Arts and Music in 1956. He was heavily influenced by the Swiss Modernist school, and while his work was often hard-hitting, it still retained an unmistakably playful side. In 1967, he was the subject of an exhibition organised by Paul Rand at the I.B.M. Gallery in New York, and soon after he became the first Japanese designer to be inducted into the New York Art Directors Club Hall of Fame. Best known for his graphic posters, in particular those for the Osaka World's Fair in 1970, for Amnesty International and for Earth Day, Fukuda's most famous is *Victory 1945*, a striking piece showing a bullet whistling back toward the gun from which it was shot, and which won him the grand prize at the Warsaw International Poster Contest in 1975.

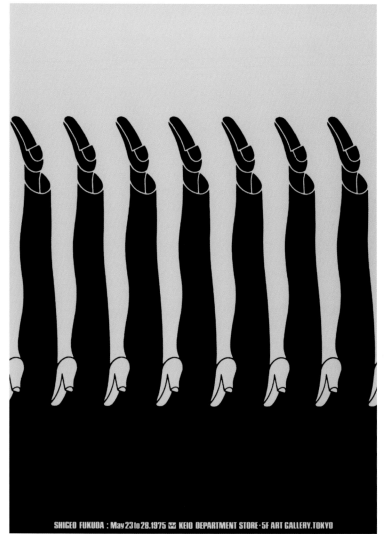

01

01 *Shigeo Fukuda Exhibition*, poster, Keio Department Store (Tokyo, Japan), silk screen, 1975
02 *Victory 1945*, poster, the International Poster Contest, offset print, 1975

ROGER HANE
1939–74

An illustrator of books, magazines, record albums and advertising campaigns, Roger Hane was born in Bradford, Pennsylvania. He studied at Maryland Institute of Art and graduated from The Philadelphia Museum College of Art (The University of the Arts) with a degree in advertising design in 1961. Hane moved to New York City in 1965. His tragically short 13-year career saw him create over 300 published illustrations for such clients as Simon & Schuster, *Playboy*, *Esquire*, *Fortune*, De Beers, BMI and Columbia Records. He posthumously received the New York Artist Guild's Artist of the Year Award in 1974, and the University of the Arts continues to give the Roger T. Hane Memorial Award for the year's best work in illustration. He died on 17 June 1974 after being mugged in Central Park for his bicycle.

01 *Untitled*, advertisement, De Beers & N.W. Ayer, acrylic on canvas, c.1970
02 *Argent*, advertisement, Columbia Records, acrylic on canvas, c.1971
03 *Bach Portrait*, record cover & poster, Columbia Records, acrylic on canvas, c.1972
04 *A Separate Reality*, book cover from *Further Conversations with Don Juan*, Simon & Schuster, acrylic on canvas, c.1971

◄01

O2

03

O4

JACK UNRUH

b.1935

The recipient of many awards, Jack Unruh was born in Pretty Prairie, Kansas. He graduated from Washington University in St. Louis, but moved to Dallas, Texas, to begin his career in illustration. Taking inspiration from the outdoors, Unruh has seen his work appear in *Rolling Stone*, *Time*, *National Geographic* and *GQ*. Other commissions include annual reports for Herman Miller, Sony, Triton and Reader's Digest, and advertising assignments for ExxonMobil, Leatherman Tools, Pacific Bell and The Bronx Zoo. In 1998, Unruh received the Hamilton King Award from the New York Society of Illustrators, and, in 2006, he was inducted to the society's Hall of Fame. Unruh lives and works in Dallas.
www.jackunruh.com

01 *Cover of Triton Oil & Gas Annual Report*, editorial cover, RBM & M Design, ink & watercolour, 1978
02 *Untitled*, editorial illustration, RBM & M Design, ink & watercolour, 1979

O2

O1

JEAN-MICHEL FOLON

1934–2005

Born in Brussels, Belgium, Jean-Michel Folon studied architecture at the city's Institut Saint-Luc before moving to Paris to work as an artist in 1955. A prolific draughtsman and painter, Folon initially found fame outside Europe with many of his drawings published in American magazines including *Time*, *Esquire* and *The New Yorker*. He went on to illustrate books by Albert Camus and Ray Bradbury and created a series of works for Italian manufacturer Olivetti. Global recognition came in 1969 when Folon exhibited his watercolours at a solo show at the Lefebre Gallery in New York. Exhibitions in Tokyo and Milan followed soon after, and in 1973, he illustrated Franz Kafka's *Metamorphosis*, which turned out to be one of his most enduring works. Folon's imaginative style proved incredibly popular and he continued to exhibit at major museums and galleries around the world throughout his life. *www.fondationfolon.be*

01 *La Jungle des Villes, Monstres*, personal project, screen print on paper, 1971
02 *Fumées*, personal project, watercolour on paper, 1971
03 *Un Cri*, personal project, coloured inks on paper, 1978
04 *Le Quotidien*, personal project, screen print on newsprint, 1978

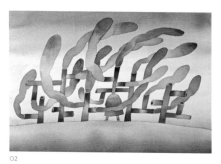

O2

O1

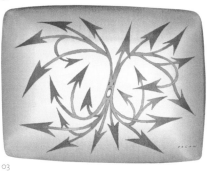

O3

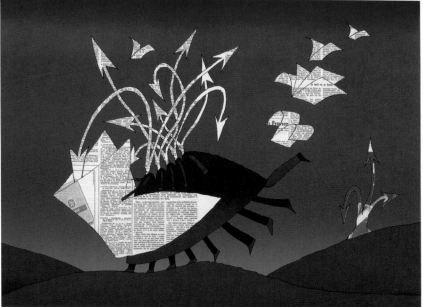

O4

GEORGE HARDIE

b.1945

While still studying at the Royal College of Art in London, George Hardie designed the artwork for Led Zeppelin's eponymous 1969 debut album. Many high-profile LP covers followed (with the design group Hipgnosis), including Pink Floyd's *Dark Side of the Moon* and *Wish You Were Here*, and 10cc's *How Dare You!* He has been commissioned extensively by clients including Royal Mail, for whom he created sets of stamps to celebrate the Channel Tunnel and the millennium. Made a Royal Designer for Industry in 2005, Hardie is also a committed educator and has taught at the University of Brighton, where he is a professor, since 1990.

01

02

06

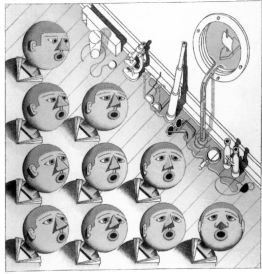

07

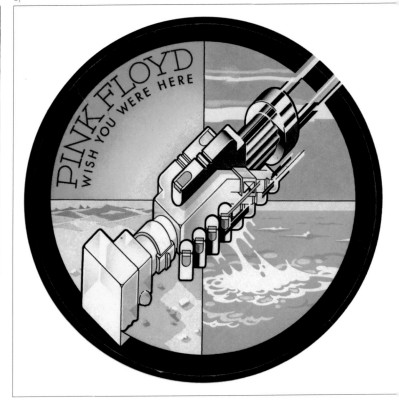

01 *Mr Feed'em*, menu cover, Tommy Roberts of Mr Freedom, ink & colour separations, 1971

02 *Still Life. Flowers*, announcement, Peter Bentley & NTA Studios, silk-screen print, 1972

03 *Mrs Howie*, announcement, Lynn Franks, ink & airbrush, 1978

04 *Dark Side of the Moon*, stickers, Hipgnosis for Pink Floyd, ink & airbrush, 1973

05 *Venus and Mars. Linear Bag*, stickers, Hipgnosis for Wings, 1975

06 *Ten See Sea*, unpublished proposal, 10cc, pencil & airbrush, c.1979

07 *Wish You Were Here*, sticker, Hipgnosis for Pink Floyd, ink & airbrush, 1975

08 *High Speed Blade*, unpublished poster, Peter Silk for Wiggins Teape, ink & airbrush, 1979

03

04

05

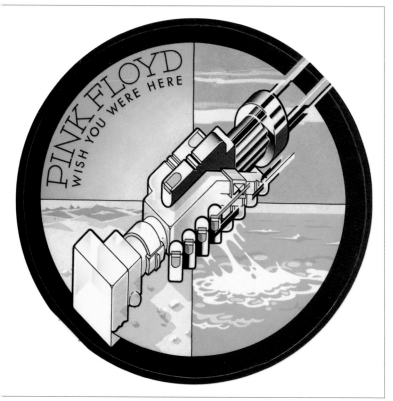

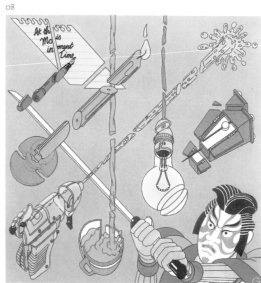

08

BRAD HOLLAND

b.1943

A self-taught artist from Ohio, Brad Holland began working as an illustrator at 17 and moved to New York (where he still lives and works) in 1967. He has worked extensively for *Playboy*, *The New York Times* and many other publications and clients, including *The New Yorker* and *Vanity Fair*. Never one to shy away from controversy, he published the book *Human Scandals* in 1977, a cutting social commentary in pen and ink. A prolific artist and tireless advocate for illustrators' rights, Holland co-founded The Illustrators' Partnership of America and led the campaign to prevent the adoption of the US Government's 'Orphan Works' copyright Act in 2008.

www.bradholland.net

02

01

03

04

01 *Junkie*, editorial illustration, *The New York Times*, ink on paper, 1971

02 *Feline Dementia*, book illustration from *The Illustrated Cat*, Harmony Books, acrylic on canvas, 1976

03 *Voices Echo*, editorial illustration, personal project, ink on paper, 1978

04 *Yellow Cat*, book illustration from *The Illustrated Cat*, Harmony Books, acrylic on canvas, 1976

05 *Capricorn*, editorial illustration, *Playboy*, acrylic, 1974

06 *Passenger*, editorial illustration, *Playboy*, acrylic, 1974

07 *The Metaphysician*, editorial illustration, *The New York Times Magazine*, acrylic on canvas, 1980

05

06

07

JANOSCH

b.1931

Horst Eckert was born in Hindenburg, Upper Silesia (now Zabrze, Poland) and fled with his family to West Germany after World War II. Based in Munich, he worked as a freelance artist, and in 1960 published his first children's book with friend George Lentz, who suggested he adopt the pen name Janosch. Many more children's books followed, along with a number written for adults, which dealt with some of his difficult childhood experiences. By 1980, he had published over 100 children's books, which have been translated into many languages. He resides on the island of Tenerife.

www.janosch.de

01 *No. 20*, book illustration from *Das Starke Auto Ferdinand*,
 first published by Parabel Verlag, gouache on paper, 1975
02 *No. 12*, book illustration from *Das Starke Auto Ferdinand*,
 first published by Parabel Verlag, gouache on paper, 1975
03 *No. 103*, book illustration from *Komm nach Iglau Krokodil*,
 first published by Parabel Verlag, gouache on paper, 1970
04 *No. 17*, book illustration from *Bärenzirkus Zampano*,
 first published by Parabel Verlag, gouache on paper, 1975
05 *No. 16*, book illustration from *Bärenzirkus Zampano*,
 first published by Parabel Verlag, gouache on paper, 1975

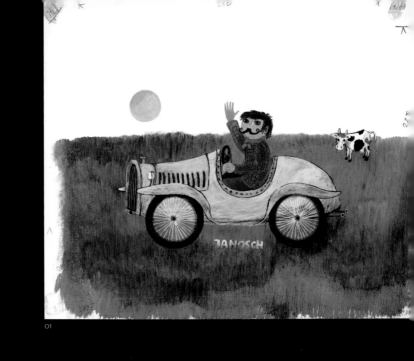

01

03

04

05

KAZUMASA NAGAI
b.1929

Born in Osaka, Kazumasa Nagai studied for a short period at the Tokyo National University of Fine Arts and Music, before going on to work for the textile company Daiwabo. One of the founders of the Nippon Design Center in 1960, he continues to work there. Nagai has designed numerous logos and symbols, including one for the 1966 Olympic Winter Games in Sapporo. He has also created many striking geometric posters that effortlessly blend Eastern and Western approaches, for clients such as *Life*, Toshiba, Prince Lighters and *GQ*. More recently, Nagai has taken his inspiration from nature, creating a series of striking posters often highlighting environmental issues.

01

01 Poster, *GQ*, offset print, 1974
02 Poster for the exhibition 'Graphic4' by four artists, Tobu Department Store Co., Ltd, offset print, 1974
03 *No More War*, poster, personal project, silk screen, 1970
04 Poster for the exhibition 'Identity', personal project, offset print, 1976

02

03

BARBARA NESSIM

b.1939

Influenced by her fashion-designer mother, illustrator and educator Barbara Nessim supported herself through college by working as a fashion illustrator. After graduating from New York's Pratt Institute, she was recognised for her groundbreaking avant-garde illustrative style and designed everything from shoes to clothing and textiles. Always interested in embracing new techniques, in 1980 she became one of the first high-profile illustrators to use a computer. Her pioneering work has been widely commissioned and acquired by both private and public collections. Hugely influential, she has lectured extensively on digital illustration and helped shape New York's prestigious School of Visual Arts MFA Computer Art Program.
www.barbaranessim.com

01, 02 *Fashions for the Recession*, editorial illustration, *New York* magazine, pen/ink/watercolour, 1970

03, 07 *Amazon Odyssey*, book cover and illustration, Music Sales Corporation, pen/ink/watercolour, 1972

04 *Women and Madness*, editorial illustration, *Ms. Magazine*, pen/ink/watercolour, 1972

05 *Untitled*, record sleeve, CBS Records, pen/ink/watercolour, 1979

06 *Genetic Synthesis: Wish for the World's Future*, editorial illustration, Mother Jones, pastel, 1978

01

04

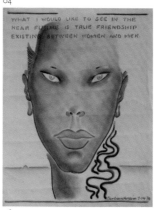

06

05

07

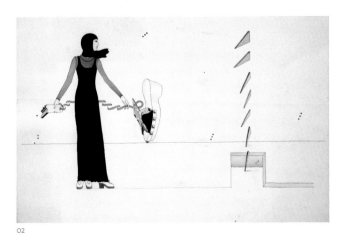

02

03

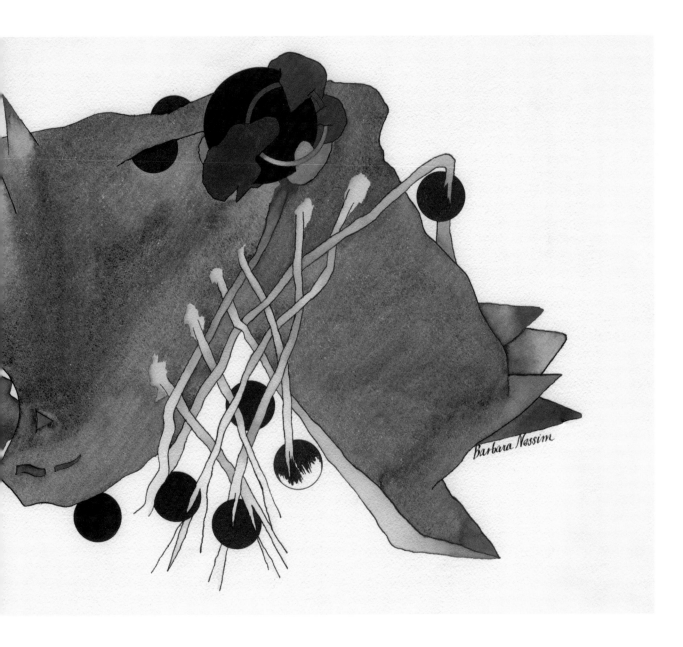

GUY PEELLAERT

1934–2008

Born in Brussels, Belgium, Guy Peellaert studied fine art before moving to Paris, where he worked in advertising and set design and as a comic-strip artist. In 1973, he collaborated with rock journalist Nik Cohn on the book *Rock Dreams*, which became an instant best-seller. Commissions followed for high-profile album covers such as The Rolling Stones's *It's Only Rock and Roll* and David Bowie's *Diamond Dogs*, the controversial original design of which was withdrawn soon after release. His work appeared on posters for the films *Taxi Driver* (Martin Scorsese, 1976), *Wings of Desire* (Wim Wenders, 1987) and *Short Cuts* (Robert Altman, 1993). In 1999, Peellaert collaborated on another book with Cohn featuring historical and political figures, entitled *20th-Century Dreams*. *www.guypeellaert.com*

01 *Elvis Presley, John Lennon, Bob Dylan, Mick Jagger, David Bowie*, photography/collage/paint on paper, 1970–73

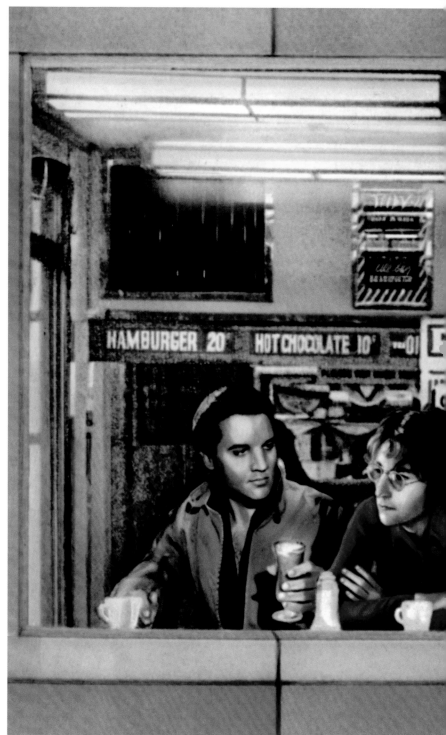

01

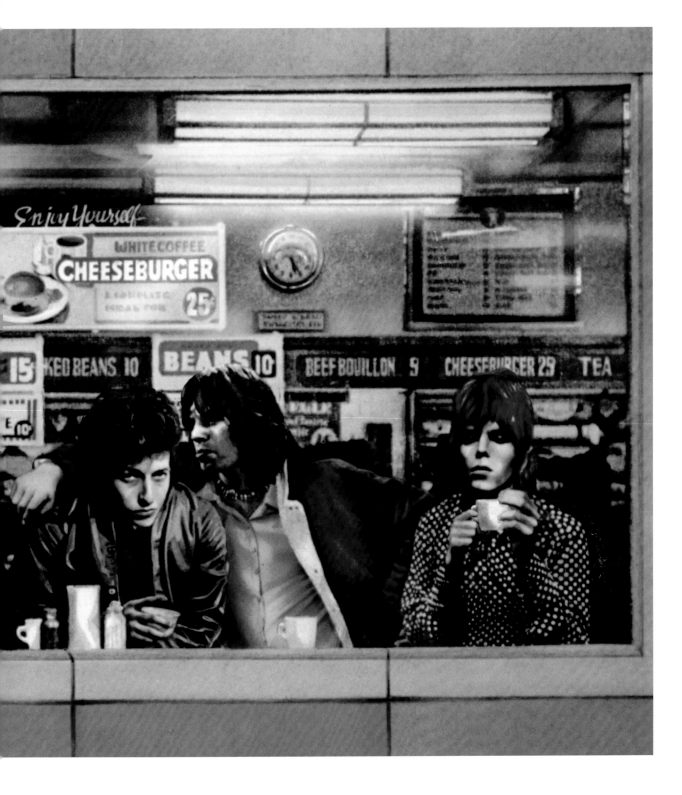

GERALD SCARFE

b.1936

Artist and illustrator Gerald Scarfe began his career creating caustic cartoons for *Punch* and satirical drawings of public figures for *Private Eye*. He worked for *The Daily Mail* in the 1960s, has been political cartoonist for *The Sunday Times* for 46 years and works on a number of periodicals. He collaborated with the rock group Pink Floyd on its stage shows and subsequent feature film *The Wall* (Alan Parker, 1982). He designed the Disney film *Hercules* (Ron Clements and John Musker, 1997) and created the title sequences for the BBC television programmes *Yes Minister* and *Yes Prime Minister*. Scarfe has designed for the theatre, opera and ballet, and there have been many exhibitions of his work around the world.
www.geraldscarfe.com

01 *Idi Amin – Isn't He a Laugh?*, editorial illustration, *The Sunday Times*, pen/ink/watercolour, 1977
02 *Richard Nixon*, personal project, 1974
03 *Just When You Thought It Was Safe to Go Back in The Water*, personal project, 1977
04 *Famous Old Bag*, personal project, 1974
05 *Ian Paisley and Gerry Adams*, *The New Yorker*, 1972
06 *The Wife – Pink Floyd The Wall*, Pink Floyd, 1979

O1

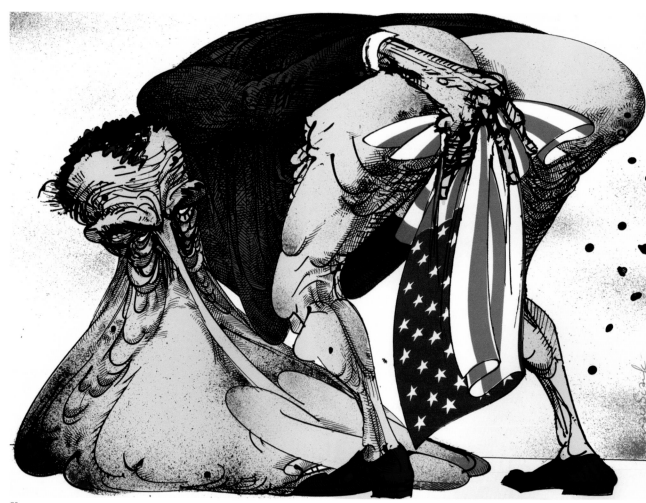

O2

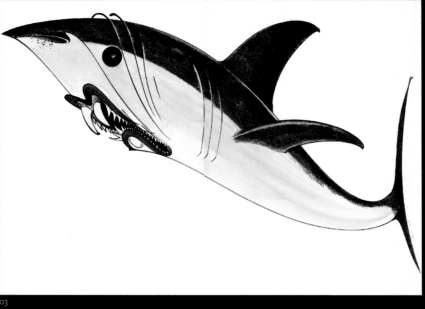

03

Famous old bag

04

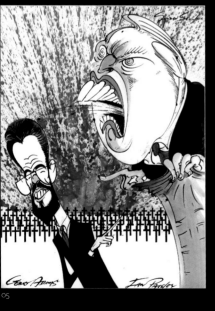

05

06

MICK HAGGERTY

b.1948

Currently living and working in South Africa, Mick Haggerty was born and educated in the UK, and moved to Los Angeles in 1973. Working predominantly in the music industry, his output as a graphic designer, photographer, illustrator and director has won him numerous awards, including a Grammy in 1980 for Supertramp's *Breakfast in America,* as well as four further nominations. Often using the aliases Art Attack, Neo Plastics and Brains, Haggerty has worked for many high-profile bands and artists including David Bowie, The Rolling Stones, The Police and Public Image Ltd. He has also been employed by major record companies as art director of both Virgin Records and Warner Brothers Music. Haggerty was elected Chair of Design and Illustration at Otis-Parsons School of Design.

www.mickhaggerty.com

01

02

03

04

01 *Blackfoot: No Reservations,* record sleeve, Island Records, ink & acrylic, 1975

02 *Yellow Magic Orchestra: Solid State Survivor,* record sleeve, A&M Records, composited transparencies, 1979

03 *Bobby Whitlock: Rock Your Sox Off,* record sleeve, Capricorn Records, ink & acrylic, 1976

04 *Stereo Music,* editorial illustration, *Rolling Stone,* ink & acrylic, 1976

ANTONIO LOPEZ
1943–87

Born on 11 February in Utuado, Puerto Rico, Antonio Lopez moved to New York at the age of eight. He attended the Fashion Institute of Technology, going on to work for *Women's Wear Daily* in 1962. His influences ranged from Old Masters to Pop Art and from Cubism to pin-ups from the 1940s, but above all he was inspired by people. Lopez's illustrations appeared in *The New York Times: Sunday Magazine* and in the American, Italian, French and Japanese editions of *Vogue*. Lopez lived and worked in Japan in 1970, but spent most of the decade in Paris. He always worked from life, and his models included Jerry Hall, Pat Cleveland and Grace Jones. In 1983, the Council of Fashion Designers of America named him American Fashion Illustrator of the Year. *www.suzannegeiss.com*

01

01 *Billie Jean King*, editorial illustration, *Esquire*, pencil & coloured pencil on paper, 1974

ROGER DEAN

b.1944

An artist and designer working in many fields from painting and type design to furniture, stage and architecture design, Roger Dean spent four years at Canterbury College of Art, followed by three years at the Royal College of Art, London, from where he received his master's degree in 1968 with a medal for work of special distinction. He is known for his album cover designs for such groups as Asia and Yes, and the Victoria and Albert Museum hold originals of the logos for Yes and examples of his album covers and record labels in its permanent collections; they also have the prototype for his Sea Urchin chair. With over one-hundred-million copies of his images sold as album covers, posters, cards, calendars and books, he has exhibited his work in many galleries and museums around the world, including The Royal Academy, Daelim Contemporary Art Museum in Seoul and the Royal College of Art. He lives and works in East Sussex. *www.rogerdean.com*

01 *Flights (of Icarus)*, personal project, watercolour/ink/acrylic, 1977

02 *The Leap*, record sleeve, Yes, enamel & acrylic, started 1970, completed 2009

03 *Beginnings*, record sleeve, Steve Howe, watercolour/ink/acrylic, 1975

04 *Pathways (Yessongs)*, record sleeve, Yes, watercolour/ink/acrylic, 1973

05 *Relayer*, record sleeve, Yes, watercolour/ink/ acrylic, 1976

06 *Tales From Topographic Oceans*, record sleeve, Yes, watercolour/ink/ acrylic, 1973

01

06

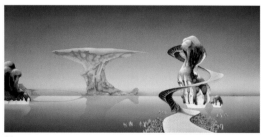

04

05

02

03

PETER LLOYD

1944–2009

Peter Lloyd was born in the UK but moved to the USA when he was young, graduating from the Art Center School with a master's degree when he was just 15. Lloyd's seductive, futuristic work was much in demand from advertising clients; it appeared extensively in publications including *Playboy* and was commissioned by record companies for albums by artists Rod Stewart, Kansas and Jefferson Starship. In the late 1970s, he began working for the film industry, creating storyboards and special effects. Lloyd designed the digital effects for Disney's cult 1982 film *Tron* (Steven Lisberger), and went on to work on such films as *An American Werewolf in London* (John Landis, 1981), *The Day After Tomorrow* (Roland Emmerich, 2004) and *Sin City* (Frank Miller, 2005).

01 *Disco Droids*, personal project, late 1970s
02 *Ski Rio*, New Mexico resort advert, late 1970s
03 *Office Sex*, personal project, early 1970s
04 *Bored*, editorial illustration, *OUI* magazine, airbrush on board, 1970
05 *Stitch in Time*, personal project, 1970s
06 *Lila the Werewolf*, storyboard, late 1970s
07 *Robots*, editorial illustration, *Playboy*, airbrush on board, 1973

01

02

03

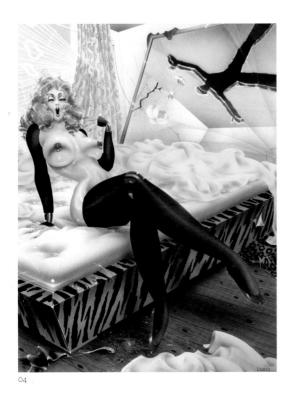

04

05

06

07

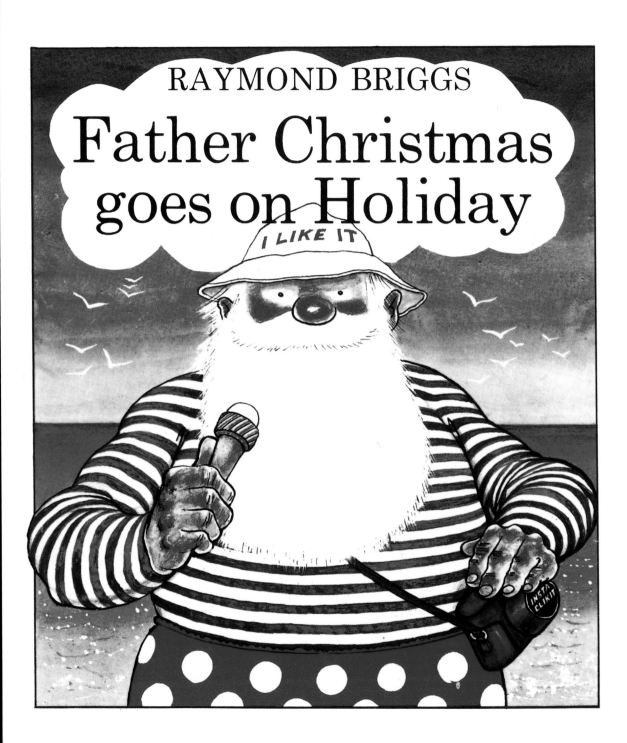

RAYMOND BRIGGS
b.1934

Raymond Briggs was born in Wimbledon Park, London, and is one of the foremost creators of illustrated books for adults and children. He left school at 15 to study painting at Wimbledon School of Art, followed by a typography course at Central School of Art and Design and further study at the Slade School of Fine Art. Briggs began work in advertising but quickly gained acclaim as a book illustrator. He was awarded the Kate Greenaway Medal in 1966 for *The Mother Goose Treasury* and in 1973 for *Father Christmas*, the main character in which shares many traits with Briggs's father. After two years working on *Fungus the Bogeyman*, he published his most famous wordless book, *The Snowman*, in 1978. Briggs is the recipient of the Boston Globe-Horn Book Award, the Victoria and Albert Museum Francis Williams Prize, the Illustrated Book of the Year and the Silver Pen Award, among others.

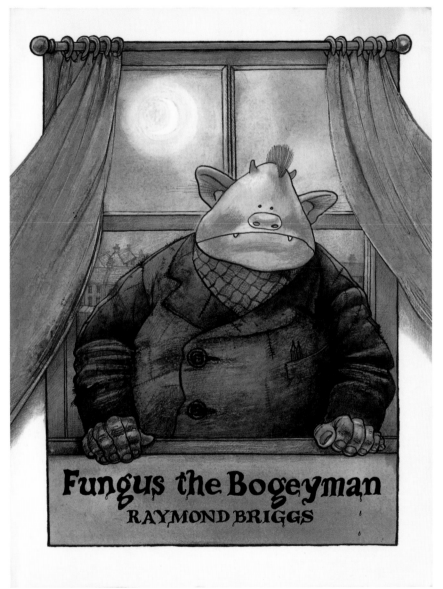

01 *Father Christmas Goes on Holiday*, book cover, Penguin Books, 1975
02 *Fungus the Bogeyman*, book cover, Hamish Hamilton, 1977

02

EUGÈNE MIHAESCO

b.1937

The creator of over 70 covers for *The New Yorker* magazine, Eugène Mihaesco was born in Romania and studied art in Bucharest. In 1967, he moved first to Switzerland and then to New York, where he regularly contributed to *The New York Times, Time* and various European publications. Mihaesco taught at the Pratt Institute and has exhibited his work in many galleries worldwide, including the Centre Georges Pompidou and the Louvre in Paris. He has received many awards, among which is the 1985 Gold Medal from the Art Directors Club of New York. Mihaesco lives and works in Bucharest and Montreux, Switzerland.
www.eugenemihaesco.com

01 Editorial cover, *The New Yorker*, coloured pencils on coloured Canson paper, 1976
02 *Have No Fear*, editorial illustration, *Horizon*, pen & ink on paper, 1971
03 *Full Control*, editorial illustration, *The New York Times*, pen & ink on paper, 1972
04 *Stairs*, editorial illustration, *The New York Times*, pen & ink on paper, 1976
05 Editorial cover, *The New Yorker*, coloured pencils on coloured Canson paper, 1976

July 26, 1976 THE NEW YORKER Price 75 cents

01

02

03

04

05

Jan. 26, 1976

The

NEW YORKER

Price 75 cents

ALAN ALDRIDGE

b.1943

Born in the East End of London, Alan
Aldridge lives and works in Los Angeles.
One of his first jobs was as art director
of Penguin Books, where he specialised
in science-fiction book covers. In 1968,
he founded his studio Ink Inc., and his
intricate psychedelic style soon became
very much in demand. He designed adverts
and identities for iconic brands, illustrated
the much-loved 1973 book *The Butterfly
Ball and The Grasshopper's Feast*, created
a poster for Andy Warhol and produced
numerous LP covers. Aldridge had a long-
standing association with the Beatles – he
visualised their song lyrics in the book *The
Beatles Illustrated Lyrics* and was described
by John Lennon as 'His Royal Master of
Images to Their Majesties The Beatles'.
www.alanaldridge.net

01

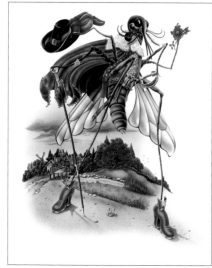

02

03

04

05

JAN PIEŃKOWSKI

b.1936

Born in Warsaw, Jan Pieńkowski fled Poland during World War II, arriving in the UK in 1946. After graduating from King's College, Cambridge, where he read Classics and English, Pieńkowski and Angela Holder set up the successful Gallery Five greetings-card company. He worked in advertising and publishing, and began to illustrate children's books in his spare time. His hobby became a vocation and he created illustrations for two award-winning children's books: Joan Aiken's *The Kingdom Under The Sea* and the groundbreaking pop-up book *Haunted House*, both winners of the Kate Greenaway Medal in 1972 and 1980, respectively. His series 'Meg and Mog', created with Helen Nicoll, consists of over 20 titles, and has been adapted for both television and stage.
www.janpienkowski.com

01

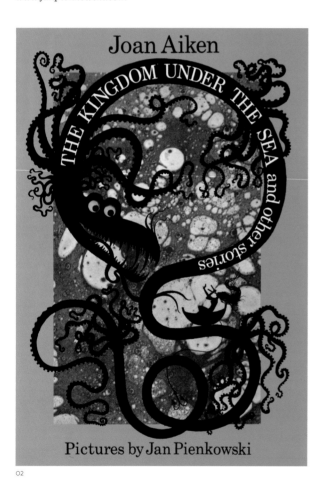

02

03

01 *Meg and Mog*, book cover, Puffin, 1975
02, 03 *The Kingdom Under the Sea*, book cover, front (02) and back (03), Jonathan Cape, 1971

MARK ENGLISH

b.1933

American illustrator and painter, Mark English was born in Hubbard, Texas. He taught himself to letter rodeo signs, and went on to study at the Art Center School in Los Angeles. His big break came when he was commissioned by Reader's Digest to illustrate the book *Little Women*, which won him his first award. Since then, his unique style has graced such publications as *McCall's Magazine*, *Time* and *Sports Illustrated*, while his client list includes IBM, US Park Service, GE, Ford and Honeywell. He has won hundreds of prizes for his work and is the most awarded illustrator in the history of the Society of Illustrators in New York. He lives and works in Missouri.

markenglishonline.com

01

Chapter 3:
1980s
The Designer Decade

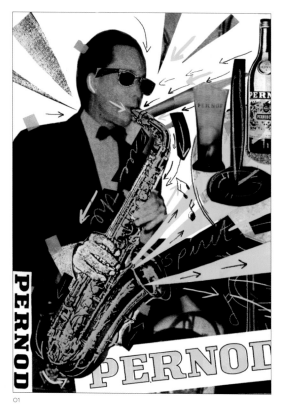

01

01 Huntley Muir, *Free the Spirit*, advertisement, Pernod Ricard/
DDB, 1985

Dubbed the 'designer decade', the 1980s were when design entered public consciousness for the first time and contemporary design began to take centre stage, for reasons both good and bad. Terence Conran, the UK designer and retailer synonymous with an avant-garde London design scene following Habitat's success in the 1970s, began to take the Conran Shop to new heights. By the end of the decade, he had launched the world's first museum of modern design – the Design Museum – in a converted banana warehouse in Shad Thames, London.

In Europe, Frenchman Philippe Starck was set to become the most celebrated international personality in the global design scene after the launch of newly designed and hugely influential projects, such as Café Costes in Paris (1984) and the Royalton Hotel in New York City (1988). A series of quirky household 'designer' objects – lemon squeezers, ashtrays and toothbrushes – soon followed, indicating Starck's ability to add his design signature to any product. Strong PR presence and constant media attention demonstrated that his position as the enfant terrible of design was assured.

Memphis, a Milan-based collective of furniture-product designers, led by Ettore Sottsass and launched in 1981, illustrated the international appeal for postmodern furniture, fabrics and ceramics. Described by Bertrand Pellegrin, a design critic for the *San Francisco Chronicle*, as a 'shotgun wedding between Bauhaus and Fisher Price', Memphis was overtly decorative, using unconventional materials, historic forms, kitsch motifs and gaudy colours. It was an explosion of radical work, representing a shift in the fundamental preconceptions of the role of design. The very appeal of Memphis was that it was over-embellished and over the top; here was a movement that articulated all that was frivolous in design.

Arguably the most influential publication of the decade, *The Face*, was launched by Nick Logan, ex-editor of pop magazine *Smash Hits*, in London in May 1980. 'The world's best-dressed magazine' presented music and fashion across the decade with an unnerving attention to detail – design and style merged perfectly. Youth culture moved away from the anti-establishment stance of punk and towards club culture's creative buzz and a fresh new optimism. *The Face* captured a new mood with perfectly synchronised journalistic and design sensibility.

Neville Brody joined *The Face* as art director in 1981, and took the lead in designing a new graphic language for the magazine. Much imitated but rarely bettered, his radical use of typography and layout deconstructed the rulebook. *The Face*'s stylistic approach immediately influenced numerous other print publications, but, just as importantly, its authority spread more slowly to the fields of advertising design and retail and interior design. Graphic design became critical in defining the look and feel of the decade, and with fellow superstars Conran, Starck and Sottsass, Brody was to spearhead the designer-led visual direction of the early 1980s.

However, outside of design not all in the world was as positive – this was a period of much political flux and unease. The 1980 summer Olympics was disrupted by a boycott, led by the USA, in opposition to the invasion of Afghanistan the previous year. With

02 Marshall Arisman, *The Clash*, editorial illustration,
Rolling Stone, oil on paper, 1984
03 Brian Grimwood, *6th Year*, editorial cover, *Graphics World*,
gouache, 1980

Ronald Reagan becoming president in the same year, a hard-line approach to the spread of communism was clearly being adopted and articulated; the fall of the Berlin Wall at the end of the decade was to be more than a simple visual metaphor for the end of communism.

The opening year of the decade ended with the shooting of John Lennon in New York City in December 1980 and ushered in a period of economic downturn and a global recession. Later recovery was epitomised by the glamorisation of the stock market through fictional characters such as Gordon Gekko in the movie *Wall Street* (Oliver Stone, 1987), and real-life characters such as Donald Trump. Greed was good.

Advertising agencies went into overdrive at the pinnacle of prosperity during the decade, keen to exploit the public's thirst for all things 'designed'. Seemingly assuring membership of an elite set, where life was lived surrounded by all things beautiful albeit not entirely functional, adverts in the 1980s presented a world of fast-paced, go-getting, industrious and ambitious individuals; greed was promoted as a virtue and image was everything. The yuppie had arrived.

With an appetite for living life to the full, the yuppie showed enthusiasm for an aspirational lifestyle that knew no bounds. In creating interiors and graphics for a glut of new wine bars, restaurants, banks and retail experiences, designers and illustrators had contributed to the visual overload of the decade; everything that could be touched by the hands of the designer invariably was.

With an upturn in the economy, companies were keen to exploit these opportunities and called upon designers and illustrators for their signature style to add a sheen of design difference to products and services. While many commissions and new projects led to important design solutions, just as many evolved into overblown design responses fed by inflated budgets and fees.

The designer decade had begun well enough, but the relatively positive label of 'designer' was rapidly becoming derogatory shorthand for overstated design 'statements' by a succession of fashion and product designers, architects and interior designers. The designer, originally viewed as the arbiter of style and cool and deemed responsible for bringing good taste to the masses, was beginning, in the public's eye, to mutate into an egocentric artist, hell-bent on creating radical and non-conformist design artefacts, neither understood nor wanted by the ordinary man, woman and child of the decade.

Illustration benefited, as did other design disciplines during the early 1980s, from a proliferation of commissions. Spanning editorial, advertising, publishing and design projects, illustration was used commercially across a much wider range of platforms than before. Greater public awareness of the role of design and the immediacy, impact and influence of illustration to connect with an audience gave it a moment in the spotlight. Products and publications keen to express a personality, and one different from their rivals in highly competitive markets, used illustration for its approachable, marketable and readily understood visual and literal concepts.

02

GRAPHICS WORLD

44

SEPT. · OCT.
£2.00

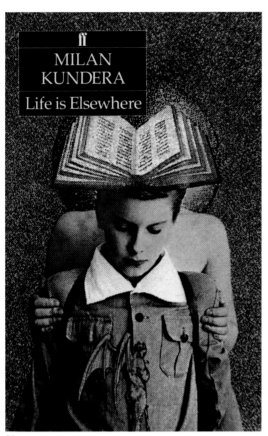

04

Illustration during the 1980s was typified by a strong graphic sensibility, not dissimilar to fashion's preoccupation at the time with graphic symbols and iconography. From London-based Culture Club's Boy George, dressed head-to-toe in gender-bending finery adorned with the graphic motifs and icons of fighter planes and religious crosses, to the 'Call of the Wild' (farting dog) T-shirt designs by Richard Allan for Sydney's Mambo Graphics, graphic art was cool. Illustration, influenced by and drawing extensively upon external references, reflected popular culture, fashion, graphics and fine-art practice of the time and many illustrators were taking visual cues from New York's street-art scene of the early 1980s.

Keith Haring arrived in Manhattan in 1978 to study at the School of Visual Arts, where Marshall Arisman (see p.128 and p.178) had enrolled on the illustration programme some 24 years earlier. By 1980, Haring was working in the city's subway stations creating drawings with white chalk on black poster paper: simple graphic line drawings of dancing figures, babies and dogs. Haring's underground artworks and the edgy, dark and mysterious street-art scrawling of newcomer Jean-Michel Basquiat went on to define a new streetwise aesthetic that emerged in the art world during the decade.

London-based Huntley Muir (see p.132), an illustration duo comprised of Su Huntley and Donna Muir, best known for its big, brash, bold, colourful and experimental work, appeared to have a direct lineage from New York's street-art scene. With work rooted in graphic design and illustration, Huntley Muir expanded into film, photography, installation and theatre design, winning numerous awards for its work across a diverse range of media. During the decade, the duo created, in their own distinct style, iconic album-sleeve designs for Sting and Joan Armatrading, as well as advertising campaigns for Sol and Pernod and book jackets for Kurt Vonnegut. Huntley Muir's work was in the right place at the right time; the pair captured visually the zeitgeist of the period, producing quick and quirky, funky and fashionable iconic images. Clients lined up to commission their unique style, albeit with a twist of Haring and dash of Basquiat in the mix.

Taking a visual cue from elsewhere, chiefly Picasso and Matisse, but making it his own, was London-based Brian Grimwood (see previous page and p.146). One of the founding members of the Association of Illustrators in London and responsible for setting up the Central Illustration Agency, or CIA, in 1983, Grimwood represented a more business-like approach to a career in illustration. Self-trained, Grimwood adopted a magpie approach, borrowing stylistically from the greats, which was to find him a loyal client base, including the London Electricity Board, *Radio Times* and *Marketing Week*.

The 1980s produced a generation of illustrators who rather than hide their influences chose to celebrate them – their output reflected the work of bygone eras. Grimwood's pastiche of Picasso sat alongside Paul Leith's roots in Russian Constructivism (see p.159) and Dan Fern's collages for the BBC and the London Underground reminiscent of the work of Kurt Schwitters (see p.162). Mick Brownfield (see p.166) plundered design nostalgia, creating pieces evocative of artworks from the 1930s to the 1950s, while

04 Andrzej Klimowski, *Life is Elsewhere*, book cover, Faber and Faber, collage/photomontage, 1986
05 Russell Mills, *First Love Last Rites*, book cover, Picador, mixed media, 1982
06 Quentin Blake, *The Witches*, book cover, Jonathan Cape, pen & ink with watercolour wash on cold-pressed watercolour paper, 1983

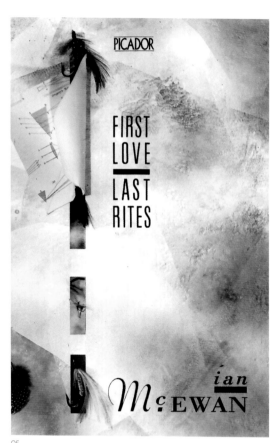

05

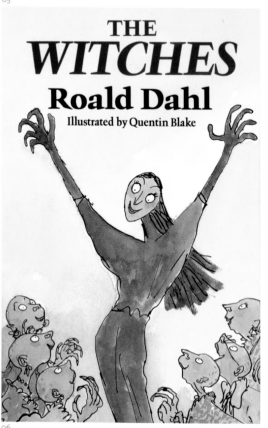

06

Andrzej Klimowski (see opposite and p.170) revealed a John Heartfield aesthetic in his collages for *The Guardian* and Faber and Faber.

Barney Bubbles (see p.140), born Colin Fulcher, a London-based graphic designer with a genuine flair for illustration, deliberately raided art history's back catalogue for his album sleeve for Elvis Costello and the Attractions; *Imperial Bedroom* depicts a scene wholeheartedly influenced by Picasso's Cubist figures. With Turkish-born Selçuk Demirel (see p.145), based in Paris, borrowing stylistically from Magritte, and Syd Brak (see p.154), originally from Johannesburg, looking fondly at 1950s Americana, it was clear that the past was seen as rich pickings for illustration in the 1980s.

Of course, there were originators, too. Russell Mills in the UK (see left and p.138) came to prominence in the 1980s, after graduating from the Royal College of Art in 1977, where he studied under Quentin Blake (see left and p.152). Mills produced illustrations using a range of media, from collage and photography to typography and model making. He created rich symbolic images, deep in meaning, to great affect and to great acclaim, across an atmospheric body of work spanning album sleeves and book jackets. Unlike his contemporaries, here was an illustrator reflecting a close emotional bond with his subject matter, and not simply a pastiche or reference to a past era.

Another illustrator with a clear passion for his work and for creating something new, albeit raw and uncompromising, was Gary Panter (see p.136). An early participant in the Los Angeles punk scene in the 1970s, Panter attended East Texas State University, studying under illustrator Jack Unruh (see p.96). Moving to Brooklyn, New York, Panter balanced life as an illustrator, comic artist and set designer.

It was Panter's set design for revolutionary children's television show *Pee-wee's Playhouse* that was to win him three Emmy Awards. Panter's work broke the mould for children's television. It was jam-packed with visual surprises; loud and obnoxious it demanded to be watched, reflecting an energetic and uncompromising approach. Matt Groening, creator of *The Simpsons*, noted that Panter 'applied his fine-art training to the casualness of the comic strip, and the result was an explosive series of graphic experiments that are imitated in small doses all over the world today'.

In terms of visual aesthetic, work by Russell Mills and Gary Panter could not be further apart. However, commonality is present in the unique and clearly dedicated method both artists employed in the creation of their work, and its influence on a generation of illustrators and image-makers.

If, on one hand, the 1980s, resplendent with excessive designer artefacts and opulence, were representative of greed and consumption, on the other, they symbolised how individuality could be recognised and rewarded. Illustrators forged successful careers making original and expressive contemporary work during the decade of the designer.

HUNTLEY MUIR

est.1981

Huntley Muir was created by chance when successful illustrators Su Huntley and Donna Muir first collaborated on an all-night project. The multidisciplinary partnership has worked for publishing houses, advertising agencies, design groups and record companies on many iconic, award-winning projects. A very fruitful move into video direction in 1986 followed, with promos and commercials for Warner Bros., Virgin, MTV, Barclays, Fiat and Boots. A series of large-scale murals for restaurants in Los Angeles and Las Vegas led to the pair being commissioned to create set and costume designs for opera, musical theatre and ballet.

www.huntleymuir.co.uk

01 Joan Armatrading, *The Key*, CD cover, A&M Records, 1983
02 *Nike Los Angeles Olympics*, poster, Nike Agency: Chiat Day, 1984
03 Sting, *Bring on the Night*, CD cover, A&M Records, 1986
04 *Paranoia in Eldorado*, editorial cover, *Time Out*, 1982

01

03

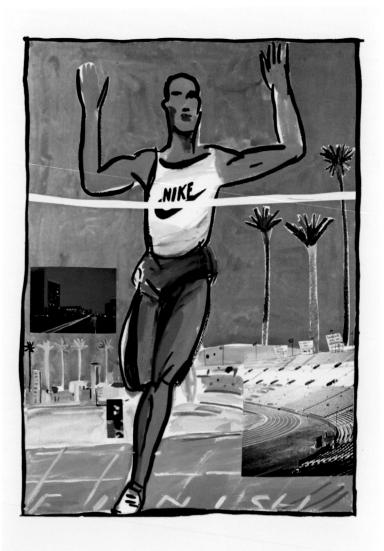

02

Time Out

Paranoia in Eldorado.

Marooned up Werner Herzog's Amazon with Mick Jagger, Klaus Kinski, Claudia Cardinale and Jason Robards.

IVAN CHERMAYEFF

b.1932

A fine artist, designer and illustrator, British-born Ivan Chermayeff has exhibited his work throughout the world, and has received numerous awards from the American Institute of Graphic Arts, the Society of Illustrators, the Art Directors Club of New York and the Royal Society of Arts and Commerce. Chermayeff moved to the USA in 1940 when he was 8. He studied at Harvard University, the Institute of Design in Chicago and graduated from Yale University, School of Art and Architecture. Chermayeff is a past president of the American Institute of Graphic Arts and was a trustee of the Museum of Modern Art in New York for 20 years. He is co-founder of branding and graphic design firm Chermayeff & Geismar in New York.

cgstudionyc.com

For the change of a lifetime.
The City University of New York Freshman Admissions Guide

01

02

01 *Churchill the Wilderness Years*, collage & paint, 1983
02 *CUNY Cover*, editorial cover, The City University of New York, collage, 1987
03 *Jacob's Pillow*, Jacob's Pillow Dance, collage, 1985
04 *Jacob's Pillow*, Jacob's Pillow Dance, collage, 1983
05 *NYU Cover*, editorial cover, New York University, collage, 1981
06 *Two One-Act Operas*, poster, collage, 1980
07 *By the Sword Divided*, poster, Mobil Masterpiece Theatre, collage, 1986
08 *Amicus Journal Cover*, editorial cover, *Amicus Journal*, pen & ink, 1983

03

04

05

06

07

08

THE PEE·WEE HERMAN SHOW

9009 SUNSET **ROXY** 878-2222

O1

GARY PANTER

b.1950

Born in Oklahoma and raised in Texas, Gary Panter studied painting at East Texas State University before relocating to Los Angeles in 1977 to work in a variety of fields from commercial art to comics. In the late 1970s, he introduced Jimbo to the world. The following decade was a prolific period for Panter, who was creative director of the USA children's television programme *Pee-wee's Playhouse.* He also designed record sleeves (for, among others, The Red Hot Chili Peppers), his own mini comics and graphic novels, and contributed to *RAW* magazine. Panter has been honoured with three Emmy Awards for his production design on *Pee-wee's Playhouse* and the 2000 Chrysler Award for Design Excellence. He lives and works in Brooklyn.

www.garypanter.com

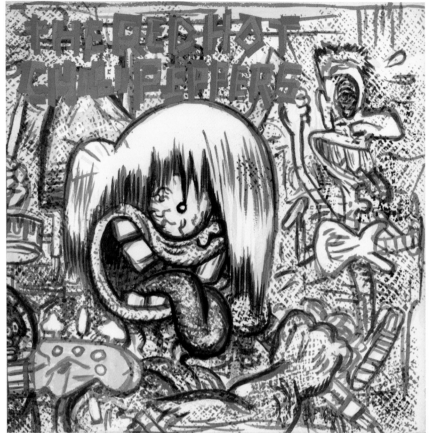

02

01 Poster, *The Pee-wee Herman Show,* 1981
02 Record sleeve, The Red Hot Chili Peppers, 1984
03 *Invasion of the Elvis Zombies,* editorial illustrations, Raw Books, 1984
04 *Jimbo,* editorial cover, personal project, 1982

03

04

RUSSELL MILLS

b.1952

Known primarily for his influential book and album covers using collage techniques and richly textured images, Russell Mills was born in Ripon, North Yorkshire, and studied at Canterbury College of Art, Maidstone College of Art and the Royal College of Art in London, graduating in 1977. In the 1980s, Mills was commissioned to design record sleeves and associated packaging for such musicians as Roger Eno, Japan and David Sylvian, before going on to work with Nine Inch Nails on cover artwork and promotional material in the 1990s. Mills is visiting tutor at the Royal College of Art and visiting professor at Glasgow School of Art. He lives and works in Ambleside, Cumbria.

russellmills.com

01 *Apollo: Atmosphere & Soundtracks*, Brian Eno with Daniel Lanois and Roger Eno, record sleeve, Virgin Records, photography, 1983

02 *Mustt Mustt*, Nusrat Fateh Ali Khan, record sleeve, Real World Records, mixed media, created c.1989, published 1990

03 *Mettle*, Hugo Largo, record sleeve, Land Records, photography, 1989

01

02

03

04

05

06

07

BARNEY BUBBLES

1942–83

Colin Fulcher was born on 30 July in Whitton, Middlesex, only becoming known as Barney Bubbles in 1967. He attended Twickenham College of Technology, which was closely associated with the local music scene and provided Bubbles with his first piece of commercial art: a poster for The Rolling Stones. In 1963, he began working at Michael Tucker + Associates, before moving to The Conran Group in 1965 as a senior graphic designer. In a freelance capacity he designed for underground magazines *Oz* and *Friends*, going on to join Stiff Records and then Radar Records in the late 1970s. Bubbles made a huge contribution to the British independent music scene, creating remarkable artwork for Elvis Costello, Ian Dury, Billy Bragg and Depeche Mode. *www.barneybubbles.com*

01

02

03

TOM CURRY

b.1945

Graduating with a degree in art from the University of North Texas, Tom Curry credits much of his education to his extensive travels around Europe in the 1970s and 1980s. His work, which has appeared in *Time, Newsweek, Rolling Stone, Playboy* and *The New York Times,* has been described as 'socially relevant, satirical, sometimes twisted, or surreal humor with a bite'. Now based in Austin, Texas, and working in acrylic on hardboard or canvas, Curry has evolved his style from drawing from life, sketching in public places and incorporating much of that experience into illustration assignments. He has illustrated six children's books and has held ten solo shows. His paintings are in collections in the USA, Europe and Japan.

01 *Bum Steer,* editorial cover, *Texas Monthly,* acrylic on canvas, 1983
02 *Cactus Jack,* editorial illustration, *Texas Monthly,* acrylic on canvas, 1984
03 *Don't Blame the Product, Blame the Customer,* editorial illustration, *The Quality Review,* acrylic on hardboard, 1988
04 *Doubletalk,* editorial illustration, *Ohio Magazine,* acrylic on canvas, 1980
05 *A Public Beef,* editorial illustration, *Harrowsmith Country Life,* acrylic on hardboard, 1989

01

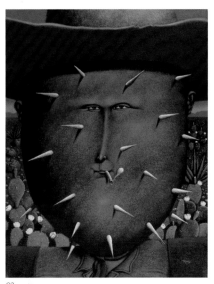

02

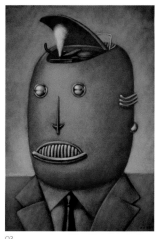

03

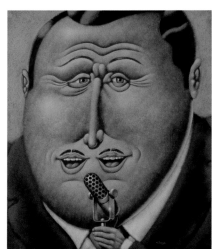

04 05

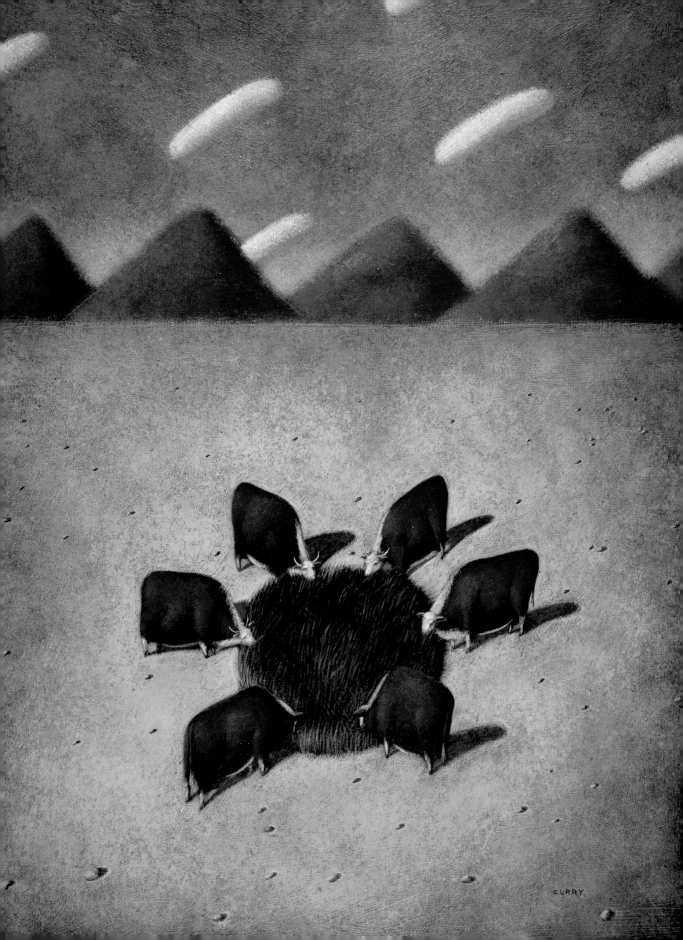

GUY BILLOUT

b.1941

Guy Billout worked as a graphic designer in the advertising industry in his native Paris before moving to New York to become an illustrator in 1969. His expansive graphic-influenced work was much in demand, and has appeared in publications from *Newsweek* to *Playboy*. From 1982 to 2006, he had a regular full-page colour feature in *The Atlantic Monthly*, for which he was given a free brief. He has also written and illustrated nine books for children, many of which have won awards, and has taught illustration at Parsons The New School for Design since 1985.

www.guybillout.com

01 *Risk at Sea*, editorial illustration, Assuranceforeningen Gard-Gjensidig (Norway), Winsor & Newton watercolour & airbrush on vellum paper, 1989

02 *Date Line*, editorial illustration, *The Atlantic Monthly*, Winsor & Newton watercolour & airbrush on vellum paper, 1989

03 *Quicksand*, editorial illustration, *The Atlantic Monthly*, Winsor & Newton watercolour & airbrush on vellum paper, 1987

04 *Rescue*, editorial illustration, *The Atlantic Monthly*, Winsor & Newton watercolour & airbrush on vellum paper, 1985

01

02

03

04

01

02

SELÇUK DEMIREL
b.1954

Now residing in Paris, Selçuk Demirel was born in Artvin, north-eastern Turkey. While studying architecture, he also published his illustration work in some of the country's leading newspapers and magazines, such as *Mimarlik*. He moved to Paris in 1978, and was soon commissioned by publications *Le Monde, The New York Times* and *The Washington Post,* among many others. His surrealist-inspired work has many applications, appearing on book covers, music packaging and posters, and in magazines and numerous children's books. *www.selcuk-demirel.com*

01 *Poire Belle Hélène,* Galeri Nev (Istanbul), lithograph, 1989
02 *Female Perfume,* Galeri Nev (Istanbul) & published by *Le Nouvel Observateur,* watercolour, 1988
03 *Pouvoir Intellectuel,* editorial illustration, *Le Nouvel Observateur,* watercolour, created 1984, published 1990

03

BRIAN GRIMWOOD

b.1948

An influential figure in the world of British illustration, Brian Grimwood was one of the founding members of the Association of Illustrators, championing the rights of illustrators and encouraging professional standards. Hugely successful in his own right as an illustrator, Grimwood has exhibited his work in five solo shows. He has also been responsible for promoting the work of fellow artists through the Central Illustration Agency, which he set up in 1983 and which now represents over 80 artists worldwide.

www.briangrimwood.com

01 *Biotechnology*, magazine illustration, *Marketing Week*, gouache/pen/ink, 1982

02 *Strike a Light Note*, editorial illustration, *Radio Times*, gouache/pen/ink, 1980

02

01

03

03 *Grimwood Logo*, logo,
George Grimwood,
gouache & brush, 1989
04 *Untitled*, editorial cover,
London Electricity Board,
gouache, 1987
05 *NABISCO Tennis Poster*,
poster, NABISCO,
gouache, 1986

04

05

SUSI KILGORE

Raised in Iowa and educated at Ringling College of Art in Sarasota, Susi Kilgore now lives and works in Florida. Starting out as a staff artist for public television, she went on to work in advertising and then as an editorial illustrator, multimedia designer, interactive children's multimedia artist and 2-D animator. Her evocative work has appeared in numerous books, magazines and newspapers and she has worked for clients including Disney World, *Sports Illustrated* and Time Life Books.
www.susikilgore.com

01 *A Good Con Job Takes More Than One Kind of Pigeon*, editorial illustration, *GQ*, oil on illustration board, created c.1989, published c.1993
02 *Ladies in Shade at Beach*, book cover, personal project, oil on illustration board, c.1988
03 *Bittersweet Memories of My Father, the Gambler* (scoreboard), editorial illustration, *Sports Illustrated*, oil on illustration board, c.1985
04 *The Chance*, editorial illustration, *Gulfshore Life* magazine, oil on illustration board, created c.1989, published c.1990
05 *Bittersweet Memories of My Father, the Gambler* (baseball player), editorial illustration, *Sports Illustrated*, oil on illustration board, c.1985

01

02

03

04

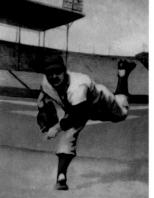

05

ANDRZEJ DUDZIŃSKI
b.1945

Born in Sopot, Poland, Andrzej Dudziński
studied architecture and poster design in
his native country. He moved to London
in 1970, contributing to the underground
magazines of the time, including *Oz, Time
Out* and *Ink*. On his return to Poland, he
became well known for his illustration
work for magazines, theatre posters and
children's books, and for Dudi, a wingless
bird that featured regularly in Poland's
satirical weekly *Szpilki*. Dudziński moved
to New York in 1977, where he forged an
equally successful illustration career and
now divides his time between New York
City and Warsaw.
www.andrzejdudzinski.com

01 *Graphis 242*, magazine cover, Graphis Press Corp.,
oil crayon on paper, 1986
02 *Fitch & Company Annual Report*, book cover,
Fitch & Company, oil crayon on paper, 1984
03 *The Big Picture – Postal Portrait*, editorial insert,
Manhattan, Inc. Magazine, pastel & oil crayon
on paper, 1986

01

02

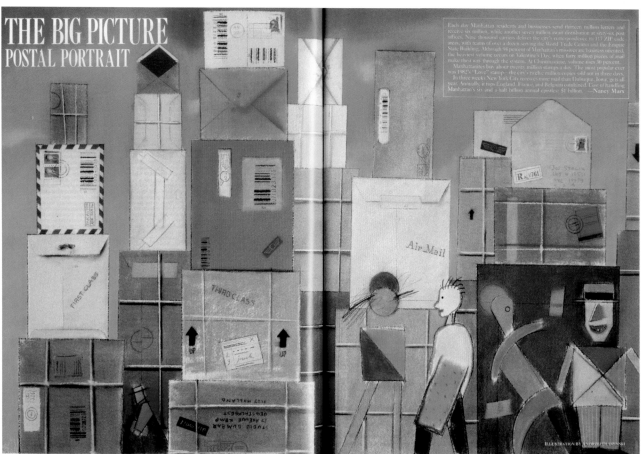

03

MACIEK ALBRECHT

b.1956

Polish-born Maciek Albrecht studied at the Academy of Fine Arts in Krakow, before moving to New York. He pursued a career as an illustrator for *The New York Times, Condé Nast Traveler, Rolling Stone* and *Businessweek*, among others. Albrecht also works as an animation director, and in 2000 he founded MaGiKworld, an Emmy Award–winning studio based in Pennsylvania that specialises in 2-D animation and character design for clients such as HBO. *www.magikworld.com*

01

02

03

GERRY HAMPTON

b.1953

Born and raised in Southern California, Gerry Hampton first started using an airbrush to create detailed renderings while he was studying biomedical illustration. Already an award-winning illustrator by the time he graduated, Hampton was heavily influenced by the psychedelic posters of the 1960s, but went about developing his own distinctive style, combining slick airbrushing with freestyle paint splatters. This technique distinguished Hampton from his peers and he found himself in great demand, with commissions from all the major advertising agencies, resulting in 500 pieces being published in the space of just 15 years. Hampton retired from illustration in the mid-1990s; now a passionate educator he has devoted himself to teaching graphic design and illustration.

01 *Get Pumped*, greetings card, PaperMoon, acrylic & airbrush, 1983
02 *Heart of a String*, greetings card, PaperMoon, acrylic & airbrush, 1983
03 *Working Gears*, poster, California Transit Authority, acrylic & airbrush, 1983
04 *Working Computer*, poster, California Transit Authority, acrylic & airbrush, 1983

01

02

03

04

QUENTIN BLAKE

b.1932

Cartoonist, author and illustrator of over 300 books, Sir Quentin Blake is probably best known for the illustrations he created for the much-loved stories by writer Roald Dahl. He has the distinction of being the only person (apart from the author) to have illustrated a Dr Seuss book – *Great Day for Up!* in 1974. A lifelong advocate of drawing, Blake is a patron of 'The Big Draw', and many people will have fond memories of his appearances on the BBC children's television programme *Jackanory*, drawing live on camera while he narrated stories. Blake received a knighthood for 'services to illustration' in the New Year Honours 2013. *www.quentinblake.com*

All illustrations shown here were created using pen & ink with watercolour wash on cold-pressed watercolour paper.

01 *The Giraffe and the Pelly and Me*, book cover, Jonathan Cape, 1985
02 *Matilda*, book cover, Jonathan Cape, 1988
03 *The Story of the Dancing Frog*, book cover, Jonathan Cape, 1984
04 *Quentin Blake's ABC*, book cover, Jonathan Cape, 1989
05 *Mrs Armitage on Wheels*, book cover, Jonathan Cape, 1987
06 *Quentin Blake's Nursery Rhyme Book*, book cover, Jonathan Cape, 1983
07 *Mister Magnolia*, book cover, Jonathan Cape, 1980

01

02

03

Quentin Blake's
A B C

MRS ARMITAGE
on
WHEELS

Quentin Blake

Quentin Blake's
NURSERY
RHYME
BOOK

MISTER
MAGNOLIA
Quentin Blake

SYD BRAK

b.1936

Originating from Johannesburg, South Africa, Syd Brak was already a successful illustrator when he moved to London (where he still lives and works) in the mid-1970s. His immaculately polished airbrush style proved popular with many high-profile advertising clients, but it was his 'Kiss' series of posters for retailer Athena that really pushed his illustrations into the public domain. Brak's iconic poster *Long Distance Kiss* was the top-selling poster in the world in 1982.

www.sydbrak.co.uk

01 *Wired Sound*, poster, Athena, airbrush, c.1984
02 *Long Distance Kiss*, poster, Athena, airbrush, 1982
03 *Brut Girl*, advertisement, Brut Aftershave, c.1987

01

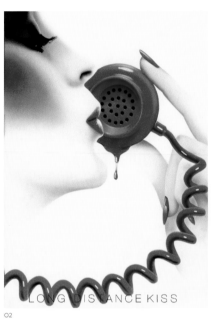

02

03

ART SPIEGELMAN

b.1948

Born in Stockholm, Sweden, Art Spiegelman moved to New York at an early age. He learned cartooning at high school, going on to study art and philosophy at Harpur College (now Binghamton University, NY). During the 1960s and 1970s, he became part of the underground comix subculture and worked as a creative consultant for Topps Bubble Gum Co from 1965 to 1987, creating Garbage Pail Kids, among others. In 1980, he founded *RAW* magazine, in which he serialized his Pulitzer Prize–winning Holocaust narrative *MAUS*. His work has been published in many periodicals, including *The New Yorker*, where he was a staff artist and writer from 1993 to 2003.

Spiegelman was introduced to the Art Directors Club Hall of Fame in 2006 and was made a Chevalier de l'Ordre des Arts et des Lettres in France in 2005. In 2011, he won the Grand Prix at the Angoulême International Comics Festival.

01 *Raw No. 7*, editorial cover, 1985

01

ASUN BALZOLA

1942–2006

Born in Bilbao, Asun Balzola studied painting and graphic arts at the Real Academia de Bellas Artes de San Fernando in Madrid. She started work as an illustrator in 1962 and soon became internationally recognised for her distinctive style, which features blocks of colour combined with bold outlines. Children's books were always her main passion; as well as illustrating and writing many titles, she also translated numerous stories into Catalan.

01 *Munia and the Red Shoes*, book cover, Cambridge University Press, watercolour, 1989
02 *La Cacería*, book cover, Altea Ediciones, watercolour, 1986
03 *Munia and the Day Things Went Wrong*, book cover, Cambridge University Press, watercolour, 1988
04 *Munia and the Orange Crocodile*, book cover, Cambridge University Press, watercolour, 1988

01

02

03

04

FINA RIFÀ
b.1939

Barcelona-based Fina Rifà illustrated her first children's book, *Chiribit*, in 1983, and since then has gone on to illustrate over 200 titles. In addition, her playful illustrations have appeared on everything from record covers and posters to programmes for cultural and civic organisations. A keen educator, Rifà is also an accomplished toy designer, winning Spain's Industrial Design for Development of Decorative Arts Association's award for outstanding toy design.
www.finarifa.com

01

02

03

01 *La Llegenda de la Rosa Nadal*, book illustration, Edicions de la Magrana, pen & ink with watercolour, 1987

02 *La Llegenda de Sant Jordi*, book cover, La Galera, pen & ink with watercolour, 1986

03 *Les Aventures de Pinotxo*, book illustration, La Galera, pen & ink with watercolour, 1982

LIONEL KOECHLIN

b.1948

Lionel Koechlin studied at the École Nationale Supérieure des Métiers d'Art in Paris, where he still lives and works. His illustrations have appeared in publications such as *National Geographic* and *The New Yorker* and in ad campaigns. He has also designed the film poster for *Tango* (Patrice Leconte, 1993) and cover artwork for the platinum-selling Genesis album *Duke*. Koechlin has published over a hundred children's books, a number of which have been adapted for French television.
www.lionel-koechlin.com

01 *Der Schöne Schein*, editorial illustration, *Manager Magazine*, china ink & watercolour, 1989

02 *Trois Baleines Bleues*, editorial illustration, Hachette, china ink & watercolour, 1980

03 *Savoir Choisir son Ordinateur*, editorial cover, *Théorème*, china ink & watercolour, 1986

04 *Pères et Fils*, book cover, *Autrement*, china ink & watercolour, 1984

01

02

03

04

PAUL LEITH

b.1946

Living and working in Cumbria, Paul Leith studied at Sunderland College of Art, then the Royal College of Art in London. His first commission was for the *Radio Times* magazine, and in 1984 Leith won gold in the coveted Benson & Hedges competition. Commissions followed from a raft of clients including *The Times*, Penguin Books, *Rolling Stone* and British Rail, along with a one-man show at the Association of Illustrators' Gallery and a pencil from D&AD. Leith has also created a set of stamps to commemorate Kew Gardens and a series of etched glass panels for Heathrow Airport. *paulleith.co.uk*

01 *Body Shop*, poster, The Body Shop, 1986
02 *Adventures in Travel*, magazine cover, *The Boston Globe*, 1980s
03 *Office Design*, editorial cover, *Interior Design*, 1986
04 *New Plan for London's West End*, editorial cover, *The Architects' Journal*, 1987

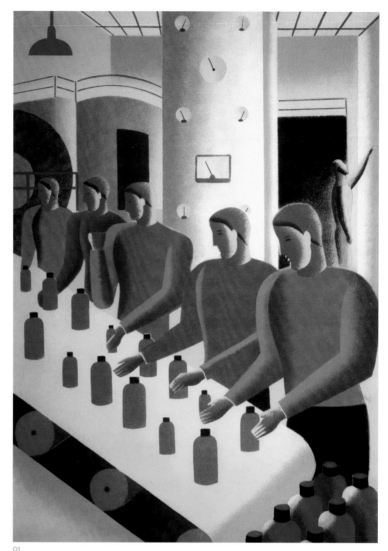

01

02

03

04

R.O. BLECHMAN

b.1930

American illustrator, animator and cartoonist Oscar Robert Blechman was born in New York. On graduating from Oberlin College, he immediately published his first book *The Juggler of Our Lady* in 1953. Blechman's diverse career has included television commercials for Alka-Seltzer, covers for *The New Yorker*, illustrations for *Harper's Bazaar* and *Esquire* and Vietnam War cartoons for *The Village Voice*. The recipient of many awards, he was voted Illustrator of the Year by *Adweek* in 1983, he was given a lifetime achievement award in 2011 by the National Cartoonists Society and he was inducted to the Society of Illustrators Hall of Fame in 2012. He lives and works in New York.
www.roblechman.com

01

01 *Circular Path*, advertisement, Hitachi Data Systems,
 pen & ink & watercolour, 1983
02 *Museum Mile*, poster, Museum Mile, mixed media, 1981
03 *Dancing Cow*, poster, Leaf Peeper Concerts, gouache, 1989

02

03

DAN FERN

b.1945

Known both for his work as a graphic and multimedia artist and in education, Dan Fern was Head of the School of Communications at the Royal College of Art in London between 2000 and 2010. His commercial work has featured on London Underground posters, magazine covers, record sleeves and stamps for Royal Mail; it has been exhibited widely and is in the permanent collection of the Victoria and Albert Museum. In 2000, Fern co-founded the MAP/making project, which encouraged collaborative projects between RCA students and musicians from the Guildhall School of Music and Drama in London. Throughout his career, Fern has also exhibited self-generated artworks in galleries in the UK and overseas. For the past 15 years, he has been inspired by the landscape of south-east France, where he has a studio. A keen mountaineer, he produced the award-winning book *Walks with Colour* to accompany an exhibition of the same name in 2006.
www.dan-fern.com

O1

03

04

O2

01 *Untitled*, limited-edition print for winners of the BBC Design Awards, Alan Yentob, 1987

02, 05, 06 *ADCN*, section headings, Art Director's Club Nederland annual, 1985–86

03, 04 Album cover front (03) and rear (04, an early computer-generated image using the ARTON 2000 at I.M.A.G.I.N.E), BBC Artium, 1985

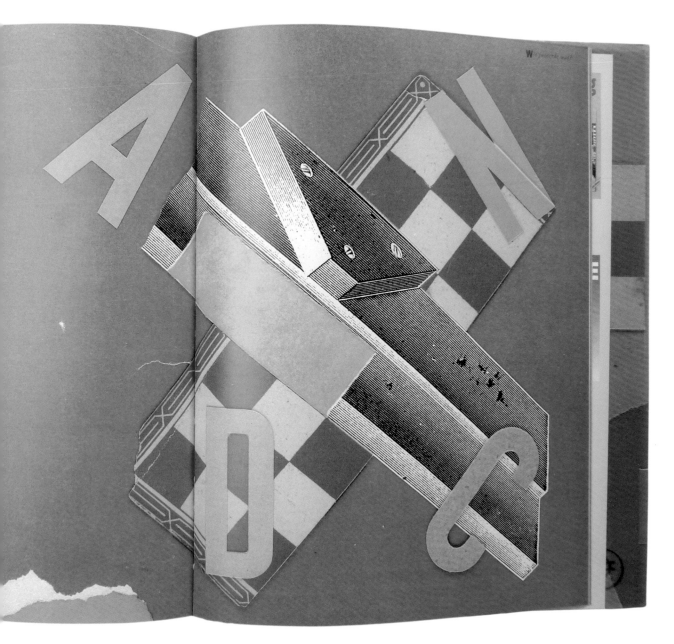

05

06

MARK HESS

b.1954

A rodeo bull rider at the age of ten, Michigan-raised Mark Hess started out as a painter in the mid-1970s in New York. He illustrated his first cover for *Time* magazine when he was just 20 years old, going on to create 17 iconic *Time* covers, plus numerous others for *Newsweek* and *Forbes*. His witty, attention-grabbing conceptual style ensures that he is always much in demand from commercial clients across a wide range of industries. As well as creating packaging and restaurant graphics, Hess has designed 46 stamps for the United States Postal Service, and 12 for the United Nations. *www.hessdesignworks.com*

01 *Original & Chunky*, Prince, 1986
02 *Jay McShann*, CD cover, Atlantic Records, 1982
03 *Lenox Ave. Breakdown*, CD cover, Atlantic Records, 1983
04 *Art Webb*, CD cover, Atlantic Records, 1980

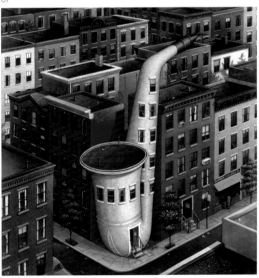

01

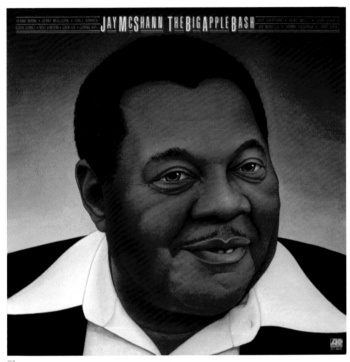

02

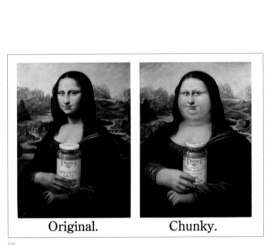

03

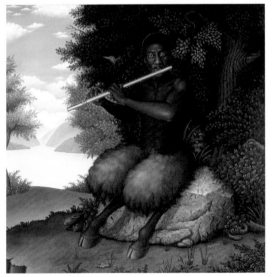

04

STASYS EIDRIGEVICIUS

b.1949

Stasys Eidrigevicius was born in Lithuania, and went on to study painting at Vilnius Academy of Arts. After graduating, he worked as an artist in the Vilnius Philharmonic Hall, finally moving to Warsaw, Poland, in 1980. He became well known for his oil paintings, book illustrations and poster designs, and has been the subject of numerous exhibitions in Poland and beyond. Eidrigevicius has won many prestigious awards for his distinctive, immaculately crafted work.

www.eidrigevicius.com

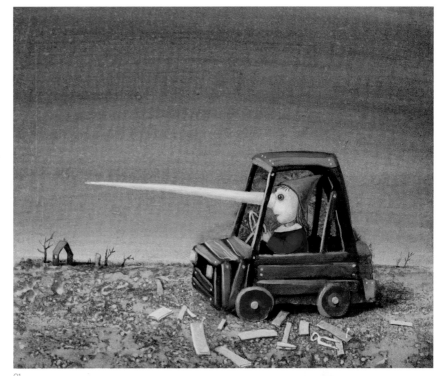

01

02

03

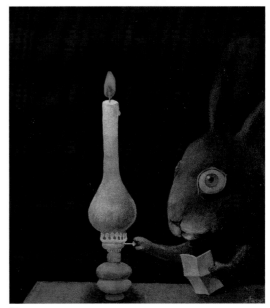

04

01 *Tank*, illustration from *Hans Naselang*, Nord-Süd-Verlag, tempera, created 1982, published 1989
02 *House*, illustration from *Hans Naselang*, Nord-Süd-Verlag, tempera, created 1982, published 1989
03 *A Newspaper Dress*, book illustration, tempera, mid-1980s
04 *Light*, book illustration, Iskry, tempera, 1984

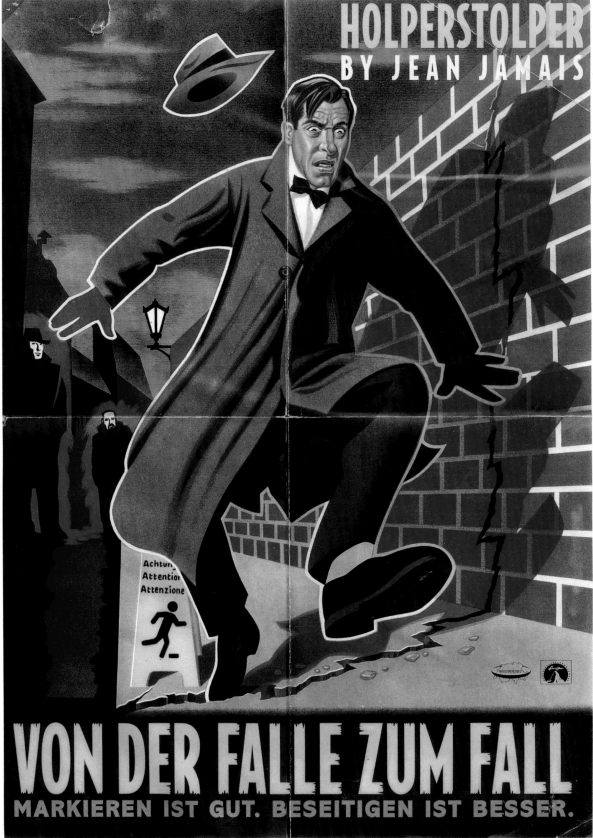

MICK BROWNFIELD

b.1947

Born in London, Mick Brownfield studied
at Hornsey College of Art. He left in 1969
to become a freelance illustrator and has
crafted a successful and varied career
divided between editorial, advertising,
publishing and work in films and animation.
His graphic cartoon-led style has always
had widespread appeal, and he has the
honour of having illustrated more *Radio
Times* magazine's Christmas covers than
any other artist.
www.mickbrownfield.com

02

03 04

MARZENA KAWALEROWICZ
b.1956

Marzena Kawalerowicz studied at the Jan
Matejko Academy of Fine Arts in Krakow,
Poland, and then at the Academy of Fine
Arts in Warsaw, where she now lives
and works. Her expressive, visceral work
often features dark sexual imagery and
has always used mixed media, sometimes
taking the human body as a canvas.
Her illustrations have appeared in such
magazines as *Elle*, *Penthouse* and *Playboy*
and she has exhibited her work in galleries
around the world.
www.kawalerowicz.com

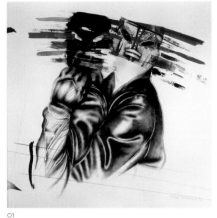

01

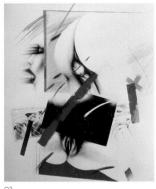

02

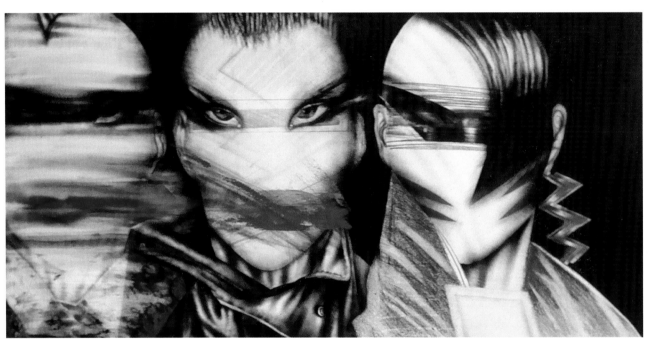

03

04

01 *Untitled*, personal project, 1980s
02 *Untitled*, personal project, 1980s
03 *Untitled*, personal project, 1980s
04 *Untitled*, personal project, 1980s

PATRICK NAGEL

1945–84

After a spell as a graphic designer for ABC television, Patrick Nagel worked as a successful freelance illustrator in Los Angeles. Nagel's work was commissioned by numerous commercial clients and, in 1976, his glamorous, stylised images gained popularity after regularly appearing in *Playboy* magazine. In 1978, he was commissioned to create the first of many posters featuring his revered Nagel Woman for Mirage Editions. Nagel enjoyed a short but prolific career, creating over 400 paintings and illustrations, one of which is instantly recognisable as the cover image used by pop group Duran Duran for its 1982 double-platinum LP *Rio* (see p.11).

www.patricknagel.com

01 *Untitled*, album cover, Duran Duran, acrylic on canvas, 1982
02 *Invitation*, Mirage Editions, acrylic & serigraph, 1980
03 *Untitled*, editorial illustration, *Playboy*, acrylic on artist's board, 1980

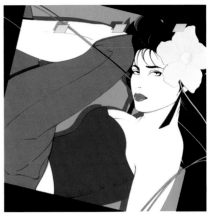

01

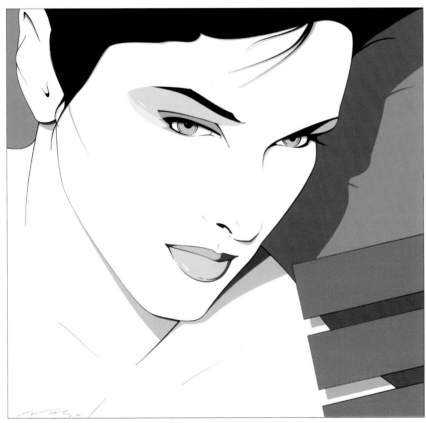

02

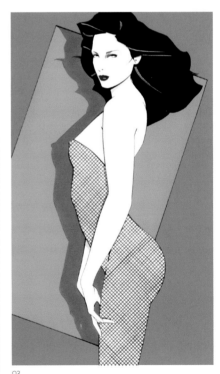

03

ANDRZEJ KLIMOWSKI

b.1949

After graduating from Saint Martin's School of Art in London, Andrzej Klimowski moved to Warsaw where he studied poster design and film animation at the Academy of Fine Arts. Klimowski designed many posters for Polish cultural institutions and covers for book publishers. On his return to the UK, he worked for *The Guardian*, Penguin Books and Faber and Faber. He has also written several graphic novels and exhibited widely across Europe. A keen educator, he has won many illustration awards and his work can be found in public collections including the Stedelijk Museum in Amsterdam, the National Museum in Warsaw and in Poznan and the Library of Congress in Washington, D.C.
www.klimowski.com

01 *Thrashing Doves,* exhibition invitation, A&M Records & Vanessa Devereux Gallery, 1989
02 *Laughable Loves,* book cover, Faber and Faber, 1987
03 *Eclipse Fever,* book cover, Faber and Faber, 1986
04 *Gustav Mahler & the 21st Century,* Music Cultural Foundation, 1989
05 *Danusia,* collage, 1987

01

02

03

04 05

SUE COE

b.1951

Sue Coe grew up in Tamworth, Staffordshire, in close proximity to a slaughter house. This had a profound effect on her, making her a passionate campaigner against cruelty to animals and informing much of her work as an artist and illustrator. Coe studied at the Royal College of Art in London before moving to New York in 1972. Her unflinching work explores themes such as factory farming, AIDS, war and sweatshops, and, in 1983, she published the powerful comic book *How to Commit Suicide in South Africa*, which dealt with the issue of apartheid. Her work has been exhibited extensively, and since 1998 she has sold prints in support of animal-rights charities.

03

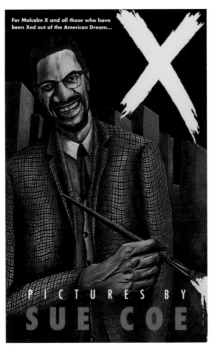

01

02

38 BACKED BY THE BOMB AND U.S. CORPORATIONS 39

04

JOHN VERNON LORD

b.1939

Born in Glossop, Derbyshire, John Vernon Lord studied illustration at Salford School of Art and the Central School of Arts and Crafts in London. An author, illustrator and teacher, Lord works in pen and ink, with a particular love of black and white. His children's books have been published widely and his picture book *The Giant Jam Sandwich* has become a classic. His illustrations for *The Nonsense Verse of Edward Lear* and *Aesop's Fables* have won national prizes, with the latter also given the W. H. Smith/V&A Illustration Award in 1990. He has illustrated a number of books for the Folio Society, including James Joyce's *Finnegans Wake* and three books by Lewis Carroll for Artists' Choice Editions. Lord's career in education has spanned over 52 years; he was Professor of Illustration at the University of Brighton (1986–99), where he is now Professor Emeritus. Lord lives and works in East Sussex.

johnvernonlord.blogspot.co.uk

O1

O2

O3

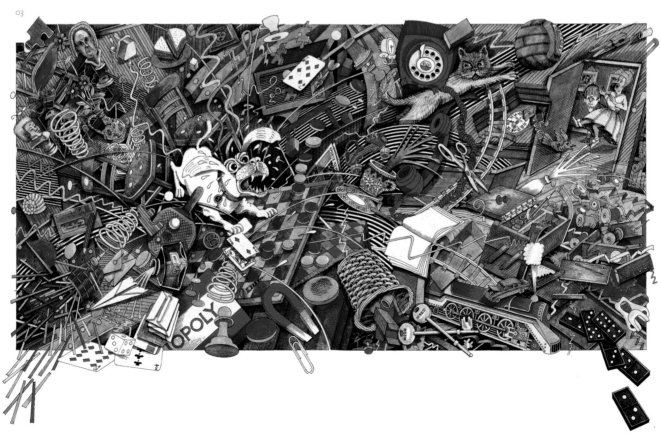

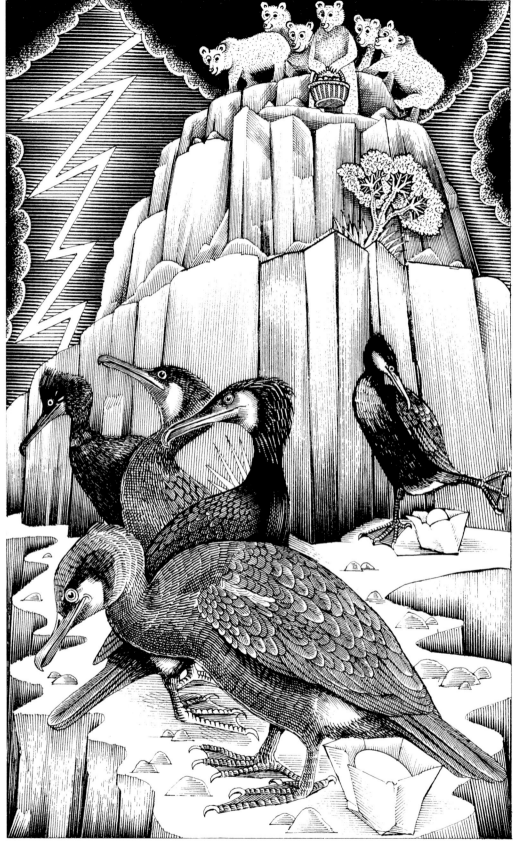

04

175

IAN POLLOCK

b.1950

Manchester-born Ian Pollock graduated from the Royal College of Art, London, in 1973. His illustrations, in particular his acerbic portraits, have appeared in publications from *Rolling Stone* and the *Radio Times* to *Penthouse*. He has designed posters for the Royal Shakespeare Company and has illustrated a number of books including a cartoon version of King Lear. Unfortunately his stamp designs commemorating the 150th anniversary of Thomas Hardy's birth were vetoed, but his subsequent 'Tales of Terror' series proved extremely popular with the stamp-buying public. *www.ianpollock.co.uk*

01 *Thought Crimes at the Barbican*, editorial cover, Royal Shakespeare Company, watercolour/ink/gouache, 1984

02 *The Sweet Smell of Success*, editorial cover, *New Scientist*, watercolour/ink/gouache, 1985

03 *Prince*, editorial illustration, *Rolling Stone*, watercolour/ink/ gouache, 1985

04 *Mick Jagger*, editorial illustration, *Rolling Stone*, watercolour/ ink/gouache, 1985

05 *Dylan*, editorial illustration, *Rolling Stone*, watercolour/ink/ gouache, 1985

01

02

03

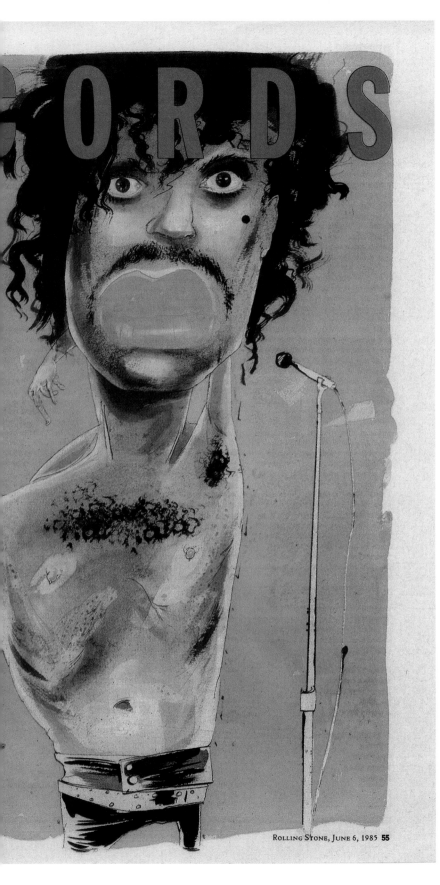

ROLLING STONE, JUNE 6, 1985 **55**

04

05

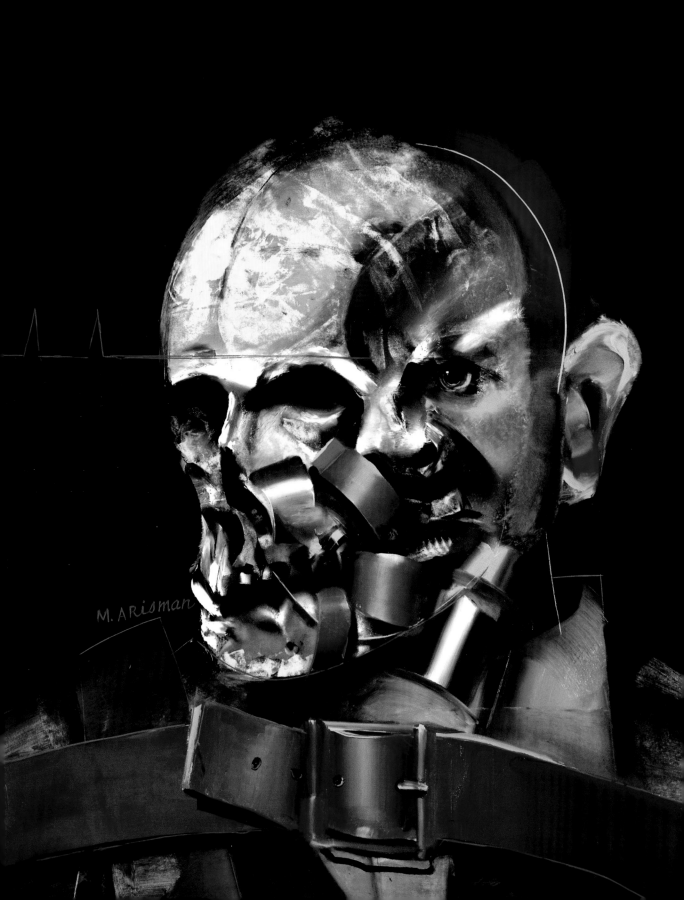

MARSHALL ARISMAN

b.1938

Marshall Arisman still lives and works in his native New York. After graduating from the Pratt Institute, he began to produce illustrations for publications including *Time, The New York Times* and *Penthouse*. Arisman's powerful illustrations, first showcased in his 1973 book *Frozen Images*, are full of tortured souls, violence and exposed flesh. His works are held in the permanent collections of many museums, and, in 1999, he was the first American artist to be invited to exhibit in mainland China with his 'Sacred Monkeys' show. His work will be familiar to many from the book cover of Bret Easton Ellis's controversial novel *American Psycho*, published in 1991. *www.marshallarisman.com*

01 *The Death Penalty*, editorial cover (unpublished), *Time*, oil on paper, 1983
02 *Bird Head on Red Background*, editorial cover, *Communication Arts* magazine, oil on canvas, 1986
03 *Man with Turtle*, poster, School of Visual Arts, oil on canvas, 1982

01

02

03

STEVEN GUARNACCIA
b.1953

A former art director of *The New York Times* 'Op-Ed' page, Steven Guarnaccia is chair of the Illustration Program at Parsons The New School for Design in New York. His distinctive work has featured in high-profile magazines and newspapers, including *Rolling Stone*, *The New York Times*, *Abitare* and *Domus*. He has contributed exhibition drawings for a show of Achille Castiglioni's work at the Museum of Modern Art (MoMA) in New York and murals for Disney Cruise Line. Guarnaccia has also designed watches for Swatch, greetings cards for MoMA and numerous books for adults and children, including *The Three Little Pigs: An Architectural Tale* and *Cinderella: A Fashionable Tale*.

stevenguarnaccia.com

01 *Free Agents*, book cover, Harper & Row, 1984
02 *Fast Five*, Weitek, 1985
03 *Season's Greetings*, editorial cover, *The Boston Globe Magazine*, 1987
04 *Pearl's Progress*, book cover, Alfred A. Knopf, 1989
05 *Slaves of the Lawn*, editorial cover, *The Washington Post*, 1989
06 *Sidelines*, editorial cover, *American Bookseller*, 1980

O2

O1

03

04

05

06

NIKOLAUS HEIDELBACH

b.1955

Nikolaus Heidelbach was born in the Rhine area of Germany and studied German and art history in Cologne and Berlin. An extremely successful children's book illustrator, he publishes many of his own books, as well as creating artwork for various poems, short stories and fairy tales by Hans Christian Andersen and the Brothers Grimm. Heidelbach has also illustrated textbooks, and his work has appeared on numerous book covers, including Eoin Colfer's popular 'Artemis Fowl' science-fiction series.

01 *Prinz Alfred*, book illustration, Beltz & Gelberg, created 1983, published 2012

01

IKKO TANAKA

1930–2002

Born in Nara, Japan, Ikko Tanaka studied at the Kyoto City College of Fine Art. He set up his design studio in Tokyo in 1963, working for clients including Mazda and Issey Miyake, and creating logos and symbols for Expo '85 in Tsukuba and World City Expo Tokyo '96. He designed and curated exhibitions across Japan, in London and Moscow. One of the three founders of Muji (along with Kazuko Koike and Takashi Sugimoto), Tanaka conceived the store's distinctive visual language and remained its art director until 2001. His reductive style seamlessly blends East and West and is most evident in his striking posters, perhaps the most famous of which is 'Nihon Buyo'.

01 *Japan*, poster, Japan Graphic Designers Association Inc., silk screen, 1986
02 *The Ginza Saison Theatre*, poster, The Ginza Saison Theatre, offset print, 1986
03 *Nihon Buyo*, poster, UCLA Asian Performing Arts Institute, 1981
04 *Close-up of Japan – London 1985*, poster, Mitsui Public Relations Committee, silk screen, 1985

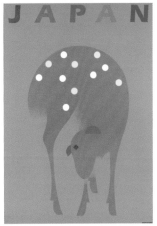

01

02

03

04

MICHAEL FOREMAN

b.1938

Publishing his first children's book in 1961, Michael Foreman was born in Suffolk and studied commercial art at London's Saint Martin's School of Art, followed by a graphics course at the Royal College of Art. His work has taken him around the world, from Denmark to research *The Saga of Erik the Viking* to Sikkim to illustrate folk stories. His book *War Boy* presents his memories of World War II as seen through the eyes of a young boy. Aside from creating his own books, Foreman has illustrated the works of Shakespeare, Oscar Wilde and Charles Dickens. Among a multitude of awards, he has received the Kate Greenaway Medal twice, the Smarties Prize twice and the Victoria and Albert Museum Francis Williams Prize twice. He lives between London and Cornwall.

01 *The Beast With a Thousand Teeth*, book illustration, Pavilion Children's Books, pen & wash & watercolour, 1981
02 *War Boy*, book cover, Pavilion Children's Books, watercolour, 1989
03 *The Island of Purple Fruit*, book illustration, Pavilion Children's Books, watercolour, 1981

01

WAR BOY
A WARTIME CHILDHOOD
Michael Foreman

Winner of the Kate Greenaway Medal

'An unforgettable experience'
The Guardian

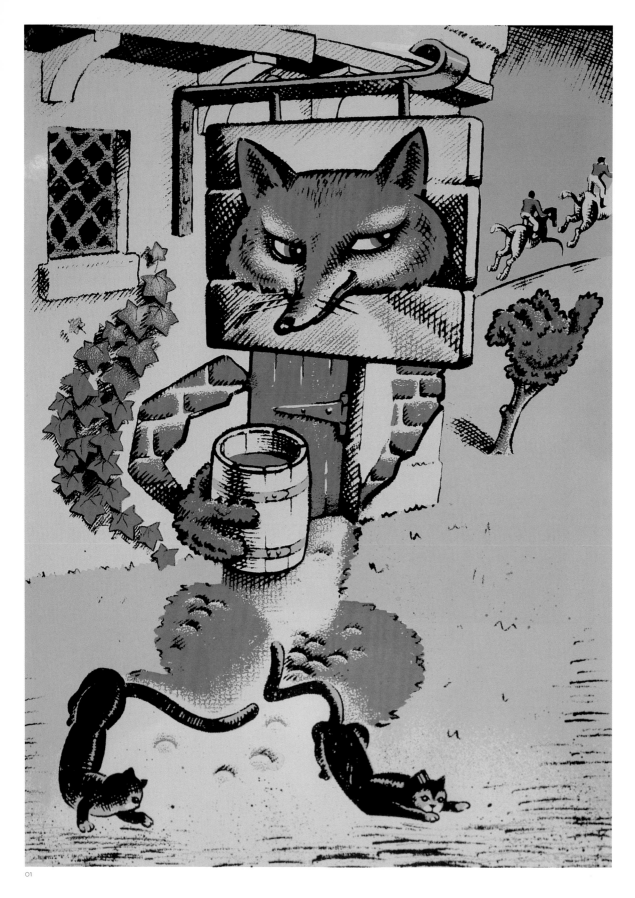

BUSH HOLLYHEAD

b.1949

Born on Tyneside in north-east England, Bush Hollyhead attended Newcastle and later Hornsey College of Arts. In 1970, he became one of a talented group of designer-illustrators employed at Nicholas Thirkell Associates. When Thirkell left the company in 1973, the remaining members continued as NTA Studios. The company gradually began to wind down during the 1990s, as the partners increasingly worked independently. Hollyhead has worked for clients from 16 countries around the world, producing artwork for book covers, magazines, advertising, animation, murals, logo design and the music business. Among his many awards are the Swedish Golden Egg for advertising illustration in 1974, a Grammy Nomination for record-sleeve design in 1981 and the D&AD Silver Award for poster design/illustration in 1985. Hollyhead currently lives in London, producing commissioned and personal works.

01 *The Fox*, pub sign, Pentagram, enamel, 1980
02 Editorial cover, *Idea*, 3-D model covered with collage, 1985
03 *Thamesday 1985*, poster, Greater London Council, 1985
04 Advertisement, TDK Corporation, 1983

02

03

04

Chapter 4:
1990s

The Digital Dawn

01

01 Andy Martin, *A Lucky Break*, editorial illustration,
The Observer Magazine, collage & digital, 1994

The early 1990s were to signify the dawn of the digital revolution for communication design practitioners. An analogue world was in a state of change, and by the end of the decade nothing would be quite the same again for the creative industries and, of course, for the wider digital realm.

The mass production of the microchip and the increased availability of high-end technology helped to fuel a revolution. As prices crashed, software and hardware finally became within the financial reach of the man in the street. Despite the early adopters, trendsetters and trailblazers who had grappled with digital technology in the 1980s, it was this new-found affordability coupled with increased spec that saw a digital uprising gather momentum.

It was clear that the world was rapidly changing; media channels had exploded, with CNN broadcasting the First Gulf War live into homes across the planet. Digital technology was soon in the hands of most Western consumers in the form of the mobile phone, and with the first Web browser's launch in 1993, the rise of the digital age was proved unstoppable.

Canadian philosopher of communication theory Marshall McLuhan predicted three decades earlier that the planet would become a 'global village', and this was fast becoming a reality as the World Wide Web, invented by Tim Berners-Lee, was launched in 1991. The immediacy of instant global communication was no longer a sci-fi dream. Following the upload of the first photograph to the Web in 1992 by Berners-Lee, the capability for sharing ideas and resources via the Web soon became the norm.

Across the creative industries, reactions to the digital revolution were initially mixed. The early years of the decade witnessed graphic designers keen to embrace the new digital world order – change was not to be feared. With financial support from the studio or agency that employed him or her, the graphic designer was able to purchase the necessary hardware and software for digital experimentation. The more traditionally focused illustrator, seemingly a very different beast, appeared blissfully unaware of the onslaught of the digital age. This was either genuine naivety or, more likely, a reaction against switching from the comfort zone of traditional working methods to the shock of the new. Most illustrators, unwilling to see themselves as digital immigrants and with a head-in-the-sand attitude, refused to engage with the allure of the digital.

By the mid-1990s, however, many younger illustrators became increasingly aware of a seismic shift within contemporary communication design, recognising that they would need to adapt or die. Graphic designers, keen to commission digital illustration, found a discipline floundering and in need of reinvention. It fell to a new breed of illustrator, keen to capitalise on the moment, to bridge the gap with graphic design and to present ways and means of breathing new life into the field and ensuring its place within the creative industries.

Alongside a new wave of illustrator, leaving art and design schools with a new attitude and a fresh aesthetic, was a different kind of graphic designer keen to branch out and re-imagine him- or herself as an illustrator. The concept of the graphic artist – the

02

03

designer and illustrator combined – took shape, which was to have an immediate effect on the look and feel of illustration: a more graphic edge and a greater digital aesthetic appeared, supported by more knowledgeable production techniques and methods. Here was work created on the computer and proud of it – pixels were prominent and the look overtly digital.

To shape a new approach to illustration, designers and art directors began to engage directly as image-makers. In the UK, Andy Martin (see p.200), a young magazine designer and art editor at *New Musical Express* (*NME*), was introduced to an Apple computer at an expo and invited to take it away and experiment. Bold, graphic and with a digital edge, Martin's images were a breath of fresh air, creating instant impact and injected with humour. His work helped illustration to be seen as a force to be reckoned with.

Rian Hughes (see p.206), a graphic-design graduate from the London College of Printing, now London College of Communication, moved away from design work for advertising agencies and music and style magazines such as *i-D* and *Smash Hits*, and began to create digital illustrations. Both Hughes and Martin saw an opportunity to kick-start careers as illustrators – the digital desktop of the Apple Macintosh enabled them and others to work quickly and effectively, using methods that in the analogue world would have been extremely time-consuming, if not impossible. Change was speeding up.

In the USA, John Hersey (see opposite and p.196), based in San Francisco, was one of the first artists to make the move from analogue. Introduced to Apple computers in the mid-1980s, Hersey had embraced the new technology and quickly became recognised as one of the USA's innovators in digital illustration. Josh Gosfield (see p.237), on the East Coast as a New York City–based art director at *New York* magazine, quit his job to become a freelance illustrator, bringing together analogue and digital working methods, using photography and three-dimensional set-building to create a new mode of image-making. There was distinct and rapid change finally occurring on both sides of the Atlantic.

Positive developments and a renewal in the fortunes of illustration were not limited to the UK and USA. In Germany, eBoy's hyper-pixel style emerged from Berlin (see above and p.234); in Spain, comic-artist-turned-illustrator-and-designer Javier Mariscal (see left and p.194) was commissioned to create a unique mascot – Cobi – as well as signage, packaging and architecture for the Olympic Games in 1992, bringing a new vitality and life to the city of Barcelona. Another comic-artist-turned-illustrator, Joost Swarte from Belgium (see overleaf and p.248), took on bigger commissions during the decade, seeing his portfolio expand from print-based projects to the design of furniture and architecture. Illustrators were becoming more ambitious in their outlook.

By mid-decade, illustration was once again embraced by the design community, and the general public's perception also began to change. The discipline's relationship with animation came to the forefront, alerting a new generation to the power of the drawn image. *Toy Story* (John Lasseter), released in 1995, costing £19.25 million to produce and generating over £231 million in box-office revenues, told the story of a toy cowboy and was the first feature-length

completely computer-animated film, marking just how far digital
technology, and illustration, had advanced in little more than ten
years since the introduction to the market of the PC.

Gaming had come of age, too, and developed dramatically
during the 1990s, with console wars between Nintendo and Sega
being upstaged with the release of the Sony PlayStation. The
influence of digital gaming on illustration and animation – through
such character designs as Nintendo's 'Super Mario' and Sega's 'Sonic
the Hedgehog' – was vital and noticeable. The next generation of
illustration consumers were likely to be introduced to the medium,
not through children's books as previously, but through animations
on television, animated movies at the cinema or by the gaming culture
that was exploding on home consoles and hand-held devices globally.

The 1990s was a decade of opposites and extremes. With race
riots in LA, war in Bosnia and conflict in Rwanda it was clear that
humankind was to continue on a self-destructive path. But with the
dissolution of the Soviet Union, the long-awaited end of apartheid
in South Africa (with Nelson Mandela's release after 30 years
in captivity) and the historic peace agreement signed in Northern
Ireland, a note of optimism was in the air despite the deaths of
two icons of humanity, Diana, Princess of Wales and Mother Teresa.

Illustration was to play its part in reflecting the narrative
of the decade. Mariscal's playful cover illustrations for *The New
Yorker* magazine (see p.194), Kam Tang's intensely detailed work
for seminal style, fashion and architecture magazine *Wallpaper**

05

06

07 Dave Kinsey, *Say Hello to Square Circle*, CD cover,
Revolt Records, pen & ink with digital composition, 1999
08 Kate Gibb. *Untitled*, CD inner sleeve, Astral Works,
silk screen, 1999

07

08

(see p.199), Dave Kinsey's street-style-influenced images for *The New York Times* and *The Washington Post* (see p.210), Gary Baseman's quirky illustrations for *Time, Rolling Stone* and *The New York Times* (see p.212), Michael Bartalos's graphic images for Virgin Records and Nickelodeon (see p.215), Kate Gibb's music campaigns for Suede, The Chemical Brothers and Astral Works (see below left and p.204) and Archer/Quinnell's retro collages for such books as Philip Roth's *The Great American Novel* (see p.216), all demonstrated illustration's unique ability to reflect the times in which it was created. Illustration was about the here and now.

Not since the Industrial Revolution had such radical shifts in how people lived and worked occurred. Even on a micro level, the changes to the creative industries were extreme – digital technology enabled illustrators to make immediate changes to how they created their work, where they created their work, how they attracted new work and how they disseminated their work to clients and the wider world. The digital age sped up the process: no more waiting for paint to dry, no more mistakes that meant redoing a piece of artwork. Moving from analogue to digital was not without pressure, however, and keeping up with software updates and maintaining hardware were not stress-free. Another downside to digital creation and delivery was that clients expected work faster and assumed that it would be more polished and more final at early 'rough' stages.

However, by replacing paper-based with screen-based methods, illustrators had a new-found freedom, which extended to their living, as well as working, habits. Meetings between illustrator and client became increasingly rare – conversations about the brief, the potential solution and the discussion about ideas became a thing of the past, while personal contact between commissioner and commissioned seemed a quaint memory. No longer was it vital for the illustrator to live or work within a radius of the client's courier zone as artwork could now be emailed. A migration from the city to the country took place – in London from Hackney to Hastings, while in New York, San Francisco and Los Angeles, illustrators were no longer bound to the creative centres.

The Web afforded illustrators a unique resource for marketing their wares; no longer had they to carve out a career by undertaking weeks and sometimes months of dedicated portfolio viewings with clients. Of course, the opportunities that the online presented were vast, far outweighing the negatives, but there were casualties: for every bright new digital illustrator that emerged there was another from an older generation who failed to cross the divide.

The decade was to end in ways unimaginable a mere ten years before. The digital age encouraged a new visual aesthetic and enabled entirely new approaches. New tools appeared – some emulating the tried and trusted pencils and brushes of the real world and others offering brand new mark-making opportunities through filters and techniques. Experimentation was rife; the good, the bad and the ugly of contemporary illustration emerged during the 1990s. Digital working methods, communication and marketing allowed illustrators ownership of the entire process, and illustration was on the rise again. The wider creative industries, and the wider world too, were beginning to take notice of a discipline evolving.

MARISCAL

b.1950

Born in Valencia, Spain, Javier Mariscal has embraced illustration, sculpture, graphic design and interior design throughout his career. He moved to Barcelona in 1970, his popular 'BAR-CEL-ONA' logo signalling for many a new optimism within the city. His controversial mascot Cobi, designed for the 1992 Barcelona Olympic Games, was the most profitable in Olympic history. Mariscal has designed everything from bar stools to chairs for Big Brother; he has produced numerous identities, designed a hotel in Bilbao and in 2010 co-created the Oscar-nominated full-length animation *Chico & Rita*.
www.mariscal.com

01

02

03

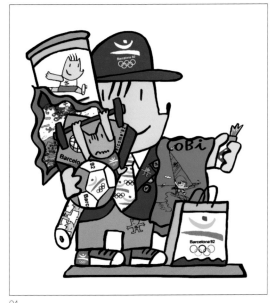

04

05

JOHN HERSEY

b.1954

Raised in Vancouver, Canada, John Hersey attended the Art Center College of Design in Pasadena, California, and moved to San Francisco in 1981. He was first introduced to the Apple Macintosh computer in late 1983 by Bruce Charonnat at *PC World* magazine, and was subsequently commissioned by him to create graphics using the basic programs available on the Mac for the company's new *Macworld* publication. This led to more digital commissions, numerous awards and Hersey being named as one of the founders of digital illustration.

www.hersey.com

01

02

03

04

01 *Handbook cover*, The Graphic Artists Guild, 1994
02 *Shockwave*, book cover, O'Reilly Publishing, 1996
03 *Wired Ameba*, editorial illustration, *Wired*, 1995
04 *Wired Egg*, editorial illustration, *Wired*, 1995

BRETT RYDER

b.1972

Brett Ryder was born in Norfolk, studied at Camberwell College of Arts and Central Saint Martins College of Art and Design, and now lives and works in Brighton. His esoteric illustrations have been commissioned by a raft of publications including *The Los Angeles Times*, *New Scientist* and *GQ*, and he has contributed to weekly columns in *The Economist* and *The Daily Telegraph*. In 2007, Ryder won the V&A Illustration Award. He created *The Guardian*'s brand identity for 2008's Glastonbury Festival, and tea drinkers will recognise his work from the distinctive packaging of Dr Stuart's range of herbal teas.

www.brettryder.co.uk

01

02

03

04

05

01, 04, 05 *Animal Behaviour*, editorial illustrations, *New Scientist*, digital collage & drawn, 1998
02 *London Philharmonic Campaign*, advertising, BBH, digital collage & drawn, 1998
03 *Dot.com*, editorial illustration, *The Guardian*, digital collage & drawn, 1996

KAM TANG

b.1971

Brixton-based illustrator Kam Tang studied at the University of Brighton and the Royal College of Art (RCA). His beautifully crafted work – often described as 'maximalist' – has been in great demand since his first commission from design agency Graphic Thought Facility (GTF) to create illustrations for the RCA's prospectus. Tang's work has appeared in magazines such as *Wired*, *Wallpaper** and *Arena*, and in campaigns for Burberry, The Chemical Brothers and Adidas. He collaborated with GTF again in 2003 to create a new identity system for London's Design Museum.

www.kamtang.co.uk

01

02

03

01, 02 *Micro Machines*, editorial illustration, *Arena*,
Macromedia Freehand, 1998
03 *Spirit of RCA*, prospectus illustration, Royal College of Art,
pen on paper, 1998

ANDY MARTIN

b.1953

After a brief spell at Derby College, UK,
Andy Martin arrived in London in 1977.
He worked in magazine and book design,
becoming a full-time image-maker in
1985. His witty deconstructed pieces,
often featuring found images and wordplay,
have appeared in publications including
The Economist, *Newsweek* and *The
Guardian*. His animated short films have
been screened on Channel Four and the
Sundance Channel, as well as at festivals
in Japan, Korea and Taiwan.
andy-martin.com

O1

O2

O3

04

05

MASAKO EBATA

b.1962

Masako Ebata was born in Japan. After completing her degree in art education, she worked for one of the top advertising agencies in Tokyo as a graphic designer, winning several prestigious awards. She then moved to New York and received her MFA from the School of Visual Arts within the 'Illustration as Visual Essay' programme. In 1991, she opened her own studio in Manhattan and works as a freelance art director, designer and illustrator. Her pieces have featured in several worldwide publications, including the *American Illustration* annuals. She relocated to Tokyo in 2012, continuing her work as an artist, while also teaching art. *www.ebata.com*

01 *Lou Marini*, Tokuma Japan Communications, oil on wood, 1996
02 *Book Club*, The Philadelphia Inquirer, acrylic, 1997
03 *New Parent*, Disney, acrylic, 1997

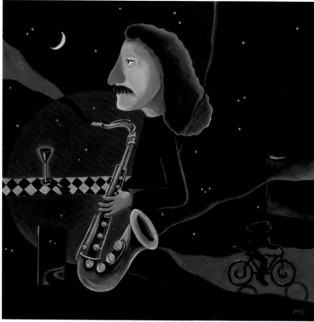

01

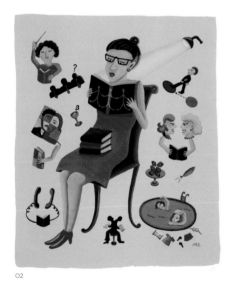

02

03

WOLF ERLBRUCH

b.1948

A graduate of the Folkwang University of
the Arts in Essen, Germany, Wolf Erlbruch
illustrated his first children's book in 1985.
Since then, he has written and illustrated
many much-loved titles, including *Mrs.
Meyer the Bird*, *Leonard* and *Duck, Death
and the Tulip*. Erlbruch combines drawing,
painting and collage in his illustration work,
which often touches on difficult subjects
presented in ways that his readers can
easily relate to. A professor of illustration
at the University of Wuppertal, in 2006
Erlbruch won the Hans Christian Andersen
Medal for his illustration work.

01 *L'ogresse en Pleurs*, Éditions Milan, mixed media, 1996
02 *Die Fürchterlichen Fünf*, Peter Hammer Verlag, 1993
03 *'S nachts*, Querido, mixed media, 1999

01

02

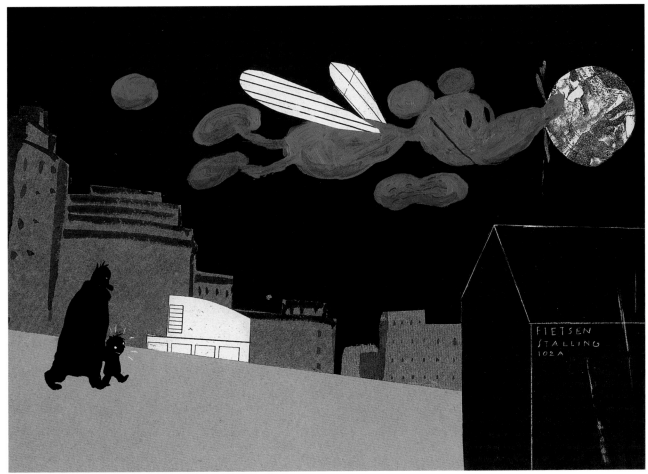

03

KATE GIBB

Kate Gibb studied printed textiles at Middlesex University, going on to complete a master's in illustration at Central Saint Martins College of Art and Design, London. Her distinctive screen-printed work has featured in many publications including *Le Monde*, *The Observer* and *Atmosphere*, among others. Fashion and lifestyle clients include Dries Van Noten, Levi's, Nike, Adidas, Puma and Apple; and she has created music campaigns for the likes of Simian, The Magic Numbers, Suede, Bob Marley and Kate Nash. Her long-standing creative relationship with The Chemical Brothers has made her work familiar to millions, particularly through the band's double-platinum album *Surrender*, which was voted as one of *Q Magazine*'s '100 Best Record Covers of All Time'.
www.bigactive.com/illustration/kate-gibb

01

02

03

01 *Hey Boy Hey Girl*, CD artwork, Virgin Records & The Chemical Brothers, silk screen & hand painting, 1999
02, 03 *Untitled*, CD artwork, Echo Records for Mono, paper collage/silk screen/hand drawing, 1997
04 *Untitled*, CD artwork, Virgin Records & The Chemical Brothers, silk screen & hand painting, 1999

04

RIAN HUGHES

b.1963

After graduating from the London College of Printing, designer, typographer and illustrator Rian Hughes worked extensively in the comics industry, creating numerous comic strips, graphic novels and logo designs for DC and Marvel, including X-Men, Batman and Robin, Batgirl and Captain America. His retro-cool illustrations have been used for everything from music packaging to Hawaiian shirts, and his successful type foundry, Device Fonts, sells many of the fonts created for his comic art. His forthright cultural manifesto *CULT-URE*, which he both wrote and designed, was published by Fiell in 2011.
www.devicefonts.co.uk

01 *Trick of the Mind*, book cover, Oxford University Press, Illustrator & Fontographer, created 1999, published 2003
02 *Hairdressing Placements Abroad*, editorial illustration, *Hairdresser Magazine*, India ink/pantone film/board, 1992
03 *Birthday Boy*, greetings card, Roger la Borde, Illustrator, 1998
04 *Simms Weekender*, poster, David Simms, Illustrator/Photoshop/digital camera, created 1997, published 2002
05 *Springtime in Paris*, poster, Rainey Kelly Campbell Roalfe & Y&R, Eurostar, 1999
06 *Jetset*, greetings card adapted from *The Daily Telegraph* editorial illustration, Santoro Cards & *The Daily Telegraph*, created 1997, published 2001

01

02

03

04

05

06

IAN WRIGHT
b.1953

After studying graphic design at the London College of Communication, Ian Wright went on to work as an assistant to illustrator George Hardie, before setting up his own studio in 1981. Wright worked extensively for *The Face* and *New Musical Express* (*NME*), where he created weekly black-and-white portraits. Mixing analogue and digital, Wright often uses unusual materials to create his artworks: Grandmaster Flash from grains of salt, Jimi Hendrix from Hama beads, Angela Davis from mascara wands and John Lennon from dressmaking pins.
www.mrianwright.co.uk

01 *Mike Tyson*, unpublished editorial illustration, *Esquire*, acrylic, 1990
02 *Ian Brown, Golden Greats*, record sleeve, Stephen Kennedy & Polydor Records, acrylic & spray paint, 1999
03 *Skip McDonald of Tackhead*, personal project, mixed media, 1993
04 *Seikima II*, CD cover, Ki/oon Sony Records, MacPaint, 1992

O2

◂O1

03

04

DAVE KINSEY

b.1971

After studying at The Art Institute of
Pittsburgh and The Art Institute of Atlanta,
Dave Kinsey moved to California in 1994.
His painterly style has been exhibited in
museums and galleries around the world,
has been featured in such publications as
The New York Times and *The Washington
Post* and has been commissioned for
campaigns by Absolut and Polaroid. In 1996,
Kinsey founded the agency BLK/MRKT,
followed by the BLK/MRKT Gallery
(now Kinsey/DesForges) in 2001 in Los
Angeles to showcase the work of emerging
contemporary artists.
www.kinseyvisual.com

01 *Headback Japan*, digital composition, mixed media, 1999
02 *Dome*, digital composition, mixed media, 1999
03 *Pro Model Series 'Larger Than Life'*, Expedition One,
screen print on wood decks, 1999

01

02

GARY BASEMAN

b.1960

Los Angeles–born Gary Baseman has had his often dark, creature-filled work featured in publications such as *Time, Rolling Stone* and *The New York Times*, and has exhibited in galleries around the world. As well as campaigns for clients including Mercedes-Benz, AT&T and Nike, the multi-talented illustrator created the Emmy and BAFTA award-winning series *Teacher's Pet*, for which *Entertainment Weekly* named him one of the '100 Most Creative People'. Baseman has designed numerous vinyl toys and is also responsible for the best-selling board game Cranium.

www.garybaseman.com

01 *Indirect Communication*, editorial illustration, *The New York Times Magazine*, mixed media on paper, 1994

02 *Direct Communication*, editorial illustration, *The New York Times Magazine*, mixed media on paper, 1994

03 *Grossed Out Movies*, editorial illustration, *Entertainment Weekly*, mixed media on paper, 1999

01

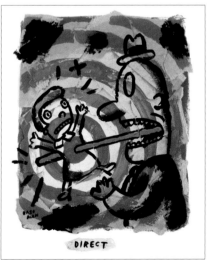
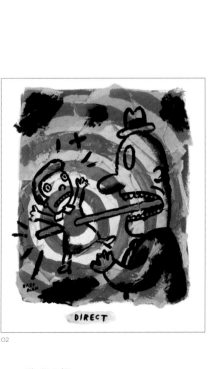

02

03

OLAF HAJEK

b.1965

German-born illustrator Olaf Hajek studied graphic design at the Fachhochschule in Düsseldorf and now lives and works in Berlin. His painterly work is both decorative and mysterious, influenced by folklore and containing unexpected elements and muted colours. He has exhibited extensively in galleries around the world and has been commissioned by such clients as Japanese *Vogue*, Mont Blanc, Apple and Mercedes-Benz. His monograph *Black Antoinette* was published by Die Gestalten Verlag in 2012. *www.olafhajek.de*

01 *Talking Plants*, editorial illustration, *SZ-Magazin*, 1994
02 *Singing Whale*, editorial illustration, *SZ-Magazin*, 1995
03 *Cover Sommerrätsel*, editorial illustration, *SZ-Magazin*, 1993
04 *Crime Story*, editorial illustration, *SZ-Magazin*, 1994

01

02

03

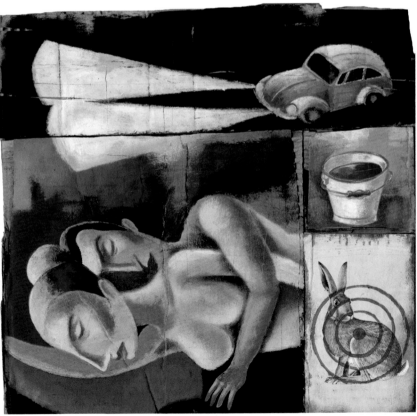

04

MICHAEL BARTALOS

Born in Heidelberg, Germany, but now living in San Francisco, Michael Bartalos attended the Art Institute of Chicago and the Pratt Institute. His vibrant work has appeared in numerous publications, on Swatch watches and postage stamps, and has been animated for Target, Virgin Records, Nickelodeon and Time Warner Cable. His artists' books have been exhibited internationally and are included in collections at the Museum of Modern Art in New York, the Walker Art Center, the Getty Research Institute and Yale and Stanford universities.

bartalosillustration.com

01 Set of three Swatch watches, Swatch Ltd, 1995
02 *Marathon Stamp*, stamp, United States Postal Service, 1996
03 *China + Morocco*, calendar, Butterfield & Robinson, 1996
04 *Sierra*, editorial illustration, *Sierra* magazine, 1998

O1

O2

O3

O4

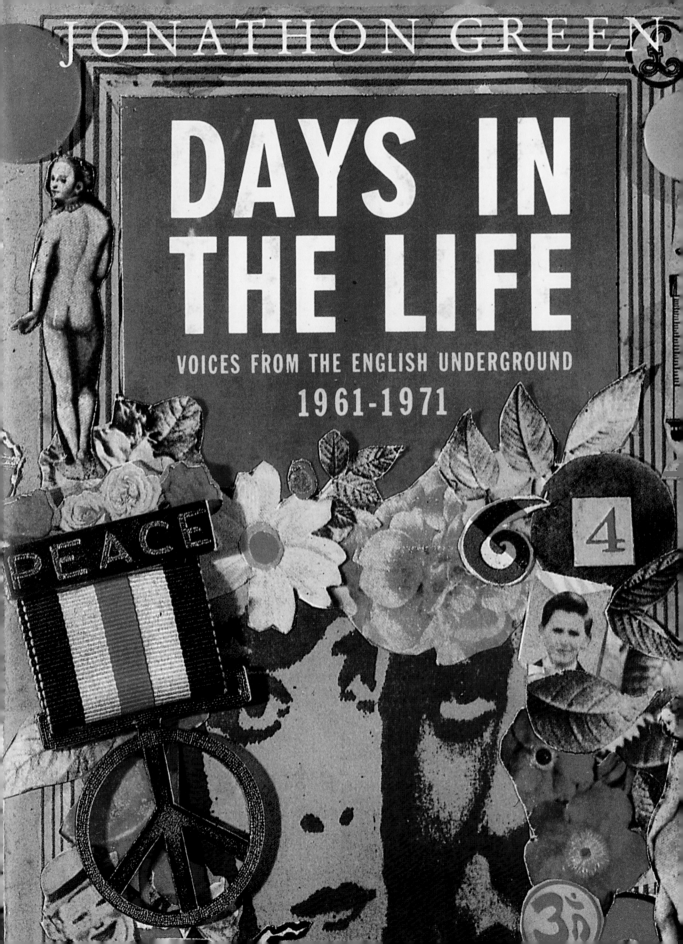

JONATHON GREEN

DAYS IN THE LIFE

VOICES FROM THE ENGLISH UNDERGROUND

1961-1971

PEACE

ARCHER/QUINNELL

est.1985

Magda Archer and Peter Quinnell met while studying at London's Chelsea School of Art in 1984 and began working together as Archer/Quinnell. Both gained a master's degree in illustration at the Royal College of Art before embarking on a fine art and illustration career, working with collage, found objects, photography and drawing. The partnership was dissolved in 1999, Archer remaining in London and Quinnell moving to Hastings. Both are still practising and have not ruled out a future collaboration.
www.peterquinnell.com/
www.magdaarcher.com

01 *Days in the Life*, book cover, Minerva, collage, 1990
02 *The Great American Novel*, book cover, Vintage, collage, 1991
03 *Made in America*, book cover, Secker & Warburg, collage, 1994
04 *Shopping in Space*, book cover, Serpent's Tail, 1992

02

01

03

04

ISTVAN BANYAI

b.1949

Award-winning Hungarian-born Istvan
Banyai studied at the Moholy-Nagy
University of Art and Design in Budapest
and was already a successful illustrator
when he emigrated to New York (via Paris
and Los Angeles) in the mid-1980s. He
published the first of five highly successful
children's books, *Zoom*, in 1995, and is
a regular contributor to *The New Yorker*,
Rolling Stone, Nickelodeon, Verve Records
and MTV Europe.
www.ist-one.com

01 *No Yorker*, unpublished cover, pencil drawing & Photoshop
colour, 1999
02 *Untitled*, editorial cover, *Flatiron Magazine*, pencil drawing
& Photoshop colour, created 1997, published 2000
03 *Photographer*, editorial illustration, pencil drawing &
Photoshop colour, 1998
04 *Darwin*, editorial illustration, *The New Yorker*, pencil drawing
& Photoshop colour, created 1999, published 2008

01

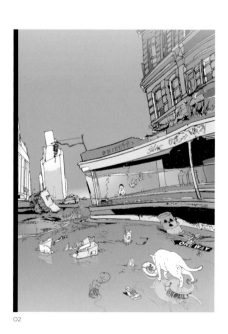

02

03

04

RAFA GARRES

b.1971

Comic artist, illustrator and painter Rafa Garres was born in Barcelona and studied at the city's Massana Arts and Design School and the university's Faculty of Fine Arts. His first role-playing game, 'Superhéroes Inc.', was released in 1994, and he has worked extensively for publishers Fleetway, DC Comics and Crusade, collaborating on series such as Judge Dredd, Jaguar God, The Spectre, Jonah Hex and The Justice League of America, with writers including Pat Mills, John Wagner and Alan Grant. His explosive, adrenaline-fuelled work has earned him a cult following among comic fans around the world.

www.garres.com

01 *Pandemonium*, print, personal project, acrylic, 1998
02 *Skullerfly*, print, personal project, gouache, 1998
03 *Skulltree*, print, personal project, gouache, 1998
04 *Mr Skars*, print, personal project, acrylic, 1997

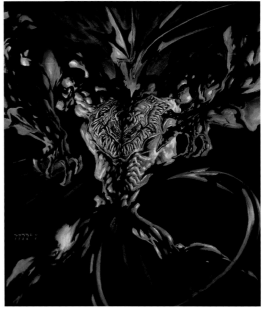

01

02

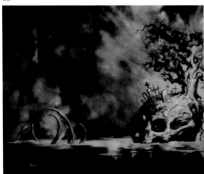

03

04

IAN WHADCOCK

b.1965

Manchester-based Ian Whadcock studied illustration at the University of Brighton and Philadelphia University of the Arts. He has lectured extensively on illustration and animation courses in the UK. His insightful work has appeared in numerous magazines and newspapers and is particularly popular with corporate clients, such as Powergen Plc (now E.ON), for whom he has produced illustrations for its customer branding, including direct mail, print ads and a series of seven television and cinema animations.
www.ianwhadcock.com

01 *Superconductors*, editorial illustration, *New Scientist* & Reed Business Limited, 1997

02 *Control and Assistance*, editorial illustration, *Traffic Technology International Magazine* & UKIP Media & Events, 1998

03 Spot illustrations across a three-page spread, editorial illustrations, BBC Publications *TopGear Magazine*, 1998

01

02

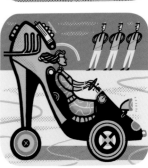

03

NANCY STAHL

b.1949

A former student of the Art Center College of Design in Pasadena, California, New York–based Nancy Stahl creates polished illustrations that have appeared in magazines and newspapers such as *Time*, *The New York Times* and *The Wall Street Journal*, in ad campaigns, on book covers and calendars and as an animated commercial for M&Ms. An early advocate of the computer program Painter, she has created 16 stamps for the United States Postal Service, including the 'American Animal' series and the hand-knitted Christmas 2007 stamps, some of which have been the most used in American post-office history.
www.nancystahl.com

01

02

01 *Weeping Geisha*, editorial illustration, *Der Spiegel* magazine, 1998
02 *Library Lion*, stamp, United States Postal Service, 1999
03 *Flying Hats*, *Travel + Leisure* magazine, 1994
04 *Dreyfus Lion*, Pentagram Design, 1995

03

04

MICHAEL GILLETTE

b.1970

Michael Gillette was born in the Welsh
town of Swansea and lived in London until
1997, when he moved to San Francisco. His
pop-culture-influenced work is effortlessly
cool, and Gillette is often asked to create
portraits of big names from the music
and film industry. In 2008, Penguin Books
commissioned him to design the entire
series of 15 covers for its reissue of Ian
Fleming's James Bond novels; the result
was an irresistible combination of seductive
Bond girls and quirky hand-drawn type.
www.michaelgillette.com

01 *Growing Up To Be Like Dad*, exhibition piece, The Groucho
Club, painting, 1997
02 *Big Apple*, editorial illustration, *Nylon*, mixed media & digital,
1999
03 *Duplicity + Compliance*, exhibition piece, The Groucho Club,
acrylic, created 1998, exhibited 2000

01

02

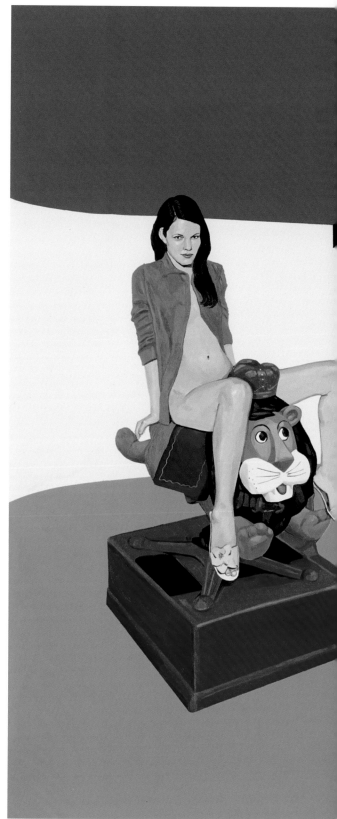

03

223

BRIAN CRONIN

b.1958

From Dublin, Brian Cronin studied at the city's National College of Art and Design. While there, he spent a summer as an intern in the studio of Milton Glaser in New York. On graduating, he returned to New York with his portfolio and has lived and worked there ever since. His haunting illustrations have earned him gold medals from the Society of Publication Designers, the Society of Illustrators and the Art Directors Club, as well as a solo exhibition at the Irish Museum of Modern Art in Dublin.

www.briancronin.com

01 *Unemployed Worker*, editorial illustration, *Newsweek*, acrylic on paper, c.1998
02 *Recipe for Depression*, editorial cover, *The Atlantic Monthly*, acrylic on paper, 1996
03 *2/3 Egg*, acrylic on paper, 1996
04 *Intuition*, book illustration from *David Carson: 2ndsight*, David Carson/Universe Publishing, acrylic on paper, 1997
05 *Foot in Mouth*, acrylic & India ink on paper, 1996

01

02

03

04

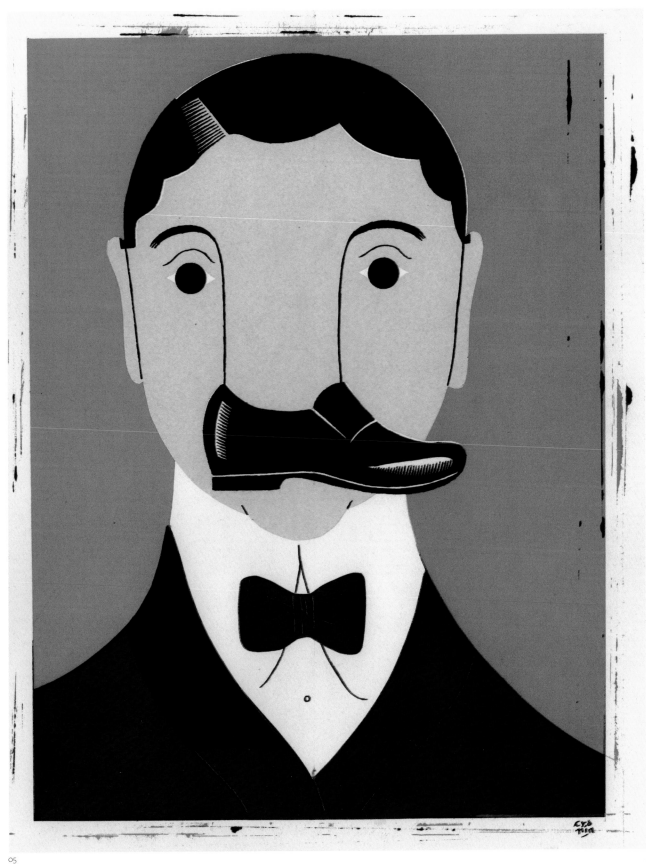

SARA FANELLI

b.1969

Born in Florence, Sara Fanelli studied in London at Camberwell College of Arts and then the Royal College of Art. Her idiosyncratic collage-led style has been commissioned by clients including the Tate, the BBC, Thomas Heatherwick and Faber and Faber, and she has won the prestigious V&A Illustration Award twice. In 2006, she was elected an Honorary Royal Designer for Industry, the first woman illustrator to receive this honour. She has published numerous children's books (including a version of Pinocchio), which have been translated into many languages – her mischievous work is loved by millions of children around the world. *www.sarafanelli.com*

01 *The Chair's Diary*, book spread from *Dear Diary*, Walker Books, collage, created 1999, published 2000

02 *The Fork's and Knife's Diary*, book spread from *Dear Diary*, Walker Books, collage, created 1999, published 2000

03 *The Spider's Diary*, book spread from *Dear Diary*, Walker Books, collage, created 1999, published 2000

04 *The Puppet Theatre*, book spread from *Pinocchio*, Walker Books, collage, created 1999–2002, published 2003

05 *Swindleton*, book spread from *Pinocchio*, Walker Books, collage, created 1999–2002, published 2003

01

02

03

04

05

SwinDleTon

CALEF BROWN

b.1959

Originally from Vermont, Calef Brown studied at the Art Center College of Design in Pasadena, California. His playful work has appeared everywhere from *Rolling Stone* to *Sports Illustrated*, on packaging, CDs and as murals. He has written and illustrated many well-loved children's poetry books (for example, *Polkabats and Octopus Slacks* and *Soup for Breakfast*), and has also illustrated classic stories by authors including F. Scott Fitzgerald and Edward Lear.

www.calefbrown.com

01 *Stomp!*, editorial illustration, *Los Angeles Magazine*, acrylic on board, 1996
02 *Portrait of Nirvana*, editorial illustration, *Rolling Stone*, acrylic on board, 1993
03 *The Buddha Head*, editorial illustration, Fraser Papers, acrylic on board, 1997

01

02

03

01

GERALD BUSTAMANTE

b.1957

San Diego State University graduate and keen surfer Gerald Bustamante has been creating his unique artworks from his studio in Cardiff-by-the-Sea, California, since 1985. Clients include Pepsi, Jose Cuervo Tequila, *Rolling Stone* and the Los Angeles County Museum of Art. His work has been used for a mural for San Diego's Urban Art Trail, and several of his posters can be found in the permanent collection of the United States Library of Congress. *www.studiobustamante.com*

02

03

04

05

PAUL SLATER

b.1953

Originally from Burnley, Lancashire, Paul Slater studied at Maidstone College of Art and the Royal College of Art in London. His larger-than-life painterly style has been commissioned by clients such as British Airways, Volkswagen and Shell, and has appeared in numerous publications including *The Week*, *The Daily Express Saturday Magazine* and *The Times: Saturday Magazine*, to which Slater contributed illustrations for its weekly restaurant review for 20 years. *The Independent* placed him at number one in its list of the top ten British illustrators. *www.paulslater.me*

01

02

03

01 *Treacled Ale*, advertisement, personal project, 1997
02 *Life on Pluto*, exhibition piece, The Coningsby Gallery, oil painting, 1997
03 *Illustration for Eating Out*, editorial illustration, *The Times: Saturday Magazine*, 1996
04 *Practical Nudity*, exhibition poster, personal project, acrylic, 1999
05 *Brighton Rock*, editorial illustration, *The Daily Express Saturday Magazine*, acrylic, 1999

04

05

STEFF PLAETZ

b.1971

One of the original members (along with
Will Barras and Mr Jago) of pioneering
1990s illustration group Scrawl Collective,
London-based Steff Plaetz produces a
unique blend of stencilling and painting
that has attracted commissions from a raft
of clients. His work has proved especially
popular with musicians including Ian
Brown, Michael Stipe and David Holmes.
A keen sci-fi fan, Plaetz has exhibited his
distinctive freehand work across the globe.
www.steffplaetz.com

01

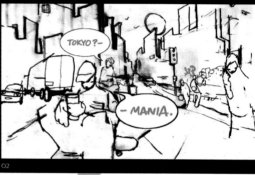

02

03

04

05

06

01 *Map Makers*, personal project, canvas, c.1999
02 *Tokyo Mania*, flyer, 1998
03 *Start Mural Mock-Up/Test*, mural, Start Ad Agency, 1999

04 *Sabafleur*, personal project, 1999
05 *Ian Brown Portrait*, The Face & Retaliate First Management, 1999
06 *S.K. Girl*, personal project, 1997

CHRISTOPH NIEMANN

b.1970

Now based in Berlin, Christoph Niemann arrived in New York from his native Germany in 1997. His archly observed pieces have appeared on numerous front covers of *The New Yorker* as well as in *The New York Times*, *Wired* and *The Atlantic Monthly* magazines. His razor-sharp weekly blog for *The New York Times Magazine*, 'Abstract Sunday', has proved hugely popular, and the collected entries have been published in book format. Other publications include several children's books and the cult board book *I LEGO N.Y.*
www.christophniemann.com

01

02

01 *Continuing Education Catalogue*, catalogue cover, Parsons The New School for Design, digital, 1998
02 *Young Visual Artists*, editorial cover, *Print Magazine*, digital, 1999
03 *The Good Portrait*, book insert, Maro Publishers, digital, 1997

03

EBOY

est.1997

Christened the 'Godfathers of Pixel', eBoy was founded in Berlin in 1997 by Kai Vermehr, Steffen Sauerteig and Svend Smital. At the beginning, eBoy's 3-D pixel art pieces, which are full of futuristic renderings of robots, cars and girls, were created just for the screen. Over the years, as they have moved into print, the images have become increasingly complex, with each illustration taking several weeks to complete, even with all three designers working full time. What started as a cult following has grown into a huge commercial success, with an international fan base and clients including Honda, Coca-Cola, Adidas and MTV.

www.eboy.com

01 *Star*, animated gif, MTV, 1999
02, 03, 04 *Robodriver*, animated gif, MTV, 1999
05, 06 *Taqueria*, online game, MTV, 1999

01

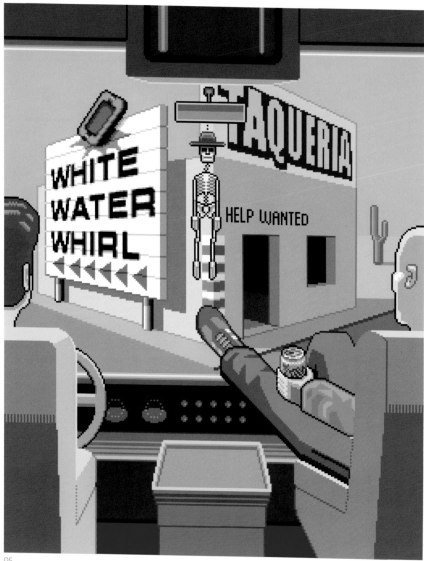

05

06

02

03

04

HENRIK DRESCHER

b.1955

Danish-born illustrator Henrik Drescher emigrated to the USA in 1967. A brief spell at the School of the Museum of Fine Arts in Boston was followed by a trip across the USA, during which he created a series of sketchbooks and produced small xeroxed books that he sent to friends and clients. He moved to New York and, in 1983, designed his first children's book; since then he has published over 40. Now residing in western China, Drescher creates limited-edition books and paintings, many of which are held in the collections of major museums.
www.hdrescher.com

01 *Memory's New Party Line*, editorial illustration, *Stanford Magazine*, mixed media, 1998
02 *Runaway Opposites*, book cover, Harcourt Children's Books, 1992
03, 04 *Notebook Spread*, notebook insert, personal project, mixed media, 1995

01

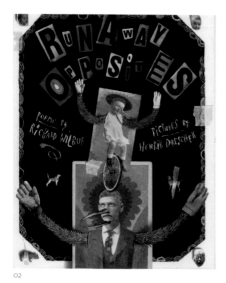

02

03

04

JOSH GOSFIELD

When Josh Gosfield moved to California
from his native New England he began
to contribute cartoons to local papers.
A subsequent move to New York saw his
career as an art director take off, with
an eight-year stint on *New York* magazine.
He left to do his own work, creating
illustrations, pop videos and installations,
and now has many awards and exhibitions
to his name. One of Gosfield's ongoing
and most-talked-about projects is 'Gigi:
The Black Flower', in which he created
an archive of the life of an imaginary 1960s
French pop singer turned modern-day
celebrity, Gigi Gaston.

joshgosfieldart.com

01 *Diana Vreeland*, editorial illustration, *The New Yorker*,
oil & acrylic on canvas, 1990s
02 *Always Humble*, personal project, oil & acrylic on canvas,
1990s

O2

O1

JEFF FISHER

b.1952

From Melbourne, Australia, Jeff Fisher studied fine art, film and animation at the city's Preston Institute of Technology. After a spell in London, he moved to France in 1993, settling south of Paris. His work has appeared in magazines and newspapers, but his decorative style lends itself perfectly to book covers, which have always formed a significant part of his output. His distinctive blue-and-white cover illustration for the first imprint of Louis de Bernières' *Captain Corelli's Mandolin* is instantly recognisable. *www.centralillustration.com/illustrators/ jeff-fisher*

01, 02, 03 *United Airlines*, advertisements, Fallon advertising agency, 1999
04 *Captain Corelli's Mandolin*, book cover, Minerva Books, 1994
05 *Soho Square III*, book cover, Bloomsbury Publishing, 1990
06 *New Writing from Ireland*, book cover, Bloomsbury Publishing, 1993

01

02

03

04

05

06

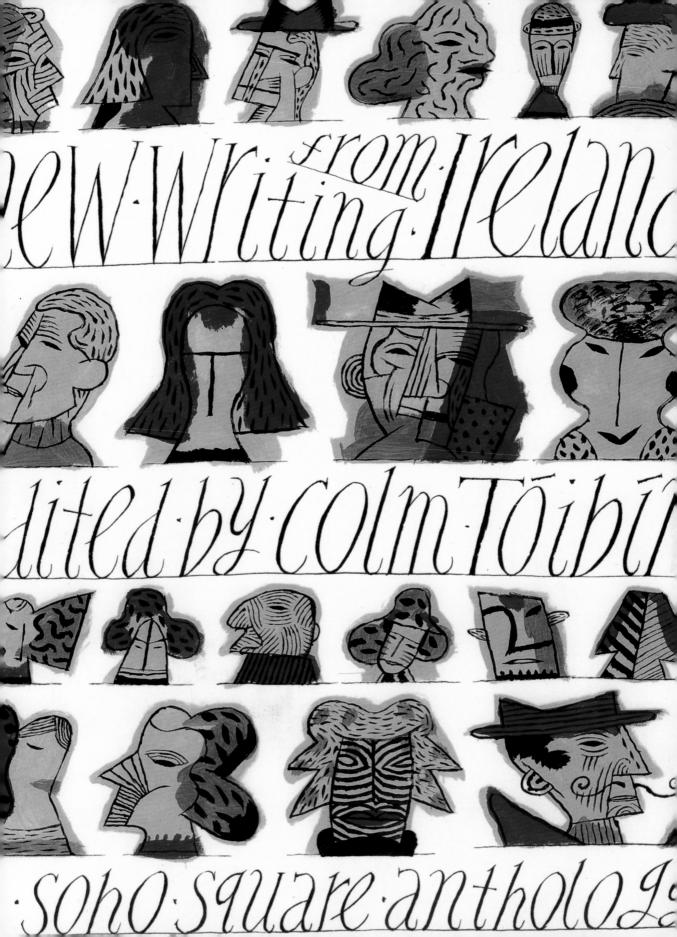

IZHAR COHEN
b.1963

While carrying out military service in his native Tel Aviv, Izhar Cohen took on the role of illustrator for his army magazine. This gave him a taste for illustration, and he went on to study at the Bezalel Academy of Arts and Design in Jerusalem, the École Nationale Supérieure des Arts Décoratifs in Paris and Central Saint Martins College of Art and Design in London before returning to live in Paris in 2005. As well as having a successful commercial career in illustration in Israel, the UK and France, Cohen also contributes to many well-known publications and has illustrated numerous books, including *ABC Discovery!*
www.izharcohen.com

01 *Nonsense*, calendar, Saison, 1997
02 *The Trouble with Snoring*, editorial illustration, *The Times: Style Magazine*, 1992
03 *Swedish Sauna*, editorial illustration, *The Times: Style Magazine*, 1992
04 *A Wave of Inspiration*, calendar, Saison, 1996
05 *The Meaning of Our Dreams*, *The Times: Style Magazine*, 1992

01

02

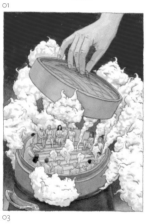

03

04

05

JORDIN ISIP

b.1967

Hailing from Queens in New York and
now living in Brooklyn, Jordin Isip studied
illustration at the Rhode Island School
of Design. His painterly illustrations have
been commissioned by a host of clients
including Atlantic Records, *The New York
Times* and *Rolling Stone*, and have appeared
on book covers, posters, T-shirts and CDs.
Isip's personal work has been exhibited
around the world, and he has curated over
a dozen group shows that have been hosted
from the Philippines to Philadelphia.
jordinisip.com

01 *Breadcrumb Trail*, editorial illustration, *Ray Gun* magazine,
1993
02 *Cause and Defect*, editorial illustration, *Time*, 1995
03 *The Inventors of Virtual Reality*, editorial illustration,
Mondo, created 1994, published 2000
04 *The Future of the Internet*, editorial illustration, *Yahoo!
Internet Life*, 1999

01

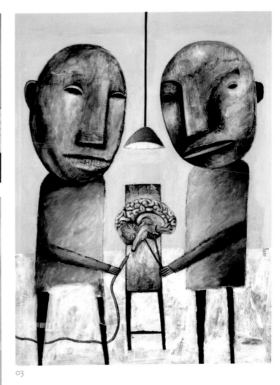

03

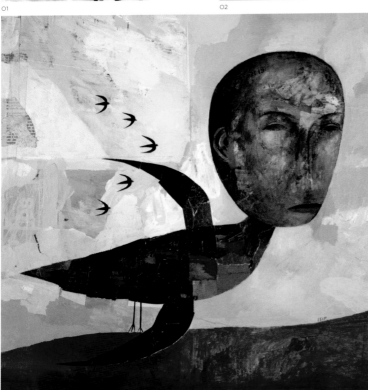

04

GRAHAM RAWLE

b.1955

Born in Birmingham and now based in
East London, Graham Rawle is probably
best known for his 'Lost Consonants'
column that appeared in *The Guardian:
Weekend* for 15 years. His witty collage-
based work has also appeared in regular
columns for *The Observer, The Daily
Telegraph* and *The Sunday Times*. Rawle has
written and illustrated a number of books,
one of which, a reworking of *The Wizard
of Oz*, was voted book of the year at the
2009 British Book Design and Production
Awards.
www.grahamrawle.com

01

02

Read the chapter on depth of focus before
setting off for Brumfit's wearing my newly
repaired shoes. Bit stiff at present but I'm
sure they'll soften up. I decided to take my
film in to be developed. There's only one
shot on it (Nature's Eiderdown) which is a
bit of a waste - I was planning to do a whole
series on the 'Winter Wonderland' theme but
yesterday's snow melted. At least it will be
ready for week 3 at the Camera Club.

When I put my coat on to go out I found the
doll in my pocket which I had forgotten about.
Put her on the coffee table.

Same strange quietness about the neighbourhood.
Nobody out in the streets. The only people
I saw were in the garden of the corner house.
A woman and a young boy were standing on the
lawn looking XXXXX all around them as though
searching for something. I crossed to the
other side of the road and tried not to look
at them.

Handed my film in at Brumfit's and bought a
barley sugar twist. When I was little we used
to peel the wrapper halfway down and then
suck one end into a point. It took ages but
you could get a really sharp point on it. One
day Timothy Abrahams was holding his sharpened
stick of barley sugar in his mouth when he
fell over in the playground and stabbed
himself in the throat. Someone said that the
point came out through the back of his neck
but I'm not sure if that's XX true. We all
stopped after that.

KNIFE

16 16

7. Chest up, always. Never let the model slump, or any pose will be ruined, however promising.

Statuesque.

Nature's Simplicity.

Door bell rang at 8.06. The post doesn't normally
come until 8.45 so I was wary of answering the
door. I checked from the bedroom and it was the
postman but not the usual one with the funny
teeth. I went XXXXX to the door anyway and he
handed me a package, but XX it was only my
Freeman's catalogue. There was also a letter.
The strange thing was, he wasn't carrying any
other letters. Perhaps his van was parked round
the corner. Or what if it was a policeman in
disguise? I've seen them do that in films. I'll
have to be careful.

Graham Rawle's LOST CONSONANTS

© Graham Rawle 1991

CUT OUT AND COLLECT THE SERIES

96 Every time the doorbell rang, the dog started baking

Graham Rawle's LOST CONSONANTS

© Graham Rawle 1990

CUT OUT AND COLLECT THE SERIES

70 One of man's earliest inventions was the heel

BERNHARD OBERDIECK

b.1949

Born in Westfalen, Germany, Bernhard Oberdieck studied lithography and then graphic arts at the School of Applied Arts in Bielefeld. He specialises in illustrating children's books, and his work, which often depicts classic fairy tales, has gained him international acclaim. An avid collector of children's books himself, Oberdieck creates beautifully detailed and multilayered illustrations that have a warm, almost timeless quality to them. *www.childrensillustrator.de*

All illustrations from *Eulengespenst und Mäusespuk*, Bayerischer Rundfunk, coloured pencil/pastel & ink, 1990

01 *Auf der Flucht (On the Run)*
02 *Eule im Wasser (Owl in the Water)*
03 *Gewitter Nacht (Thunderstorm Night)*
04 *Versteck auf dem Dachboden (Hiding in the Attic)*
05 *Zirkus in der Stadt (Circus in the City)*

01

02

04

03

05

01

RAFAL OLBINSKI
b.1945

Rafal Olbinski was born in Kielce, Poland, and originally trained as an architect at the Warsaw University of Technology. He emigrated to the USA in 1982, and three years later began teaching at the School of Visual Arts in New York. His striking surrealist-inspired work has appeared on the covers of hundreds of magazines, as murals and in solo exhibitions around the world. Widely known for designing opera posters, he has also completed over 100 album covers for Allegro Music's 'Opera D'Oro' series. In 2002, he created his first set design for Opera Philadelphia's performance of Mozart's *Don Giovanni*. *www.patinae.com/artists/rafal-olbinski*

01 *The Weight of the Rising Tide*, Nahan Galleries, acrylic on canvas, 1996
02 *Salome*, Opera Philadelphia, acrylic on canvas, 1996
03 *Misplaced Invitation*, National Arts Club, acrylic on canvas, 1997
04 *La Traviata*, New York City Opera, acrylic on canvas, 1992

02

03

04

JASON FORD
b.1965

A graduate of Brighton Polytechnic and the Royal College of Art in London, Jason Ford creates energetic illustrations that hark back to the clean lines and strong colours of the French *bande dessinée* art and mid-twentieth-century graphics that inspire him. His work has been commissioned by clients across the publishing, design and advertising industries, including American Airlines, Royal Mail, Random House, Orange, Penguin Books and *The Guardian*.
www.heartagency.com

01 *Fantasy Fitness*, editorial illustration, *The Sunday Telegraph*, acrylic & ink, 1997

02 *Empire State & Big Apple*, advertisement, DDB & American Airlines, 1998

03 *Statue of Liberty & Stars and Stripes*, advertisement, DDB & American Airlines, 1998

04 *Office Clutter*, editorial illustration, *Alodis* magazine, acrylic & ink, 1999

01

Empire State, Big Apple
American Airlines

Statue of Liberty, Stars & Stripes
American Airlines

JOOST SWARTE

b.1947

Born in Heemstede, the Netherlands, Joost Swarte studied industrial design in Eindhoven and went on to work as a comic artist, establishing his own magazine, *Modern Papier*, in 1971. A champion of comic-related art, in 1985 he founded Oog & Blik with Hansje Joustra in order to publish his own work and material from other artists. In 1992, Swarte set up Stripdagen, the international biennial comic event held in Haarlem. His work has appeared in *The New Yorker*, on stamps and as murals. He has also designed stained glass, furniture and a theatre in Haarlem.

www.joostswarte.com

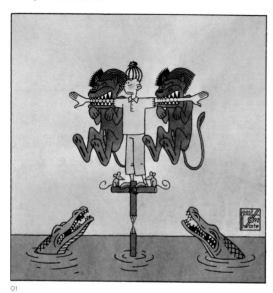

01

02

03

249

AMY GUIP

b.1965

After graduating from Syracuse University, Amy Guip moved to New York. It was there that she taught herself photography, which has played a major part in her collage-based work ever since. Her surprisingly dark and often symbolic digitally created photo-illustrations have appeared in books, magazines and on music packaging for such clients as HBO, KFC and MTV.

www.amyguip.com

01 *Gunface*, editorial illustration, *The Washington Post Magazine* (unpublished), photography, 1994
02 *Moby*, editorial illustration, *Rolling Stone*, photography & collage, 1995
03 *The Neighbours*, editorial illustration, *San Francisco Focus Magazine*, photography & collage on wood, 1994
04 *Sea and Cake*, editorial illustration, *Rolling Stone*, photography & mixed collage, 1995

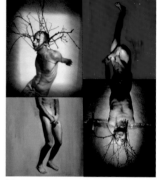
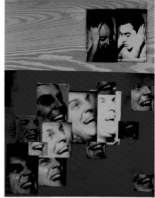

02

03

04

01

05 *Untitled*, editorial illustration, *Ray Gun* magazine,
 photo collage, 1994
06 *Untitled*, editorial illustration, *Us Magazine*, photo collage,
 c.1993
07 *Flamma Flamma – The Fire Requiem*, CD artwork,
 Sony Music, photo collage, 1994

05

06

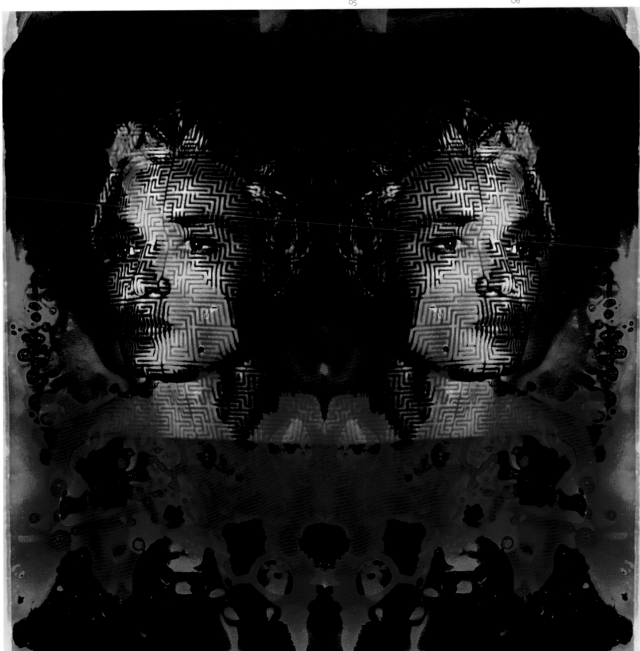

07

Chapter 5:
2000S
A New Wave

The year 2000 was the first year of a new decade, the first year of the twenty-first century and the first year of the third millennium. Commentators and the public struggled to agree on the correct terminology for the decade: was it to be referred to as the 'two-thousands' or the 'twenty-ohs'? Should it be read as the 'oh-ohs' or the 'zeros'? The BBC, on 1 January 2000, listed the 'noughties' as the potential moniker for the new era. Whatever the outcome, all agreed this was a significant moment, worthy of global celebration and lavish events.

The allure of the digital during the late 1990s was to crash in spectacular fashion at the turn of the new century as market confidence in Internet start-up companies nosedived. A speculative dot-com bubble, likened to the California Gold Rush of 1848, had blown up rapidly during 1998 and on 10 March 2000 peaked dramatically before a fall of epic proportions. Dot-com turned dot-bomb, and between 2000 and 2002 more than £3.2 trillion was wiped off the market value of technology companies.

While damaged, the appeal of the digital was not extinguished entirely, as groundbreaking Web developments throughout the decade kept pace with a public's exhaustive appetite for new ways of using online environments for communication, information and entertainment. Between 2001 and 2007, an accelerated rate of change took place online, emerging with the launch of Apple's iTunes on 9 January 2001, and followed by the first generation iPod on 10 November of the same year. Myspace, the first of the big social networking services, launched in August 2003 and between 2005 and early 2008 was the most visited social media site, surpassing Google in June 2006 as the most visited website. Facebook's launch in February 2004 soon stole Myspace's thunder and by September 2012 had one billion active users. With the launch of YouTube in February 2005 and Twitter in July 2006, the roll-out of the iPhone in June 2007 and an increase in the number of computers connected to the Internet rising from 200 million in 2001 to 395 million by 2006, the digital age had arrived.

As significant as the fast-paced digital developments were to people's lives, the biggest changes to affect people on a global scale followed the events of 11 September 2001. Four coordinated al-Qaeda attacks in New York City and Washington, D.C. resulted in the deaths of 2,996 people. The threat of international terrorism had become a reality on a scale unimaginable before 9/11. The resulting War on Terror, led by the USA and UK with support from Spain, Canada and a coalition of other nations, culminated in the invasion of Afghanistan in 2001 and the Iraq War in 2003.

Natural disasters, some of the worst and most destructive in history, altered lives immeasurably during the noughties – on 26 January 2001 an earthquake hit Gujarat in India killing around 20,000 people, with another killing over 43,000 in Bam, south-eastern Iran, on 26 December 2003. Exactly a year later, the strongest earthquake in 40 years hit the entire Indian Ocean region. The massive 9.0 magnitude earthquake generated enormous tsunami waves crashing into coastal areas across Thailand, India, Sri Lanka, The Maldives, Malaysia, Myanmar, Somalia and Indonesia, resulting in an estimated death toll of 228,000 people.

01

01 Jon Burgerman, *Rainbow Chicken*, editorial cover, *Blowback* magazine, digitally coloured ink drawing, 2007

In 2005, Hurricane Katrina nearly destroyed New Orleans in August, killing approximately 1,836 people, and at least 80,000 people lost their lives in the Kashmir earthquake on 8 October. Over 69,000 were killed on 12 May 2008 in the Sichuan earthquake in China, the same month that Cyclone Nargis killed more than 146,000 in Myanmar. Having started the new millennium with such optimism, the decade was reeling from the death and destruction of war, international terrorism and natural disasters. If the noughties were to be remembered for positive actions and events, these could only now occur during the latter years of the decade.

Barack Hussein Obama began to receive national attention during his campaign to represent the state of Illinois in the United States Senate in 2004. His presidential campaign started in 2007, and in 2008 he defeated Hilary Clinton to receive the Democratic presidential nomination before going on to defeat John McCain in the election. Inaugurated in January 2009, Obama became the first African-American President of the USA. He came to power emphasising the importance of rapidly ending the Iraq War, increasing USA energy independence and providing universal healthcare, following a campaign projecting themes of 'hope' and 'change'.

Supporting Obama's campaign for presidency was a series of posters created by Shepard Fairey (see p.274), graphic designer and illustrator and a graduate from the Rhode Island School of Design, who emerged from the skateboarding and street-art scenes. First known for his 'Andre the Giant Has a Posse' OBEY sticker and street-art campaign, Fairey came to prominence for his iconic 'HOPE' portrait of Obama. The poster originally featured the word 'PROGRESS', but campaign officials requested that he issue a new version, keeping the powerful image of Obama, but captioning it with 'HOPE'. The campaign went into overdrive with Fairey distributing 300,000 stickers and 500,000 posters, and, in December 2008, Obama wrote to Fairey thanking him for his contribution to the campaign, stating 'your images have a profound effect on people, whether seen in a gallery or on a stop sign. I am privileged to be part of your artwork and proud to have your support.' Fairey's work had struck a chord with the American public, recognised by Peter Schjeldahl, art critic at *The New Yorker*, who referred to the poster as 'the most efficacious American political illustration since "Uncle Sam Wants You".' Illustration had played a critical role in bringing about change on a national and international scale.

Back on illustration's more familiar, and arguably more down to earth, turf, the digital discipline and the traditional hand-crafted artwork began to merge – a new computer-literate generation of illustrators successfully drew together the analogue past and the digital present, creating images with pencils and brushes, inks and paints, printers and scanners, cameras and laptops. Techniques in contemporary illustration were enormously diverse, as was the range of canvases illustrators choose to work on. As the discipline broke free of the constraints of print and started to embrace the possibilities of the screen, it grew in confidence and stature, and became more visible in advertising, design, editorial, fashion, graphics, music, television and, of course, the Web.

02

02 Gary Taxali, *Disinclination*, editorial illustration, *The Atlantic*, mixed media, 2009
03 Jasper Goodall, *Pirate Fashion*, editorial illustration, *The Face*, 2002

03

04

05

UK-based Jasper Goodall (see previous page and p.258), described by *ICON* magazine in May 2005 as 'one of the most prolific illustrators of the past decade', helped to define the look of the era through his work for Levi's, *Dazed & Confused*, Nike, Adidas, BMW and *The Face*. Goodall's style, often imitated and emulated, was the product of an originator. Fusing his influences – Aubrey Beardsley and the op-art of 1960s poster art – he incorporated fashion, sex and subcultural references to create images for club flyers, album covers and magazines that served as a visual shorthand for 'urban cool'.

In Toronto, Canada, Gary Taxali (see p. 254 and p.266) led a crusade to ensure that illustration remained an expression of creativity. He worked across two studio spaces, some days dedicated to the pursuit of his own projects, devoid of a fee-paying client, and other days focusing solely on commercial work. Taxali's unique and individual collage-led aesthetic, influenced by pop culture's vintage ads and comic strips, was in huge demand, but he remained true to his principles, explaining his four rules: 'Rule 01: I create personal work every week; Rule 02: I don't do Art Directors' ideas; Rule 03: Style shouldn't drive the pictures, the pictures should drive the style; and Rule 04: Illustration is not art, but all illustrators are artists.'

Paul Davis (see left and p.310), London-based but with an international client base that includes IBM, Mercedes-Benz, the Colette store in Paris and *Vogue*, saw his career take off following a commission for an eight-page fashion feature in *The Independent on Sunday* in the late 1990s, which used a mix of acerbic wit and juxtaposed words and images. His unique blend of black humour, distinctive drawing technique and handwritten slogans and captions revealed and recorded his observations and views on the foibles and absurdities of human nature. Like Taxali, Davis exhibited his work and also created publications, exploring themes and ideas that were not linked to commercial projects but that ultimately fed into commissions conceptually and stylistically.

The renaissance in illustration in the early 2000s was not centred in any one location – Shepard Fairey was based in Los Angeles, Jasper Goodall in Brighton, Gary Taxali in Toronto and Paul Davis in London. Other key protagonists were to be found elsewhere around the world. Jeremyville's quirky characters heralded from Sydney (see opposite below and p.302), Sasha Barr's skateboard graphics from Seattle (see p.260), Airside's cult coolness from London (see left and p.262) and Alex Trochut's hand-rendered typography from Barcelona (see p.264). Illustration had become an international discipline.

A glut of new publications, magazines and books charted the rise of the subject, while online blogs and websites attracted the attention of students, graduates, professional and amateur practitioners, and a greater number of applications to art and design schools demonstrated an increased awareness of the subject. Jon Burgerman's internationally exhibited manic doodles (see p.253 and p.268), Anthony Burrill's typographic proclamations for posters and prints (see p.270), Marion Deuchars's unmistakable handwriting for Cass Art and Penguin Books (see opposite top and p.276) and Tom Gauld's precise cartoons for *The Guardian* (see p.304) became the mainstay of contemporary illustration, with

06

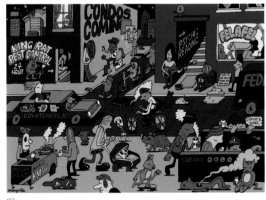

07

their creators seen as cool and visionary, courted by brands eager to capitalise on an urban edginess.

Following the launch of Apple's iPhone in 2007 and Samsung's Galaxy in 2009, smartphone ownership increased dramatically and the ability to connect to the Web anytime and anywhere heightened the demand for online services. Websites, apps and games offered new opportunities for illustrators. As the discipline continued to diversify, products and brands also sought to stamp their individualism on a crowded marketplace and turned to illustration for differentiation.

After a great number of advances during the noughties, illustration once again embraced change as a new decade began, with many practitioners actively seeking new challenges, opportunities and markets for their creativity. Illustration began to merge with motion graphics and the moving image, and illustrators became animators, game designers and interactive artists.

The future of illustration in the second decade of the twenty-first century lies with those proactive illustrators ambitious to seek greater possibilities and use a wider range of tools to advance the visual image. The first drawing made with a stick in the sand by prehistoric man was humankind's first illustration. Tomorrow's illustrators will further the discipline with the same unique desire to communicate and to express an opinion.

06 Marion Deuchars, *Let's Fill this Book with Art*, book, Cass Art, graphite, 2009
07 Jeremyville, *Rivington Street NYC*, Jeremyville, pen drawing with digital colouring, 2011

JASPER GOODALL

b.1973

Birmingham-born and Brighton-educated Jasper Goodall employs a slick illustrative style that has been hugely influential. His provocative work was at the forefront of the resurgence of interest in illustration in the late 1990s; his impossibly glamorous, long-legged women appearing in bikinis for his luxury swimwear line JG4B, in ad campaigns, on music covers and in numerous magazines. His first solo show 'Poster Girls' mixed photography and illustration to great effect, and he continues to push boundaries and explore new technology.

www.jaspergoodall.com

01 *Wasted*, editorial illustration, *The Face*, digital, 2001
02 *Dior swimwear*, editorial illustration, *Rank*, digital, 2000
03 *Anarchy*, editorial illustration, *The Face*, digital, 2001
04 *Invincible*, DVD cover, Muse (Helium 3, Warner Bros.), digital, 2006
05 *Knights of Cydonia*, CD cover, Muse (Helium 3, Warner Bros.), digital, 2006
06 *Invincible*, CD cover, Muse, (Helium 3, Warner Bros.), digital, 2006

01

02

03

04

05

06

SASHA BARR

b.1982

Around 2001, Sasha Barr started making gig posters for his friends who were in a band where he lived in Tennessee. Now resident in Seattle and in addition to his numerous freelance commissions, Barr is part of the art department at Sub Pop Records. A keen skateboarder, he is also art director at Amigos Skateboards.
www.thisisthenewyear.com

01

02

03

04

AIRSIDE

1998–2012

Founded by Fred Deakin, Alex Maclean and Nat Hunter, Airside typified the new breed of agency that emerged after the dot.com crash of the late 1990s. Its distinctive artwork for Deakin's hugely successful music project Lemon Jelly meant that Airside's illustration was exposed to a massive audience. Developing something of a cult following, Airside was one of the first design companies to sell prints, T-shirts and toys direct to its fans from its website. The agency's output included everything from branding to animation; but whatever the media, Airside's deceptively simple illustrative style was always at the forefront.
www.airside.co.uk

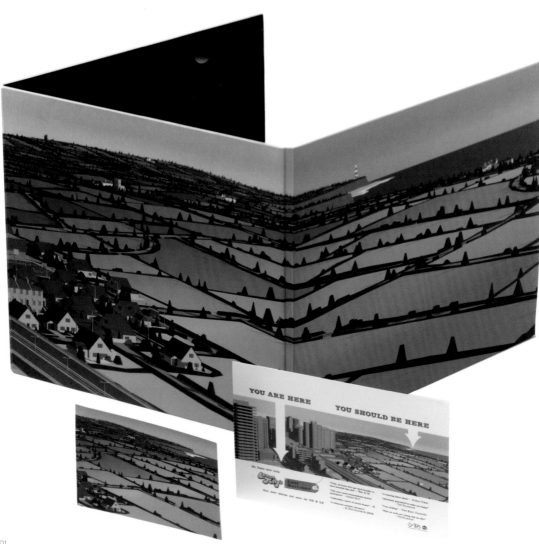

01

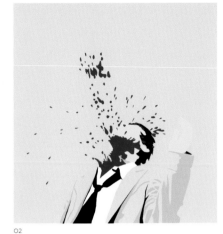

02

03

04

05

ALEX TROCHUT

b.1981

Alex Trochut's maximalist aesthetic
certainly proves his philosophy of 'More
is More'. A graduate of Barcelona School
of Design and Engineering (ELISAVA),
Trochut is the grandson of Joan Trochut,
a printer and typographer who developed
a typographic system called Super-Veloz
in 1942, which Trochut digitised in 1995.
Trochut's exuberant pieces combine his
love of illustration with his love of type,
in particular display typefaces from the
1970s. Some pieces are customised from
original typefaces and some are drawn
from scratch; what they all share is an energy
and spontaneity that is hard to resist.
www.alextrochut.com

01

02

03

01 *The Beer of Barcelona*,
print campaign,
Estrella Damm, 2009
02 *The White Rabbit*,
MTV + 55DSL, 2010
03 *The Logos Issue*,
cover illustration,
Creative Review, 2011
04 *The Decemberists*,
poster, Red Light
Management, 2009
05 *Dream on Dreamer*,
personal project, 2010
06 *Fila*, print campaign,
FILA (Japan), 2010

THE DECEMBERISTS
WITH BLIND PILOT

AUGUST 10, 2009 • W.L. LYONS BROWN THEATRE • LOUISVILLE, KY

GARY TAXALI

Born in India, but based in Toronto, Canada, Gary Taxali has a slick collage-led style influenced by pop culture, in particular old-style comics and vintage ads. As well as creating a large body of commercial work for editorial and advertising clients, in 2005 he produced his first toy – The Vinyl Monkey – going on to set up Chump Toys to release more vinyl figures. He has published the children's book *This is Silly!* and, in 2012, the Royal Canadian Mint issued a set of six Gary Taxali 25¢ coins featuring his own unique designs, his initials and his very own typeface, Chumply.
www.garytaxali.com

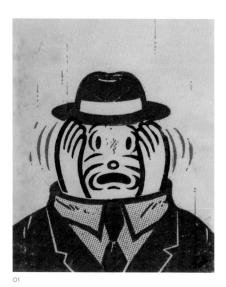

01

02

03

04

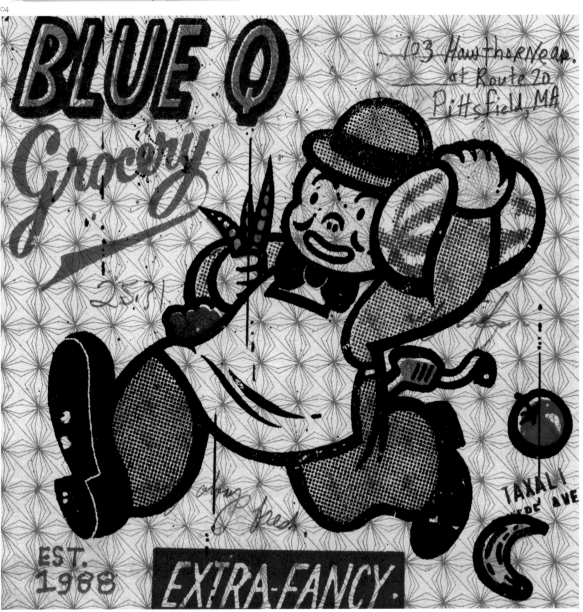

05

JON BURGERMAN
b.1979

Born in the UK but now based in New York, Jon Burgerman is often referred to as the King of Doodles. His super-charged drawing style has appeared on everything from iPad covers to jigsaw puzzles, and he has designed a range of toys for Kidrobot. His colouring book and colour-it-yourself wallpaper have proved very popular with adults and big kids alike. A prolific drawer, Burgerman also works for an impressive list of commercial clients and has held numerous solo shows around the world.
www.jonburgerman.com

01 *Brooklyn Hipster 'Grrf'*, felt soft sculpture, in collaboration with Felt Mistress, 2009
02 *Brooklyn Hipster 'K8ty'*, felt soft sculpture, in collaboration with Felt Mistress, 2009
03 *Economies of Scale*, large-scale painting, Deshan Art Space (Beijing), acrylic & emulsion paint on canvas boards, 2009
04 Christmas card & digital print, Nineteenseventythree, print, 2007
05 *Anxieteam UK Tour*, poster, Anxieteam.com, screen print, 2010
06 *Breathe Easy*, wrapping paper, American Cancer Society, digital print, 2010
07 *Totem*, poster, Cirque du Soleil, digital print, 2011

01

02

03

04

05

06

07

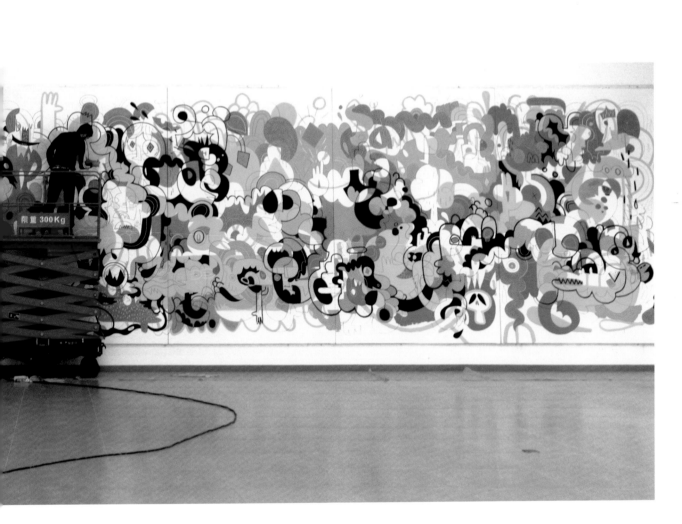

ANTHONY BURRILL

b.1966

Anthony Burrill's commercial output has always been in demand – he has worked for a raft of clients including London Underground, *The Economist*, the British Library and the Design Museum, creating advertising campaigns, posters, films and installations. His personal work has also been hugely influential, showing in galleries around the world. His series of wood-block screen prints, proclaiming 'Work Hard and Be Nice to People' and 'I Like It, What is It?' pre-dates the ubiquitous 'Keep Calm and Carry On' mantra by several years.
www.anthonyburrill.com

01

02

03

04

Last year
349 injuries,
3 fatalities.

PLEASE DON'T TRY TO BEAT THE DOORS

05

06

07

271

LAURENT FÉTIS

b.1970

After studying at the college of architecture
in Versailles and then the École Nationale
Supérieure des Arts Décoratifs, Laurent
Fétis set up his design studio in Paris
while still at college. Working mainly for
uber-cool clients in the fields of art, fashion
and music, Fétis is heavily influenced by
the psychedelic movement and scientific
imagery. His slick pop-art-inspired
illustrations for M83, Beck, Tahiti 80, DJ
Hell, DJ Mehdi, Ronan and Erwan Bouroullec,
the Centre Georges Pompidou and Paris
Social Club have made him one of France's
most talked-about designers.
www.laurentfetis.com

01 Editorial illustration, *Social Club Magazine*, ink on paper,
2009
02 *Beck Sea Change Tour*, poster, Beck Hansen, digital, 2002
03 *Wire*, editorial cover, *Social Club Magazine*, ink on paper,
2008

01 02 03

SHEPARD FAIREY

b.1970

It was Shepard Fairey's 'OBEY' sticker campaign that first brought the street artist to public attention, but it was his poster for Barack Obama's run for president that made him a household name. The unofficial poster originally featured the word 'PROGRESS' [right]; the Obama camp requested that the word 'HOPE' (see p.14) be used instead, after which it embraced the poster. One of a series of four, it became an integral part of the campaign with Fairey printing and distributing 300,000 stickers and 500,000 posters.
www.obeygiant.com

01 *Obama Progress,* personal project, screen print, 2008

02 *Afrocentric,* personal project, screen print, 2010

03 *Eye Alert,* personal project, screen print, 2001

04 *OBEY Propaganda Engineering,* personal project, screen print, 2001

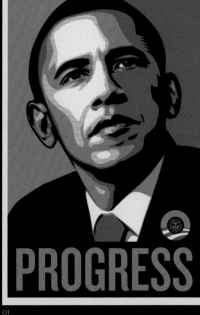

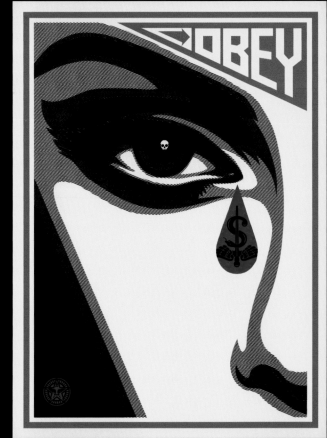

01

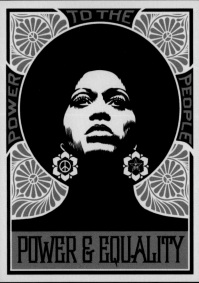

02

03

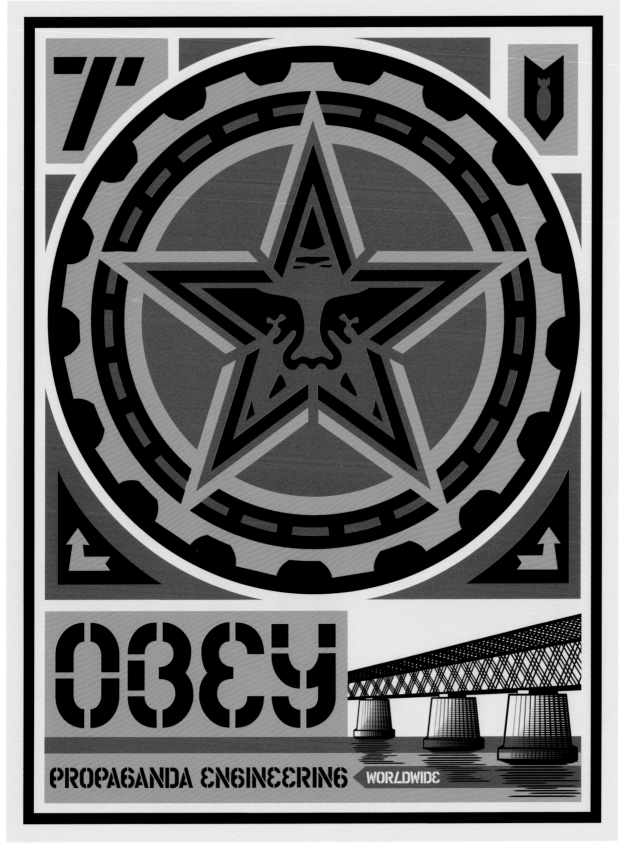

MARION DEUCHARS

b.1964

Marion Deuchars's unmistakable handwriting can be seen everywhere from book covers, magazines and newspapers to annual reports and packaging. Her award-winning work has been commissioned by such clients as *The Guardian*, Jamie Oliver and Formula One, and she has worked extensively for art supplier Cass Art on its 'Cass Art Kids' range. This led to her writing and illustrating the very popular *Let's Make Some Great Art* books, which encourage artists of all ages to pick up a pencil or paintbrush and start drawing or painting.
mariondeuchars.com

01 *D&AD What's the Point?*, annual report, D&AD, graphite, 2002
02 *Let's Fill this Book with Art*, book, Cass Art, graphite, 2009
03 *François Emmanuel*, book cover, Losada, graphite, 2004
04 *Jean-François Lyotard*, book cover, Losada, graphite, 2004
05 *George Santayana*, book cover, Losada, graphite, 2004
06 *George Orwell*, book covers, Penguin Books, photography/paint/graphite, 2001

01

02

03

04

05

George Orwell
Orwell and the Dispossessed

George Orwell Orwell's England

George Orwell Orwell in Spain

George Orwell Orwell and Politics

HERR MÜLLER

b.1977

Living and working as a graphic designer
and illustrator in Berlin, Herr Müller shares
a studio and often collaborates with video
and animation artist Martin Sulzer. His
powerful work uses collage, sometimes
taking the pieces into three dimensions.
As well as ad campaigns, his editorial work
has appeared in numerous publications,
some of which are limited-edition handmade
fanzines that he publishes himself.
www.183off.com

01 *Tapetrash*, website wallpaper, ARTE Creative, tape & plastic
sheets, 2011
02 *His Whereabouts Never Were An Issue, Only the Souvenirs!*,
billboard poster, www.just-pasted.com, tape/sellotape/
paper/plastic sheets/burned tape/paper, 2010
03 *Pfui Teufel!*, editorial illustration, *Max Joseph* magazine,
tape/sellotape/paper/plastic sheets, 2010
04 *99%*, limited print, personal project, sellotape & plastic sheets,
2011

01

02

03

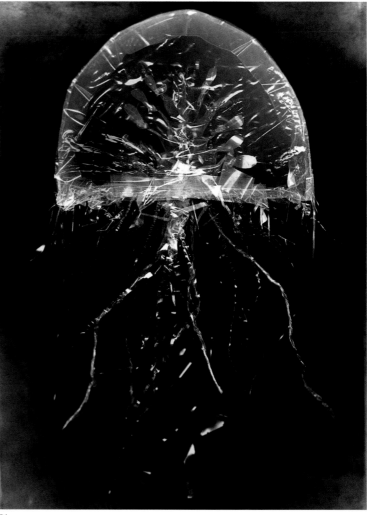

04

TINA BERNING

b.1969

Tina Berning's fluid, painterly style is much in demand from clients including *Vogue*, *Playboy* and *The New York Times*. After studying in Nuremberg, she worked as a graphic designer in the music industry before moving to Berlin to concentrate on illustration. Fascinated by the human figure and particularly the female form, she examined 'womanhood, beauty, and female hubris' in her book *100 Girls on Cheap Paper*, which kick-started a series of exhibitions based around the subject.

www.tinaberning.de

01 *Together*, key visual, Capsule fashion fair, ink on paper, 2009
02 *Steve Jobs*, editorial illustration, *Milk*, ink on paper, 2010
03 *Demut*, editorial illustration, *Relevance* magazine, ink on paper, 2009

01

02

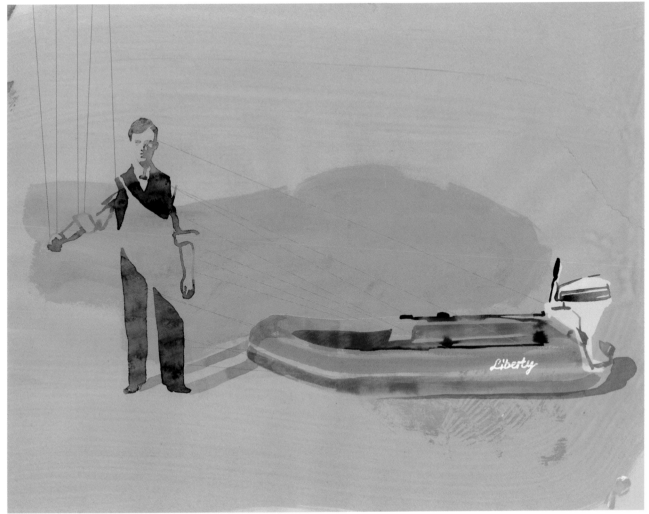

03

FRIENDSWITHYOU

est.2002

Founded by Samuel Borkson and
Arturo Sandoval III in Miami, Florida,
FriendsWithYou started out making ranges
of plush and wooden character-based
toys. Large-scale interactive installations
involving these creatures followed at such
events as Art Basel Miami Beach, the
inauguration of New York City's Highline
Park and a permanent playground for
Turnberry for the Arts. FriendsWithYou's
installations are larger-than-life, playful
affairs that blur imagination and reality
and are accessible to all.
www.friendswithyou.com

01

02

03

01 *Magical Explosions*, stage & instruments
wrap, Pharrell Williams & N.E.R.D.,
digital illustration, 2010
02 *Plasma Eyes*, illustration, Kidrobot,
limited-edition screen print, 2009
03 *Friendship Flag*, illustration, Kidrobot,
limited-edition screen print, 2009
04 *Magical Explosions*, car wrap, Pharrell
Williams & N.E.R.D., digital illustration, 2010
05 *Field of Dreams*, building wrap,
Fubon Art Foundation Commission
for Taipei, digital illustration, 2010

04

05

PATRICK THOMAS

b.1965

A graduate of the Royal College of Art, London, Liverpool-born Patrick Thomas moved to Barcelona in 1991, setting up Studio laVista in 1997. His first book *Black & White* (2005), mixed bold images with strong messages and featured his iconic Che Guevara rendered from hundreds of corporate logos. Now splitting his time between Barcelona and Berlin and no longer accepting commissions, Thomas exhibits his bold silk-screen prints in galleries around the world. His controversial second book *Protest Stencil Toolkit* was published in 2011, and encouraged readers to create their own unique protest graphics.
www.patrickthomas.com

01 *Immigration*, editorial illustration, *Público*, digital, 2009
02 *Black & White*, book cover, Studio laVista, offset print, 2005
03 *Save the Amazon*, poster, Tercera Bienal International del Cartel, silk screen, 2009
04 *The Atomic Bazaar: The Rise of the Nuclear Poor*, editorial cover, *The New York Times*, digital, 2007

01

02

03

04

NAJA CONRAD-HANSEN

b.1970

After a childhood spent living in Finland, Greece, Egypt and Germany, multilingual illustrator Naja Conrad-Hansen eventually settled in her native Copenhagen. A graduate of the Danish School of Design, she produces dark and mysterious fashion-led illustrations that have an almost gothic feel. Creating images for clients including Max Mara and Fiorucci, she has also illustrated an award-winning children's book and produces print and textile designs for clothing labels, one of which is her own brand, Meannorth. *www.meannorth.com*

01

02

01 *Shy*, personal project, oil on linen, 2008
02 *Camouflage*, personal project & various client uses, ink on paper, 2007
03 *P2*, editorial illustration, *Copenhagen Exclusive* magazine, ink & spray-paint on paper, 2007

03

MARTIN HAAKE

b.1970

Born in Oldenburg, Germany, and after a spell in London, Martin Haake now lives and works in Berlin. His quirky, faux-naive illustrative style is influenced by American folk art, and he uses a combination of collage, drawing and hand-drawn type to create his intriguing multilayered pieces, many of which include charming annotated maps. His distinctive work has been commissioned by, among others, Penguin Books, *The Boston Globe*, *Elle*, The Royal Society of Arts, Thomas Cook and Barnes & Noble. *www.martinhaake.de*

01 *Motocross*, editorial illustration, *Playboy*, mixed media, 2002

02 *Bill Gates*, editorial illustration, *Playboy*, mixed media, 2002

03 *Forbidden Manhattan*, editorial illustration, *GQ*, mixed media, 2002

04 *Hacker in Las Vegas*, editorial illustration, *Playboy*, acrylic on board, 2002

01

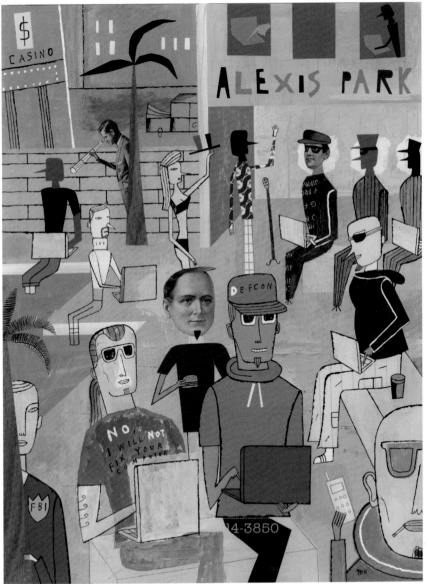

DANIEL CHANG
b.1970

An illustrator, art director and graphic designer, Daniel Chang works in Los Angeles. Having studied illustration and graphic design, he reflects his cross-disciplinary interests in his work through the conversation between analogue and digital media. As well as freelancing, he has also worked full time in the surf industry as art director and graphic designer for Billabong USA. His work has been featured in design and art magazines and annuals, such as *Communication Arts* and *American Illustration*. His client list includes *The New York Times*, IBM, *Time*, Random House, Element Skateboards and Becker Surf.
www.danielchang.net

01 *Dark Universe*, editorial illustration, *New Scientist*, acrylic, 2009
02 *Untitled*, editorial illustration, *Harvard Business Review*, acrylic, 2010
03 *Fur Love and Money*, editorial illustration, *Audubon Magazine*, acrylic, 2010
04 *How We Are Hungry* by Dave Eggers, book illustration, Vintage Books, acrylic, 2005

01

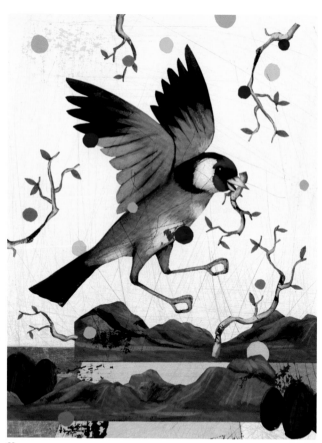

02

03

04

LAURENT CILLUFFO

b.1968

Born in Lille, Laurent Cilluffo studied architecture and fine art before going on to work in New York for five years from 1996. He started working for *The New Yorker* (which is still a major client) in 1993, and his deceptively simple work has appeared in numerous newspapers and magazines across the USA, Asia and Europe. Now living and working in Arras, France, Cilluffo has also illustrated children's books, graphic novels, and animated two short films. *www.laurentcilluffo.com*

01 *Charlie or Charlot?*, comic strip, Bayard Jeunesse/Mk2, pencil on paper to digital, 2007
02 *Countryside*, leaflet, Conseil Général de l'Oise, 2007

RAYMOND BIESINGER

b.1979

Born in Edmonton, Canada, and now resident in Montreal, Raymond Biesinger is a self-taught illustrator and part-time band member. His intelligent work is informed by his keen interest in politics (he has a BA in European and North American political history), and he illustrates social economist Tim Harford's weekly column in *The Financial Times Weekend Magazine*. He also illustrated comedian Patton Oswalt's column in music mag *SPIN* until 2012, when the print edition of the magazine was axed. At the time of writing, the extremely prolific illustrator had completed over 1,200 projects in four continents.
www.fifteen.ca

01 *Language Cow*, editorial illustration, *Maisonneuve*, collage & digital, 2004
02 *Qualities of Trade*, editorial illustration, *The Financial Times Weekend Magazine*, collage & digital, 2008
03 *Yann Martel Says...*, editorial illustration, *Maisonneuve*, collage & digital, 2003

01

02

EDA AKALTUN

b.1985

Originally from Istanbul, Eda Akaltun
is now based in East London. Her
sophisticated collage and printmaking-
based illustrations have appeared in
many magazines and on numerous book
covers, commissioned by the likes of *The
Washington Post*, *New Scientist*, *Harvard
Business Review* and Faber and Faber.
She has worked with institutions such
as the Victoria and Albert Museum and
BAFTA, is one third of Butter Collective
and was one of the original contributors
to independent publishing house Nobrow.
www.edosatwork.com

01

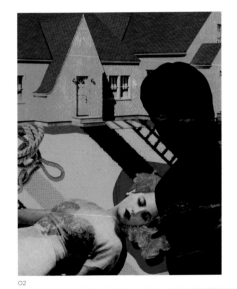

02

03

04

IAN BILBEY

b.1978

After graduating from the Royal College of
Art in London, Ian Bilbey worked with John
McConnell at design agency Pentagram
before embarking on a career as a freelance
illustrator. His graphic style has been
commissioned by a host of clients, the most
long-standing of which is retailer Paul
Smith. Bilbey has created window displays,
numerous posters, products and clothing
designs for the brand, as well as the iconic
stripy Paul Smith Minis. Under the nom
de plume William Bee, he has also written
and illustrated a number of very popular
children's books.

www.ianbilbey.com

01 *Daisy Girl*, poster, Paul Smith Ltd Women (Japan), 2002
02 *Belt Man*, poster, Paul Smith Ltd (Japan), 2001
03 *Travel Theme*, poster, Paul Smith Collection, Paul Smith Ltd,
 (Japan), 2004
04 *Miss Palm Beach*, poster, Paul Smith Ltd Women (Japan),
 2003
05 *Untitled*, show card, Paul Smith Ltd (Japan), 2005
06 *Wallpaper* Magazine Travel Theme*, editorial illustration,
 *Wallpaper**, 2002

02

paul smith collection

03

01

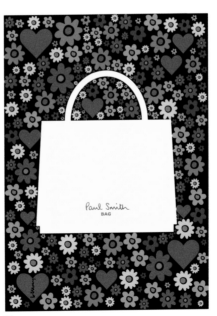

04

05

06

PAULA CASTRO

b.1978

Argentinian-born Paula Castro now lives in Paris, where she creates black-and-white drawings that have an almost otherworldly feel to them. Her intricate mark making and delicate patterns have appealed to high-profile clients including Issey Miyake, Furla, KesselsKramer, *Velvet, Vogue Russia, Rolling Stone*, Saatchi & Saatchi and Gas Jeans. Castro's work has been exhibited in Spain, France, Italy and Germany.

www.senyoritapaula.com/
www.paula-castro.com

01 *Unfaced Crowd*, magazine insert & poster, *Jalouse* magazine (France), ink on paper & digital, 2008/2010
02 *Pesci*, magazine insert, *Velvet* magazine/*La Repubblica* newspaper, ink on paper, 2009
03 *Conejos*, wallpaper, personal project, ink on paper & digital, 2008

01

02

03

POMME CHAN

b.1981

After studying interior design in her native Bangok, Pomme Chan went on to work as a graphic designer in the advertising industry. In 2002, she moved to the UK to study at the London College of Communication, and has lived in London ever since. Her fluid, almost baroque style has proved popular with clients such as Liberty, MTV, *Wallpaper** and Diane von Furstenberg. Her highly decorative typographic illustrations have appeared in *La Perla* magazine, *The New York Times* and on the cover of *Digital Arts*. *www.pommepomme.com*

01 *City Scape, Wallpaper**, 2010
02 *Power of Plait*, Hundred Eleven Days, 2010
03 *Unfold Wall Painting*, Central Embassy, 2010

01

02

03

RODERICK MILLS

b.1966

A graduate of Kingston University and the Royal College of Art, Roderick Mills has been commissioned by numerous high-profile clients including Royal Mail, the BBC, *Le Monde*, Opéra National de Paris and Google. As well as being a prolific illustrator and an award-winning film maker, Mills is a committed educator and has lectured extensively at colleges such as Central Saint Martins College of Art and Design and the University of Brighton, where he teaches at postgraduate level. Since 2012, Mills has been Deputy Chairman of the Association of Illustrators in London. He has been presented with the Quentin Blake Award for Narrative Illustration RCA and the Folio Society Awards RCA.

www.roderickmills.com

01 *Sleeping Beauty*, animation in production, self-initiated, 2009
02 *A is for Acquisition*, Opéra National de Paris, 2005
03 *Peak Oil*, editorial illustration, *The Big Issue*, 2008
04 *Water from the Sun and Discovering Japan* by Bret Easton Ellis, book cover, Picador Shots, 2006
05 *Southern Coast*, editorial illustration, *LandScape* magazine, 2006

01

02

03

04

05

DARIO ADANTI

b.1971

Born in Buenos Aires and now living in Madrid, Dario Adanti is an Argentinian illustrator, animator, cartoonist and script writer. He has worked extensively for publications such as *The New York Times*, *Interview*, *Rolling Stone*, *El País*, and has created two award-winning series for MTV: *Vacalactica* and *Elvis Christ*. Humour plays a major part in Adanti's work – he draws a regular cartoon for Spanish magazine *El Jueves*, has published seven comic books and his cartoons have appeared on networks including Cartoon Network, Canal+ and Nickelodeon.

01

02

03

01 *Suceso en Alta Mar*, personal project, 2005
02 *Como Perros y Gatos*, editorial illustration, *El País*, 2007
03 *La Esclavitud en Cuba*, book cover, Éditions Publibook, 2009

MILES DONOVAN

b.1976

University of Brighton graduate and now East London resident, Miles Donovan has a sophisticated, photomontage style that is perfect for editorial work. He has been commissioned by publications including *The New York Times*, *The Guardian*, *GQ* and *Time*. In addition, Donovan has been involved in design, art direction and animation projects for Coca-Cola, Diesel, Nike, Channel Four, the BBC, Toyota and the Victoria and Albert Museum as part of Peepshow Collective, of which he is one of the founding members.

www.milesdonovan.co.uk

01

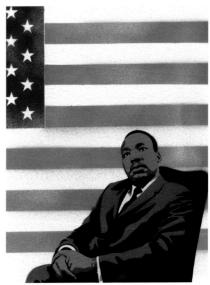

02

03

04

01 *Deface the Face – Madonna*, editorial cover, *The Face*/ HHCL/Tango, spray-paint/stencils/digital, 2001
02 *Martin Luther King*, promotional piece, Art Department, spray-paint/stencils/digital, 2009
03 *Billion Dollar Bubble*, editorial cover, *The Financial Times*, collage & digital, 2009
04 *Arctic*, promotional piece, Peepshow Collective, collage, 2009

FERNANDO LEAL

b.1976

Born in Rio de Janeiro, Fernando Leal studied graphic design at the Mackenzie Presbyterian University in São Paulo before going on to work in various Web and motion graphics studios. After a spell at MTV Video Music Brazil, he moved to London in 2006 to undertake a master's degree in animation at the Royal College of Art. His sophisticated work has a timeless quality, and he has worked for a raft of clients including MTV, Fast Company, *Playboy*, *Businessweek*, Red Bull, Air Canada and *New Scientist*.
www.fleal.com

01 Illustration for the book *V.ROM Complexo DSGN Book*, book illustration & print, V.ROM, hand-drawn & digital, 2005
02 *V.ROM Complexo 12*, print, V.ROM, hand-drawn & digital, 2004
03 *Panic Syndrome*, editorial & print, *Diálogo Médico* magazine, hand-drawn & digital, 2004

01

02

03

FLORENCE MANLIK

b.1967

The enigmatic Florence Manlik lives
and works in Paris. She treads a fine
line between art and illustration with
her delicately inked drawings – these
surreal shapes and motifs have appeared
as luxury prints for such fashion houses
as Cacharel, record covers, book jackets,
wallpaper, an ad campaign for Selfridges
and in magazines. Most recently, they
have featured on Hermès Carré scarves,
and Manlik has developed a long-standing
working relationship with the brand
since 2009.

www.florencemanlik.com

01 *Untitled*, personal project, hand-drawn ink on paper, 2011
02 *Untitled*, personal project, hand-drawn ink on paper, 2011

JEREMYVILLE

b.1975

Self-styled artist, product designer
and author, Jeremyville divides his time
between his studios in New York and
Sydney. Credited with writing the first
ever book about vinyl toys, *Vinyl Will Kill*
(2003), Jeremyville has designed several
limited-edition toys for Kidrobot and Trexi.
His cheeky character-led work has appeared
in ad campaigns, magazines and galleries
around the world. It can be found on stickers,
badges, T-shirts, baseball caps and bags,
and on two of Converse's Jeremyville Chuck
Taylor high tops.
www.jeremyville.com

01 *Community Service Announcements* (various), posters,
Studio Jeremyville, pen on paper & digital, 2010–13
02 *Sunset At Santa Monica*, Tendergreens (LA, USA),
pen on paper & digital, 2011

DON'T FEAR
THE UNKNOWN.

WITH YOU
I HAVE
EVERYTHING.

LET'S BUILD A
CONNECTION.

WELCOME
OTHERS
INSIDE.

LET NATURE
UNWIND US.

DON'T LET THEM
DOUBT YOUR
EXISTENCE.

ERODE AWAY
YOUR
MOUNTAINS.

MOUNTAIN BOY
LOVES
FOREST GIRL.

LET'S
HANG OUT.

01

02

TOM GAULD
b.1976

Tom Gauld grew up in the Scottish countryside close to Aberdeen. He studied illustration at Edinburgh College of Art, then moved to London to attend the Royal College of Art, and soon after graduating started drawing his popular weekly comic strip for *The Guardian*. His precise illustrations and cartoons have appeared in many newspapers and magazines, and he has published a number of books under the imprint Cabanon Press. His epic graphic novel *Goliath* (which reworks the myth of David and Goliath) was published by Canadian comic-book publisher Drawn & Quarterly to much acclaim in 2012.
www.tomgauld.com

01

02

01 Three Illustrations for 'Riff' essays, magazine cartoon, *The New York Times*, ink & digital, 2012

02 *The Great Author*, magazine cartoon, *The Guardian*, ink & digital, 2010

ROBERTO DE VICQ DE CUMPTICH

b.1958

Born in Rio de Janeiro, Roberto de Vicq de Cumptich moved to New York on a painting scholarship to the Pratt Institute in 1982. A prolific designer of book covers, he also created *Bembo's Zoo* in 1999, a book featuring animals made from the typeface Bembo as a gift for his daughter. This playful approach to type continued: *Men of Letters & People of Substance* presents a series of typographic portraits of famous people, *Words at Play* is a promotional booklet for Adobe and Typecalendar uses type to depict each day's events in history.

Toronto just got cooler. The polar bears have made their long awaited return to the Toronto Zoo. Experience the excitement of getting face to face with these colossal creatures at their new home at the Tundra Trek Exhibit, also featuring Arctic wolves, reindeer and more. Now open and free with Zoo admission. **torontozoo.com**

toronto ZOO
Same planet. Different world.

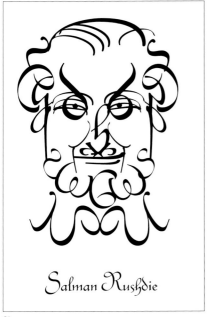

Salman Rushdie

01

01 *Salman Rushdie*, book illustration from *Men of Letters & People of Substance*, David Goldine Publisher, digital (Illustrator), 2008
02 *Polar Bear Exhibit*, poster, Toronto Zoo, digital (Illustrator), 2009
03 *Bembo's Zoo*, book illustration, Henry Holt Publisher, digital (Illustrator), 2000

02

03

ANTTI UOTILA

b.1979

Helsinki-based Antti Uotila creates
striking work using geometric forms
saturated with colour and texture.
Influenced by Japanese illustration icons
such as Tadanori Yokoo and Kazumasa
Nagai (whom he discovered while studying
in Tokyo), his mysterious-looking neon-
tinged work has been commissioned by
clients including Levi's, Burton Snowboards
and Nixon. It has also featured extensively
in magazines, and transferred effortlessly
on to T-shirts, wallpaper and textiles.
www.anttiuotila.com

01

02

03

04

01 *Blackhawk Over and Out*, Giclée print, personal project,
mixed media, 2009
02 *Stalker*, textile pattern, Ctrl Clothing, digital, 2010
03 Editorial illustration, *Dwell* magazine, digital, 2009
04 *Palette*, Giclée print, personal project, mixed media, 2010

SILJA GOETZ

b.1974

Now living and working in Madrid but
hailing from Regensburg in Germany, Silja
Goetz studied communication design in
Nuremberg, going on to work as a graphic
designer for *Allegra Magazine* in Hamburg.
Her eclectic work has appeared on the
pages of such magazines as *The New
Yorker*, *Cosmopolitan*, *Nylon* and *Vogue*,
and Goetz has been commissioned by
brands including Kiehl's, Bloomingdale's
and Champagne Henriot.

www.siljagoetz.com

02

03

01

01 *Goddess*, personal project, collage & Photoshop, 2008
02 *Spray Bottle*, Renuzit air freshener, pencil drawing &
Photoshop, 2009
03 *Madrid*, Art Department, pencil drawing & Photoshop, 2009

GINA & MATT

Gina Triplett and Matt Curtius produce expressive work bursting with vivid flora and fauna. Now living and working in Philadelphia, the pair met at the Maryland Institute College of Art in Baltimore, where Curtius studied fine art and Triplett studied illustration. Gina & Matt has been commissioned by clients such as Whole Foods, Macy's, Warner Bros., Starbucks and *The New York Times*, and the studio's work can also be found on skateboards, book jackets and rugs. They work on projects separately and together; Triplett's approach is more pattern-led, Curtius's is more painterly.

www.ginaandmatt.com

01 Woman's snowboard, product, Lamar Snowboards & Apparatus Inc., acrylic & ink, 2004
02 *Citrine*, product, Sims Snowboards & Apparatus Inc., acrylic & ink, 2005
03 *Bumbershoot*, poster, Wieden + Kennedy & Starbucks, acrylic & ink, 2005
04 *The World is Never Enough*, calendar, Salvato, Coe + Gabor & Baseman Printing, acrylic & ink, 2006
05 *Buck Tooth*, calendar, Salvato, Coe + Gabor & Baseman Printing, acrylic & ink, 2006

01

02

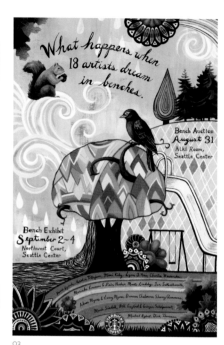

03

04

05

STÉPHANE GODDARD

b.1968

Born in the French Alps, Stéphane Goddard studied at the École Nationale Supérieure des Arts Appliqués et des Métiers d'Art in Paris. He has worked as an art director in the advertising industry, officially embarking on his career as an illustrator in 1994. His elegant, urbane style has proved extremely popular with clients worldwide, including *Elle*, Louis Vuitton, Nike and Club Med. Goddard's artworks have been sold at Christie's in London.

www.stephanegoddard.com

01 *Akarso* (from Neocortex creatures series), exhibition piece, gouache & Photoshop, 2012
02 *Carbon Jump*, *WARE* magazine & Nike, gouache & Photoshop, 2004
03 *NYC Messenger 1*, exhibition piece, gouache & Photoshop, 2012
04 *NYC Messenger 2*, exhibition piece, gouache & Photoshop, 2012
05 *Skateboarder*, Citadium (PPR Group), gouache & Photoshop, 2006

01

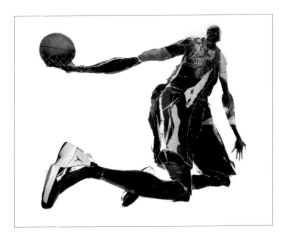
02

03

04

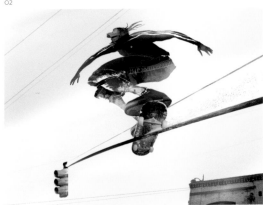
05

PAUL DAVIS

b.1962

Paul Davis's acerbic drawings reveal and record the endless foibles and absurdities of human nature. His clever combinations of words and pictures have been commissioned by many clients, including IBM, Mercedes-Benz, the Colette store in Paris and *Vogue*. A long-standing member of Shoreditch's Big Orange Studio Collective, he has had many solo exhibitions, published several books, including *Blame Everyone Else* and *Us & Them*, and is also the drawings editor of the quarterly magazine *The Drawbridge*. *www.copyrightdavis.com*

01

02

01 *Smells*, Graffiti Meets Windows, 2004
02 *A Surfer Explains*, editorial cover, *Eye* magazine, 2005
03 *Untitled*, book insert from *God Knows*, Browns Editions, 2004
04 *What About the Future?*, book insert from *The Book of Flow*, 2008–13

03

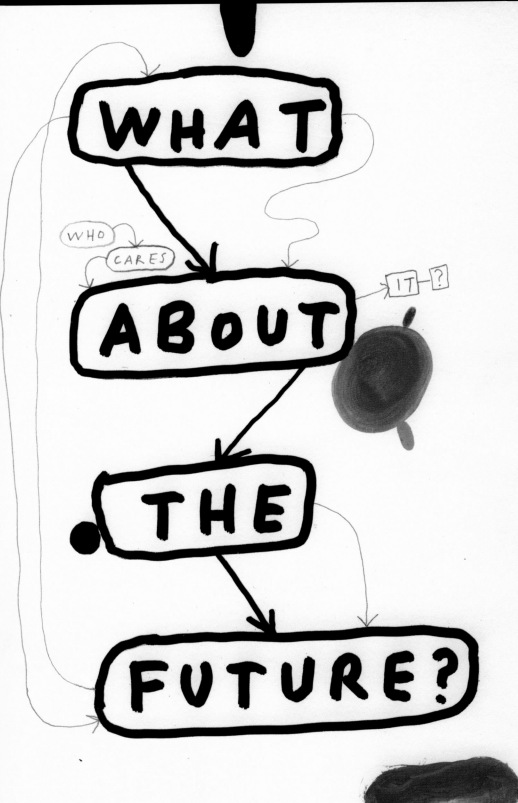

WHO CARES

WHAT ABOUT THE FUTURE?

IT ?

AURÉLIEN ARNAUD
b.1987

Lyon-based Aurélien Arnaud is an
illustrator and graphic designer who
co-founded PNTS Studio with Denis
Carrier in 2009. His bold, pop-art-
influenced style is often described
as typically French, and has featured
on T-shirts, flyers, LP covers and in
numerous magazines. Appearing under
the moniker of Reworks, the multi-
talented Arnaud is also an acclaimed
club DJ and dance music producer.
www.aurelienarnaud.com

01 *Get Physical*, BEWOL,
 2010
02 *Skull*, FST Gloves, 2009
03 *Japan*, Cell DVSN, 2010
04 *Monkey*, Cell DVSN, 2010

01

02

03

04

HIRO SUGIYAMA

b.1962

After graduating from Tokyo's East Art School, Hiro Sugiyama set up Enlightenment Publishing with Shigeru Suzuki and Kaname Yamaguchi. As well as illustrations for editorial and ad campaigns, its output has included a free paper called *Track*, art books, magazines and exhibitions as well as installations. The trio have been professional VJs since the early 1990s, touring with high-profile DJs including Towa Tei and Darren Emerson and appearing at festivals such as Sonar and Electraglide.

www.elm-art.com/hirosugiyama

01 *Seeing Sounds/NERD*, CD cover, Virgin Records, digital, 2008
02 *Justin Samson Portrait*, exhibition piece, AA Galleries (Paris), digital, 2008
03 *Audio Sponge/Sketch Show*, CD cover, Avex Inc., digital, 2002

01

02

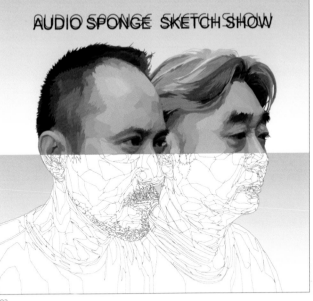

03

ELEANOR GROSCH

b.1979

Animals and birds feature heavily in Philadelphia-based illustrator Eleanor Grosch's playful work; she even named her studio PushMePullYou after the mythical two-headed creature in Doctor Doolittle books. Originally from Tampa, Florida, where she was a frequent visitor to the zoo as a child, Grosch studied fine art at the College of the Arts, University of South Florida. She has been commissioned by clients including Keds, Giro, Urban Outfitters and Wilco – her cute, vector-based graphic style lending itself perfectly to many applications including skateboards, sneakers, tableware and pillows.

www.justeleanor.com

01 *Chameleon*, print, digital vector, 2010
02 *Seahorses*, print, digital vector, 2010
03 *Cheetah*, print, digital vector, 2011
04 *Aesop's Fables: The Swan and the Crow*, print, personal project, digital vector, 2011

01

02

03

04

TAKERU TOYOKURA

b.1978

A graduate of the Sogo College of Design in Osaka, the city in which he was born, Takeru Toyokura uses paper and felt in his collage-based works. He creates mysterious tableaux featuring faceless children in deserted urban landscapes somewhere between reality and non-reality. While at college, Toyokura started the artist's group Re:VERSE, in which he remains involved. He has exhibited internationally and worked for high-profile clients including Honda, Northport and Converse.

www.hcn.zaq.ne.jp/re-verse

01 *Children Wonder 84*, personal project, felt & coloured paper, 2005
02 *Children Wonder 88*, personal project, felt & coloured paper, 2005
03 *Children Wonder 94*, personal project, felt & coloured paper, 2005
04 *Children Wonder 118*, personal project, felt & coloured paper, 2005

01

02

03

04

KARIN HAGEN
b.1979

A graduate of Stockholm's Konstfack University College of Arts, Crafts and Design, Karin Hagen makes haunting illustrations that have been used for book jackets, magazines and prints. Not someone to be easily pigeonholed, she has created her own fanzine based on the film *The 'Burbs* (Joe Dante, 1989), written and illustrated a guide for children visiting the Moderna Museet's permanent collection (Stockholm's Museum of Modern Art) and made a series of collaged paper and wood necklaces.
www.karinhagen.com

01 *Cowboy & Indian*, personal project, watercolour, 2009
02 *Hans/The 'Burbs*, fanzine, Sketchklubb, ink, 2010
03 *Lurking/The 'Burbs*, fanzine, Sketchklubb, ink, 2010

01

03

02

JENS HARDER
b.1970

A graduate of Berlin's Kunsthochschule and the École Supérieure des Beaux-Arts in Marseille, comic artist Jens Harder was one of the founding members of the artist group Monogatari, which became known for its series of reportage-style comics. The group's debut publication *Alltagsspionage* (2001) was well received by both critics and the comic scene. Harder went on to collaborate with Israeli comic group Actus Tragicus in his epic comic about a whale, entitled *Leviathan* (2003), which won him several awards. *Alpha...Directions* (2009) was a mammoth four-year project in which Harder attempted to draw millions of years of evolution, and which remains a seminal piece of work.
www.hardercomics.de

01

02

01 *The Old Harbour of Marseille*, personal project, 2000
02 *Shipwreck in the Desert*, editorial illustration, *Mare* magazine, 2004
03 *Food Chain*, personal project, 2005

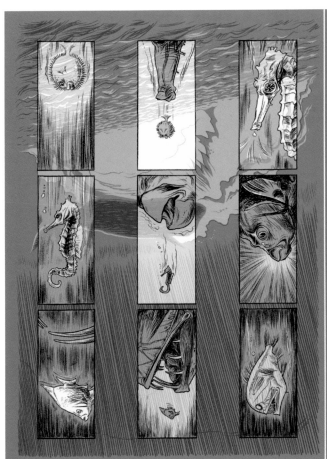

03

PAUL BLOW

b.1969

Scottish-born illustrator Paul Blow grew up in Dorset (where he now lives), and attended Maidstone College of Art followed by the University of Brighton, where he gained a master's degree in narrative illustration. His work has graced the pages of many newspapers and magazines including *The Guardian, Time, The Financial Times, New Scientist* and *Harvard Business Review.* Blow lectures extensively at art colleges in the UK, and in 2006 he received the gold award for editorial illustration from the Association of Illustrators. *www.paulblow.com*

01 *Mother,* editorial illustration, *The Boston Globe,* 2008
02 *Perfectionism,* editorial illustration, *The Boston Globe,* 2009
03 *Trickery,* editorial illustration, *Businessweek,* 2009
04 *Engine,* editorial illustration, *Businessweek,* 2010
05 *Kids,* editorial illustration, *The Boston Globe,* 2011
06 *Slide,* editorial illustration, *The Boston Globe,* 2009

01

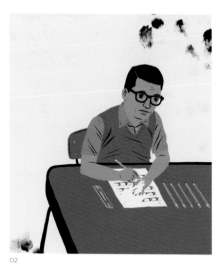

02

03

06

04

05

OLIVER HIBERT

b.1983

Oliver Hibert creates his striking psychedelic-influenced pieces from a farm in the desert in Scottsdale, Arizona. Originally from Seattle, Hibert is self-taught and has been showing his work in galleries since the age of 16. He made his first video for MTV at 18, and has exhibited his work all over the world. Clients include the BBC, Disney, Nike, Adidas, Fender Musical Corp, *GQ*, Diesel and *Time Out*. In 2008, his work for Designersblock was shortlisted for the 'Designs of the Year' exhibition at the London Design Museum.
www.oliverhibert.com

01

02

03

01 *No More War #1*, poster, personal project, digital, 2010
02 *No More War #2*, poster, personal project, digital, 2010
03 *Designersblock – 'Illustrate'*, various, Hawaii Design, digital, 2007

IDOKUNGFOO

b.1969

Also known as illustrator Simon Oxley, IDOKUNGFOO is based in Oxford, UK, after spending a number of years in Japan. Oxley studied design at Bournemouth and Poole College of Art & Design, graduating in 1989. His simple, anecdotal style features an array of different creatures from monkeys to aliens. He has created characters for the RSPB, logos for iStockphoto and annual reports for Sharp, Mazda, Yamaha Instruments and Nikon. One of his most well-known creations is the original blue Twitter bird, which was used for many years as a decorative element on the Twitter site.

www.idokungfoo.com

01

02

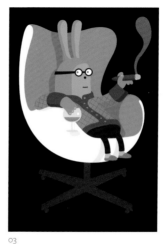

03

04

05

06

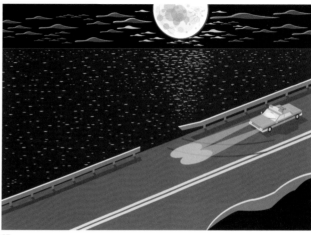

07

01 *Help Us Helicopter*, personal work, 2010
02 *Gitune Mascots*, mascots, Gitune, 2012
03 *Boss of Bunny*, personal work, 2010
04 *Cube Karate*, personal work, 2007
05 *Original Twitter Bird*, logo, Twitter, 2006
06 *Octocat*, Github, 2006
07 *Moonlight Drive*, personal work, 2007

FIODOR SUMKIN

b.1978

Originally from Belarus, illustrator Fiodor Sumkin is now based in Paris, where he established his 'Opera78' design project in 2005. Preferring the analogue approach of hand drawing, he uses basic gel ink pens to produce forthright pieces that combine superior drafting skills with a meticulous attention to detail and a strong social commentary. Sumkin works for a wide range of editorial and advertising clients from Europe and the USA.

www.behance.net/Fiodor

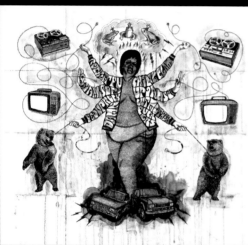

01

02

04

05

03

01 *Rock Out!*, poster, promotional piece, hand-drawn with gel ink pen/mixed & coloured in Photoshop, 2006

02 *Europe's Last Dictator (Portrait of Alexander Lukashenko)*, poster, Amnesty International, hand-drawn with gel ink pen/mixed & coloured in Photoshop, 2006

03 *Gabrielle d'Estrées et sa soeur*, poster,

pen/mixed & coloured in Photoshop, 2009

04 *The Devil Drives Lada (Portrait of Natalia Negoda)*, poster, promotional piece, hand-drawn with gel ink pen/mixed & coloured in Photoshop, 2008

05 *The Modern Religion (Portrait of Steve Jobs)*, poster, promotional piece, hand-drawn with gel ink pen/mixed & coloured in

MARIA RAYMONDSDOTTER
b.1971

After studying at Beckmans College of Design in Stockholm and Kingston University in London, Maria Raymondsdotter went on to work in London for several years as a freelance illustrator before returning to her native Stockholm. Her quirky figures, astute portraits and distinctive hand-drawn type have been commissioned by clients across the globe for magazines, packaging, interiors and advertising campaigns.
www.raymondsdotter.com

01 *BBC Great Lives: Ian Curtis*, book illustration, BBC Books, pen & ink, 2011
02 *Straight Hair/Iron*, Vo5, pen & computer, 2008–09
03 *Straight Hair/Mangle*, Vo5, pen & computer, 2008–09

02 03

ANNELIE CARLSTROM

b.1979

After graduating from Beckmans College of Design in Stockholm, Annelie Carlstrom settled in the city to work. Her detailed line-drawn illustrations have been commissioned by many clients, including the Moderna Museet (Museum of Modern Art in Stockholm), *The Sunday Times*, H&M, Amnesty International and HSBC. Women, often with huge eyes and fixed stares, feature heavily in her work, which displays an intriguing mix of realism and naivety. A 0.3mm propelling pencil (and a very light touch) is used to achieve this impressive level of detail.

www.anneliecarlstrom.se

01 *Dev*, private portrait, pencil & Photoshop, 2010
02 *Minimarket Queen*, Minimarket, pencil & Photoshop, 2008
03 *Anakronista Records*, Edith Söderström, pencil & Photoshop, 2010

01

02

03

01

02

ADRIAN JOHNSON

b.1974

Originally from Liverpool, Adrian Johnson spent 15 years in London before moving to Lewes, East Sussex. He has developed a distinctive approach through his work for high-profile clients such as Stüssy, Paul Smith, Adidas, *Monocle* magazine, *The New York Times* and Unicef. His sophisticated style with its gentle nod to illustration greats such as Ryohei Yanigahara and Geoff McFetridge, has led to his work being exhibited in galleries in London, New York, Los Angeles and Tokyo. Johnson is an enthusiastic (if occasional) member of the Soho Warriors Football Club.
www.adrianjohnson.org.uk

01 *Pancho Villa*, poster, About Great People, mixed media, 2010
02 *Distinction in Extinction*, poster, About Great People, mixed media, 2010
03 *Poseidon*, T-shirt, Stüssy, mixed media, 2008
04 *Rainbow Warrior*, poster, personal project, mixed media, 2008

03

04

TATSURO KIUCHI

b.1966

Initially graduating in biology from the International Christian University in Tokyo, Tatsuro Kiuchi changed direction and went to study at the Art Center College of Design in Pasadena, California. A spell illustrating children's books followed, one of which, *The Lotus Seed*, has sold over a quarter of a million copies. His understated work has an almost nostalgic feel and has been commissioned by clients including Royal Mail (for its Christmas stamps) and Starbucks, and he has created a weekly comic strip entitled *The Earthling* for *The Thinker* magazine.
www.tatsurokiuchi.com

01 *Not So Polar Bear*, group exhibition piece, Society of
 Illustrators, digital, 2010
02 *Smart Book*, booklet cover, Narita Airport, digital, 2011
03 *The Sea, The Sea*, book illustration, The Folio Society,
 digital, 2008
04 *Pure Love Moratorium*, book cover, Penguin/Futabasha
 (Japan), digital, 2011

01

02

03

04▸

RON JONZO

b.1975

Illustrator and animator Ron Jonzo was born in Munich, studied in Hamburg and moved to London in 2001. He cut his teeth at some of the capital's leading interactive design agencies (such as Unit 9 and Less Rain), and now creates work for brands including Channel 4, the BBC, Fiat, Nike and Levi's. Also known as 'Johnny Fu' and 'Man with Pen', Jonzo mixes analogue and digital very effectively to produce cool character-led work that clients are keen to acquire.

www.ronjonzo.com

01

03

04

05

01 *Toasty – Domestic Demon No 5*, personal project, three-colour screen print on paper, 2006

02 *I-Cat – Domestic Demon No 2*, personal project, three-colour screen print on paper, 2006

03 *Dusty – Domestic Demon No 4*, personal project, three-colour screen print on paper, 2006

04 *Bubble-Goggle – Domestic Demon No 3*, personal project, three-colour screen print on paper, 2006

05 *Freezo – Domestic Demon No 1*, personal project, three-colour screen print on paper, 2006

JAMES JOYCE

b.1974

Forthright and bold, James Joyce's colourful work has a very graphic sensibility. Joyce studied at Kingston University and, while working as a graphic designer in London, he illustrated a series of 36 flyers for 'It's Bigger Than', a club night run by some friends in Hackney. A full-time career in illustration followed, with a hugely popular series of personal prints and commissions from clients such as *The New York Times, Wallpaper**, Howies, Save the Children, MTV and the BBC. *www.jamesjoyce.co.uk*

01 *Two Dollars*, screen print, 2013
02 *Clown*, Giclée print, 2006
03 *Happiness*, screen print, 2013
04 *Rainbow Cup*, Giclée print, 2009
05 *Chemical World*, Giclée print, 2007

01

02

03

04

05

HELLO VON

b.1980

After studying illustration and animation at Kingston University, Von set up his studio in 2006. Vector-based graphics were all the rage, so his beautifully detailed pencil and graphite drawings of people, birds and animals made a big impression. A consummate draughtsman, he easily combines his much sought-after personal work (which has been exhibited in galleries around the world) with the strong demand for his commercial pieces for clients such as Nike, Becks, Royal Mail and ESPN. *www.hellovon.com/www.shopvon.com*

01 *Semblance 02*, artwork, personal project, pencil & graphite, 2009
02 *Plan B*, editorial illustration, *Hunger* magazine, mixed media, 2012
03 *Untitled*, private installation, Nike, mixed media, 2011
04 *Nike Stadium at Selfridges – World Cup 2010*, window installation, INT Works/Nike, mixed media, 2010

01

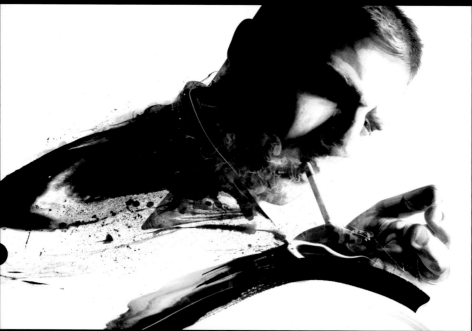

02

03

04

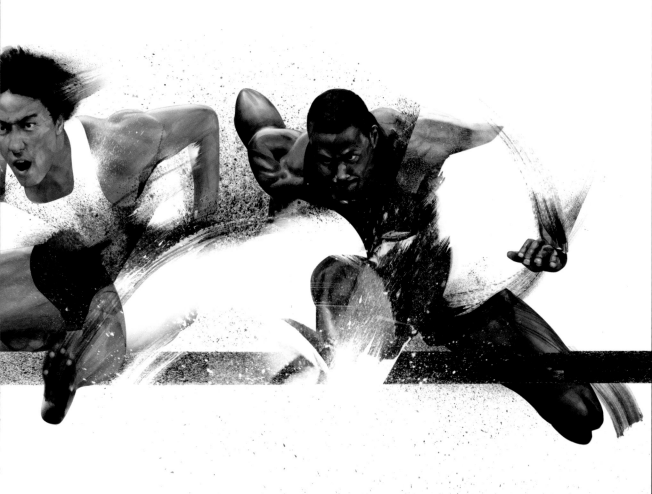

JULES JULIEN

b.1975

Paris-based Jules Julien studied in
Toulouse and worked as an art director
for ten years before becoming an illustrator.
While on the surface his very graphic
images appear to be refined and beautiful,
his finely crafted pieces often reveal a
sinister edge. His clients include Diesel,
Sony PlayStation and Cartier, and he has
exhibited his work in Japan, Switzerland,
New York and London.
www.julesjulien.com

01

02

01 *Français*, Nuit Blanche of Metz City, France, digital, 2010
02 *Three Pink Illustrations*, Diesel Art Gallery, digital, 2009

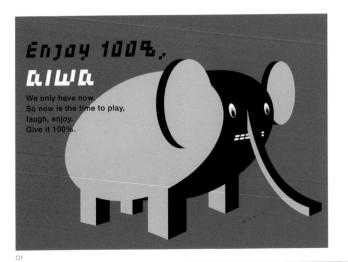

Enjoy 100%.
AIWA

We only have now.
So now is the time to play,
laugh, enjoy.
Give it 100%.

01

SEIJIRO KUBO
b.1968
Born in Sasebo, Nagasaki, Seijiro Kubo is a
graduate of the Nippon Designers School in
Kyushu. He now resides in Tokyo, where he
creates a menagerie of colourful characters
– animal and human – for clients including
Kirin, Aiwa, Nike, Coca-Cola and Sony.
Kubo is also the brains behind the cult of
Copet, the online zoo full of his cute 3-D
creatures that have appeared in a movie,
in an exhibition and are also available to
download as an app.
www.seijirokubo.com

Special

Seijiro Kubo

HOT LUNCHES

03

02

01 *Copet (Elephant)*, poster, Aiwa, digital, 2002
02 *Junk Food Hamburger*, T-shirt, HOT MARKET, digital, 2010
03 *Junk Food Popcorn*, T-shirt, HOT MARKET, digital, 2010

ANDREW RAE

ANDREW RAE
b.1976

Andrew Rae is one of Peepshow Collective's founder members. Formed in 2000 by a group of graduating students from the University of Brighton, Peepshow now has nine members who collaborate on a wide range of commercial projects. Rae's laconic, almost comic-book style lends itself perfectly to editorial work, and his love of drawing is evident in all his pieces. Strange creatures often appear in his work and humour is never far away. Along with Luke Best, Rae organises 'Heavy Pencil', a regular club night involving drawing-related fun at London venues including the ICA and Pick Me Up at Somerset House.
www.andrewrae.org.uk

02

01 *Characters*, print, personal project, hand-drawn & digitally coloured, 2000–05
02 *Skeleton and Balloon*, fanzine illustration, personal project, hand-drawn & digitally coloured, 2010
03 *Composite*, print, personal project, hand-drawn & digitally coloured, 2001
04 *King of Beasts*, print, personal project, hand-drawn & digitally coloured, 2009
05 *Deity School*, book illustration for *A Graphic Cosmogony*, Nobrow, 2010

01

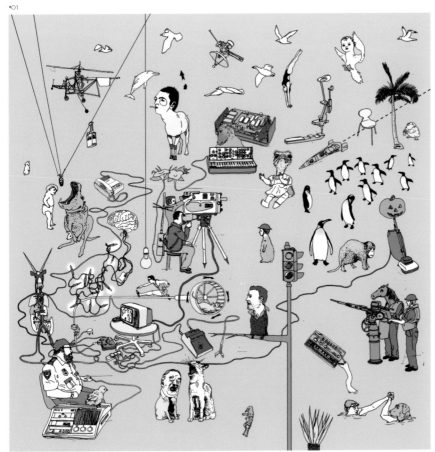
03

04

05

IZUMI NOGAWA

b.1976

After a nomadic childhood spent travelling around Japan, Izumi Nogawa settled in Tokyo, studying environmental and graphic design. Her exotic artwork seamlessly mixes motifs from the East and West, with goddesses and geishas, Hello Kitty and sensual female forms entwined with flowers and foliage. She has worked for a wide range of clients in advertising, publishing, editorial and design including Shu Uemura, *Flair* magazine and GHD.
www.quietblue.org

01

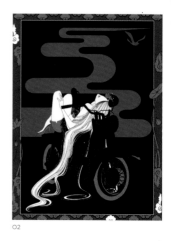

02

03

05

04

01 *The Bike*, apparel design, Custo Barcelona, 2008
02 *The Bike 2*, apparel design, Custo Barcelona, 2008
03 *Samsara*, editorial illustration, AiiA Corporation, 2010
04 *Blown*, personal project, 2008
05 *Hikari*, poster, Shu Uemura (L'Oreal Paris), 2007

FAIROZ NOOR

b.1974

After studying interior architecture followed by multimedia design at Swinburne University of Technology in Melbourne, Australia, Fairoz Noor started out as an illustrator before moving on to motion graphics, animation and interactive design. He has created work for television and the Web for such clients as MTV, the Sci-Fi Channel, HP and Sony Ericsson. In 2010, he set up Vision+Labs with partners in Singapore, Tokyo and Australia to collaborate on various digital projects.
www.depthandlayers.com

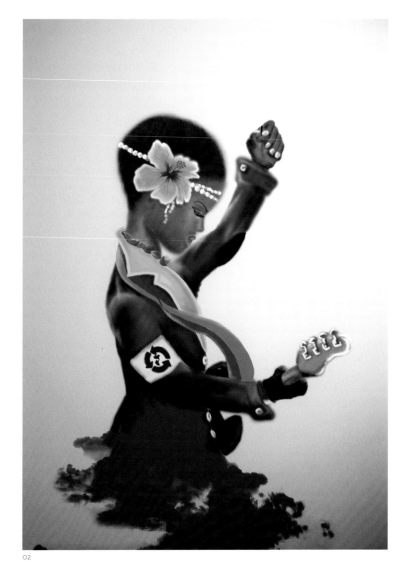

02

01

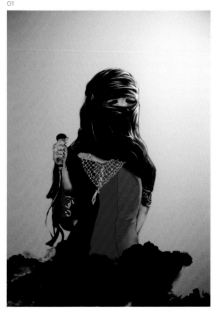

03

04

01 *Change*, book insert, digital painting, 2011
02 *Sustainability*, book insert, digital painting, 2011
03 *Faith*, book insert, digital painting, 2011
04 *Strength*, book insert, digital painting, 2011

JOHN McFAUL

b.1973
Hailing from The Wirral, Kingston
University graduate John McFaul worked
in London before moving his design studio
to Chichester on England's south coast in
2002. His vibrant surf- and skate-inspired
illustrations have proved hugely popular
with a raft of clients including Levi's,
Carhartt-Europe, Havaianas, Orange and
British Airways.
www.mcfaulstudio.com

01 *Havaianas*, mural, Havaianas/BBDO NYC, paint, 2007
02 *Wham Bam Uncle Sam*, apparel, Levi Strauss & Co.,
 mixed media, 2010
03 *9*, apparel, Levi Strauss & Co., digital, 2010

01

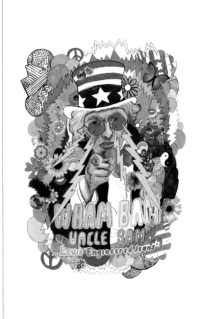

02

03

CHRISTIAN MONTENEGRO

b.1972

Argentinian illustrator Christian Montenegro's love of comics – gained while studying at the atelier of the legendary comic artist Alberto Breccia – shines through in his vibrant art. His work has appeared all over the world, in advertisements, magazines, books and galleries, as well as on kites and board games. He has also illustrated a selection of tales from the Bible, including the Creation, Adam and Eve, Noah's Ark, the Tower of Babel and Sodom and Gomorrah. He likens his bold and colourful work to the Lego system, with simple pieces combining to make more complex pictures.
www.christianmontenegro.com.ar

01 *Anger*, editorial illustration, personal project, digital, 2009
02 *Proud*, editorial illustration, personal project, digital, 2009
03 *The Tower*, tarot deck, personal project, digital, 2009

01

02

03

MR BINGO

b.1979

Mr Bingo's acerbic illustrations have graced the pages of book covers, publications such as *Wired*, *The Washington Post* and *Esquire* and books on The Mighty Boosh and Jimmy Carr. Another initiative, Hate Mail, saw him (for a small fee) send to fans, from his studio in East London, vintage postcards with one of his drawings and an offensive message on the back. Hate Mail proved incredibly popular, resulting in a book published by Penguin. Just don't ask Mr Bingo if he works for free.

www.mr-bingo.org.uk

01 *Architects*, editorial illustration, *Architectural Review*, pen/paper/Photoshop, 2011

02 *Dollar*, editorial illustration, *Money Magazine*, pen/paper/Photoshop, 2009

03 *Chairs*, advertisement, *The Financial Times*, pen/paper/Photoshop, 2009

04 *I Met All My Friends on the Internet*, personal project, pen/paper/Photoshop, 2007

05 *Ozzy Vs. China*, editorial illustration, *Esquire*, pen/paper/Photoshop, 2006

06 *A New Hope*, screen print, 2007

01

02

Plot your path to the top.
From finance to management.
find your next role in Appointments.
Every Thursday in the FT.

We live in FINANCIAL TIMES

03

I MET ALL MY FRIENDS ON THE INTERNET

04

05

JUNICHI TSUNEOKA

b.1975

Born and educated in Japan but now resident in the USA, Junichi Tsuneoka is a self-confessed exponent of the 'California Roll' style of illustration, a fusion of Japanese pop culture and American urban culture (or Manga and graffiti, as some suggest). His Stubborn Sideburn studio is based in Seattle, and his intricate vector-based illustrations have been commissioned by clients including Adidas, Microsoft, Budweiser and Uniqlo. In true Manga style, Tsuneoka has created over 40 individual characters, each with unique personality traits, and some available as skateboard decks.

www.stubbornsideburn.com

01 *Six Arms*, poster, promotional piece, screen print, 2009
02 *B-Boy*, T-shirt, Adidas, digital, 2011
03 *Dragon Rider*, skateboard deck, 35TH North Skate, digital, 2010

01

02

03

JARRIK MULLER

b.1983

A graduate of the Willem de Kooning
Academy in Rotterdam and after a spell
in Berlin, Jarrik Muller now creates his
typographic-based work from his studio
in his native Amsterdam. He designs
posters, identities and music packaging,
all of which display his playful approach
to type. His experimental typography
includes a free typeface for *Neo 2* magazine,
NB Light (a collaboration with Neubau),
Soft Machine (a collaboration with
Machine) and a 3-D typeface constructed
from paper.
www.jarrik.com

01 *Berlin*, editorial insert, *Neo 2*, 2010
02 *Busy*, poster, personal project, 2009

MVM

b.1979

Magnus Voll Mathiassen (MVM) was one of the three founding members of design group Grandpeople, based in the small town of Bergen, Norway. In 2009, he moved to his home town of Drammen to set up his own studio, MVM. Influenced by nature and his surroundings, his work is full of organic, abstracted shapes, and has been commissioned by clients such as Nike, PlayStation and Rune Grammofon, and exhibited at Somerset House in London and the International Poster and Graphic Design Festival in Chaumont, France. *www.themvm.com*

01

02

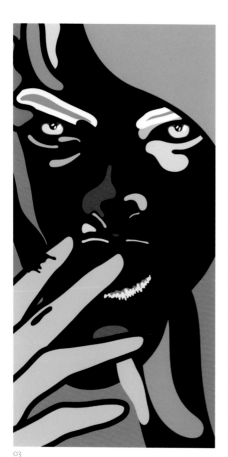

03

01, 02 *Fra Lippo Lippi*, music packaging, Rune Arkiv, digital, 2011
03 *BR*, editorial illustration, *Vagant* magazine, digital, 2009
04 *Untitled*, editorial illustration, *Vagant* magazine, digital, 2009

04

NICO

b.1976

Osaka-born illustrator NICO (meaning 'smile' in Japanese) produces artwork that is all about girls. Influenced by the 1960s, 1970s and Scandinavian design, her innocent-looking, long-limbed, doe-eyed figures are unashamedly feminine. After completing her studies, she joined a design company before becoming a full-time illustrator. Her work has appeared on the pages of Japanese *Vogue* and *GQ*, and in campaigns for L'Oréal, Toshiba and Nolita.
www.nicopop.net

01

02

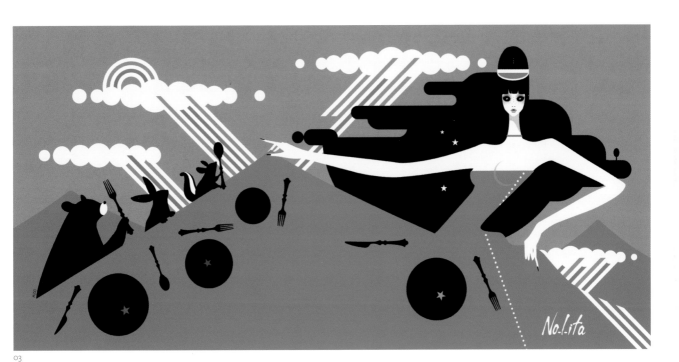

03

01 *Niwaka*, advertisement, *Vogue* (Japan), digital, July 2009
02 *Mangekyou/Okumura Aiko*, CD cover, EMI Music Japan Inc., digital, 2005
03 *Nolita*, art book, Sportswear International, digital, 2008

RAY SMITH

b.1975

London-based Ray Smith studied illustration
at Kingston University. His effervescent
pieces feature intricate patterns and vibrant
colours, and have been commissioned by
international clients including Absolut
Vodka, Nokia, British Airways and English
National Opera. His ongoing series of
'Symmian' illustrations have been exhibited
in galleries in London and Tokyo and have
seen him venture into animation.
www.raysmith.bz

01

02

01 *Lucha Libre*, bottle decoration, 1800 Tequila,
 digital, 2010
02 *Yama Symmian*, print, personal project,
 digital, 2009
03 *Find Your Flavor*, print, TBWA New York/
 Absolut Vodka, digital, 2006
04 *Attractive Prices*, print, BBH London/
 British Airways, digital, 2007
05 *Music Machine Will Rock You*, personal
 project, digital, 2010
06 *Amaze Me*, book illustration for *The Best
 Piece of Advice*, Creative Social, digital,
 2012

03

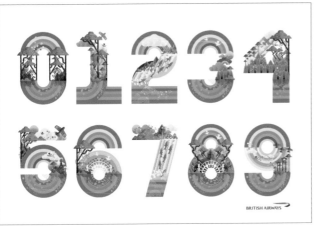

04

MUSIC MACHINE WILL ROCK YOU

05

06

STINA PERSSON

Stina Persson spent time studying and
working in Florence, Tokyo and New York
before returning to her native Stockholm,
where she now lives and works. Her elegant
watercolour style with its raw edges, washes
of intense colour and languid female forms
has proved popular with many clients
including Macy's, *Harper's Bazaar* and Sony
Music, and she has exhibited prints all over
the world.

www.stinapersson.com

01 *Imagination*, editorial
illustration, *Emotion*
magazine, watercolour
& collage, 2012

02 *Givenchy*, exhibition
piece, watercolour
& collage, 2010

03 *Smells Like Tangerine*,
exhibition piece,
watercolour & collage,
2010

04 *Deco Muse*, exhibition
piece, watercolour
& collage, 2010

O1

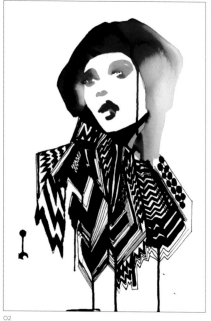

O2

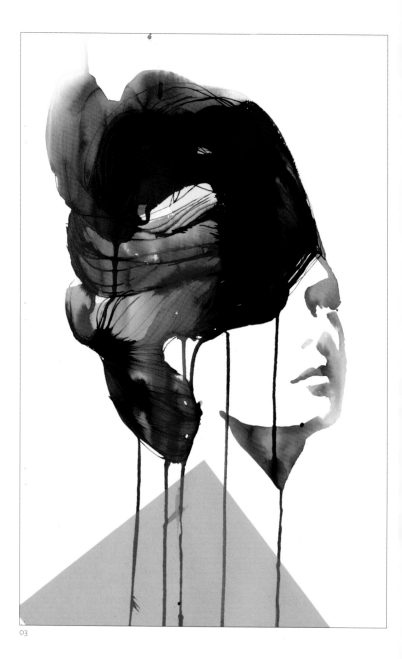

O3

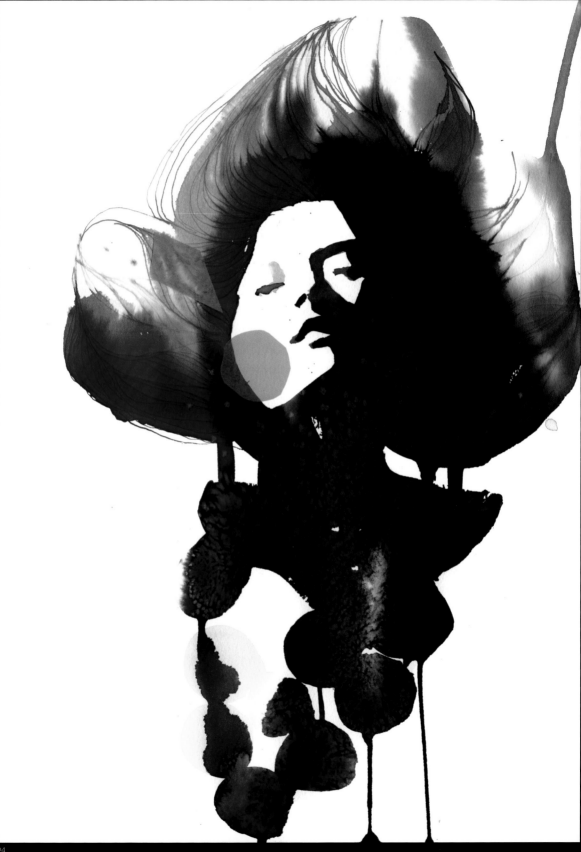

QIAN QIAN

b.1979

Now based in New York, Qian Qian hails from Chengdu in China's Sichuan province. He moved to the UK to study design and digital media at the University of Edinburgh, then to Missouri where he taught Web design. His slick illustrations mix Eastern motifs with a pop-art sensibility, and have earned him clients such as Coca-Cola, Nike, Panasonic and Louis Vuitton. Qian Qian's work has been shown at The Lincoln Center for the Performing Arts, New York, and the Victoria and Albert Museum in London. In 2005, he curated 'Get It Louder', a pioneering design exhibition held in Shenzhen, Shanghai and Beijing.
www.q2design.com

01 *Shadow Play is Fun*, poster & T-shirt, 'China Shadow Exhibition', digital, 2006
02 *Doll Face*, poster, personal project, digital, 2008
03 *Eat Them All*, poster, 'Jelly Generation' exhibition, digital, 2009

01

02

03

QUICKHONEY

est.2000

Formed in the year 2000 and based in New York, QuickHoney comprises of German-born Nana Rausch and Peter Stemmler (ex eBoy designer, see p.234). The pair's incredibly detailed work comprises mainly pixel-based pieces (created by Rausch), vector-based pieces (created by Stemmler) and a series of portraits and nudes drawn by hand. Clients include *Wired, The New Yorker,* AT&T, VH1 and MTV.
www.quickhoney.com

01 *Aerotropolis,* book cover, Farrar, Straus & Giroux Books, digital, 2010
02 *Going Under,* editorial cover, *Chicago Tribune Magazine,* digital, 2006
03 *'Erntedank' Thanksgiving,* stamp, Federal Ministry of Finance Germany, 2009
04 *Deconstruction of Bill Gates,* editorial illustration, *Wired,* digital, 2007

01

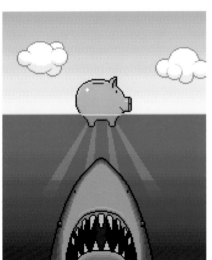

02

03

04

OLIVIER KUGLER

b.1970

Born in Stuttgart, Olivier Kugler studied and worked in Germany before winning a scholarship for a master's degree in illustration at the School of Visual Arts in New York. Described as a 'documentary illustrator', he travels extensively and draws the people and places he encounters, telling their story with words and images. His illustrated journal *Un Thé en Iran* catalogues a four-day trip with a lorry driver across Iran and won the prestigious V&A Illustration Award in 2011.

www.olivierkugler.com

01 *Istanbul-Tehran*, editorial illustration, *Jazeera Airways Inflight Magazine*, pencil drawing & digital colouring, 2009
02 *Thé en Iran*, XXI (Revue 21), pencil drawing & digital colouring, 2009
03 *Royal Wedding*, editorial illustration, *The Guardian*, pencil drawing & digital colouring, 2011

01

02

03

ROYAL WEDDING TEA TOWELS £ 2.50 EACH

2011 29th April

THO1

THONGS £5.00 Set of 3

FLIGHT LIEUTENANT ANTONY PARKINSON

RF·D

SPITFIRE AB 910 (MK VB), BUILT IN 1941, WHICH FLEW WITH RAF POLISH SQUADRON DURING THE WAR.

HWOR

NOSE ART

LANCASTER PA474, ONE OF ONLY TWO OF THE BOMBERS SURVIVING

EGG

13 30 - FLY-PAST BY THE ROYAL AIR FORCE AND BATTLE OF BRITAIN MEMORIAL FLIGHT.

TWO TYPHOONS AND TWO TORNADOS.

16

BOTH TYPES OF AIRCRAFT ARE FLYING COMBAT MISSIONS OVER LYBIA.

③ 10 10 - PRINCE WILLIAM AND PRINCE HARRY LEAVE CLARENCE HOUSE FOR WESTMINSTER ABBEY. THE PRINCE OF WALES AND THE DUCHESS OF CORNWALL LEAVE AT 10 38. ⑧

IF IT

THE MALL

HORSE GUARDS PARADE

ST JAMES'S PARK

← ROUTE FROM BUCKINGHAM PALACE TO WESTMINSTER ABBEY

← ROUTE BACK FROM WESTMINSTER ABBEY TO BUCKINGHAM PALACE

DS A VIEW L HER FINERY)

CAR GOT ATTACKED IN STUDENT PROTESTS WHEN CARRYING CHARLES AND CAMILLA TO THE THEATRE.

PARLIAMENT SQUARE

SEATING PLAN:

CELEBRITIES FRIENDS MINOR DIGNITARIES

ROYAL FAMILY CLOSE FRIENDS HEADS OF STATE

① FROM 0815 TO 0945 - THE GENERAL CONGREGATION WILL ARRIVE AT THE GREAT NORTH DOOR OF WESTMINSTER ABBEY.

PRIME MINISTERS AND GOVERNORS OF VARIOUS COMMONWEALTH COUNTRIES, THE DIPLOMATIC CORPS AND OTHER GUESTS WILL ARRIVE FROM 0950.

②

NAVE QUIRE

HENRY VIII'S LADY CHAPEL

WESTMINSTER ABBEY

PLASMA SCREENS

④ 10 15 - PRINCE WILLIAM AND PRINCE HARRY ARRIVE AT THE ABBEY.

⑤ 10 20 - MEMBERS OF FOREIGN ROYAL FAMILIES ARRIVE FROM BUCKINGHAM PALACE.

⑪ 11 00 - THE MARRIAGE SERVICE BEGINS.

ROB RYAN

b.1962

King of the paper cut-out, Rob Ryan creates elaborate tableaux with wistful figures surrounded by trees, flowers and birds. Words weave in and out of his work, his romantic and sometimes melancholy stories striking a chord with his many fans. His work has been commissioned by clients including *Vogue* and *Elle*, applied to book jackets, stationery and homeware, and he has collaborated with jewellery maker Tatty Devine and retailers Paul Smith and Liberty.

www.misterrob.co.uk

01 *Your Job*, editorial cover, *The Independent: The Saturday Magazine*, cut paper, 2010

02 *Perfect Picnic*, editorial cover, *Stylist* magazine, cut paper, 2010

03 *The Design Issue*, editorial cover, *The Independent: The Saturday Magazine*, cut paper, 2008

04 *London Fashion Week*, editorial cover, *Elle*, cut paper, 2009

01

02

03

04

355

SERGE SEIDLITZ

b.1977

Born in Kenya, Serge Seidlitz grew up travelling between the UK, Russia and Asia, before settling in London, where he studied at Camberwell College of Arts. After a spell as an in-house designer for the Cartoon Network, he specialised in illustration and was awarded the Association of Illustrators' 'Best of British Contemporary Illustration Award' in 2006. His witty pieces with their nod to pop culture and information graphics have been commissioned by Virgin, ITV, Shell, Oxfam and British Airways.
www.sergeseidlitz.com

01

01 *World Map*, billboard poster, Vodafone, pen & ink/digital, 2008
02 *Submarine Jungle*, billboard poster, First Bank, pen & ink/digital, 2010
03 *World Traveller Kit*, billboard poster, Vodafone, pen & ink/digital, 2008

02

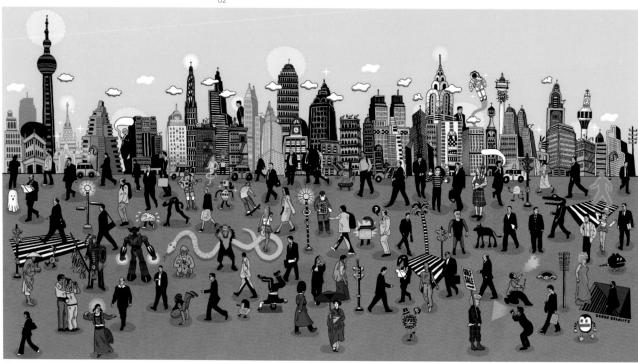

03

01

02

HELLO MARINE
b.1976

The enigmatic Hello Marine was born in Paris, grew up in the south of France and studied at the University of Brighton. Although still finding time for personal projects, she has worked for Lacoste, The Big Chill, *The Guardian* and *Time Out*. Influenced by music, fashion, toys and the yé-yé music movement in France in the 1960s, Hello Marine creates bold and vibrant work, with an unashamedly retro feel and a satisfying economy of line.
www.hellomarine.com

03

04

01 *Un Ours*, screen print, personal project, hand-drawn & Photoshop, 2011
02 *The End of Sleep*, book cover, Orion Publishing Group, hand-drawn & Photoshop, 2009
03 *Volta*, screen print, personal project, hand-drawn & Photoshop, 2010
04 *Beth*, screen print, personal project, hand-drawn & Photoshop, 2008

SERIPOP

est.2000

Montreal residents Yannick Desranleau
(b.1978) and Chloe Lum (b.1978) started
out making silk-screen posters for their
avant-rock trio AIDS Wolf. They have
since applied their distinctive style to book
covers, prints and album covers, and their
work has appeared in many gallery spaces.
They have created site-specific pieces for
the Quebec Triennial, Peacock Visual Arts
in Aberdeen (Scotland), Kunsthalle Wien
in Vienna, the University of North Texas
and the Baltic Centre for Contemporary Art
in Gateshead, UK.
www.seripop.com

01 *Zoo Story*, editorial illustration, *PilotMag*, ink & pencil on
paper, 2009
02 *Section Divider Illustrations (Modernist Architects)*,
editorial illustration, *Proximity Magazine*, ink/felt pen/pencil
on paper, 2009

01

ULLA PUGGAARD

Part of the Big Orange Studio Collective, Danish-born Ulla Puggaard divides her time between London, Copenhagen and New York. Although she studied graphic design and illustration, she is influenced by a wide variety of disciplines, such as textile design, sculpture and architecture. Her reductive graphic-led work is in great demand by clients including Audi, Vodafone, Comme des Garçons and *The New York Times*. www.ullapuggaard.com

01 *The Pen*, editorial insert, *The New York Times*, ink on paper, 2010
02 *Revolution*, editorial insert, *The New York Times*, ink & digital, 2009
03 *Empty Step*, personal project, ink & digital, 2008
04 *Anxiety*, personal project, ink & digital, 2008

01

02

03

04

JULIANA PEDEMONTE

b.1980

Originally from Argentina, where she studied graphic design at the University of Buenos Aires, Juliana Pedemonte lives in Miami, Florida. She set up Colorblok in 2003 and her motion graphics were soon commissioned by clients such as VH1, MTV and Nickelodeon Latin America. Her vibrant work with its profusion of playful motifs lends itself perfectly to animation, but is equally at home on everything from placemats and notebooks to vinyl toys and skateboards.

www.colorblok.com

O1

O2

O3

CHARLES WILKIN

b.1969

Charles Wilkin's slick pop-art-influenced collages have proved extremely popular with Australian *Vogue*, *The New York Times* and Vintage Books. Wilkin set up his company, Automatic Art and Design, in New York in 1994 to work on a wide range of projects. As well as illustration, he creates identities, packaging and ad campaigns. Wilkin has published a monograph called *Index-A*, released four of his typefaces on MyFonts and created the hugely popular mural in the library at the P.S. 186 Walter J. Damrosch School in the Bronx. *www.automatic-iam.com*

O1

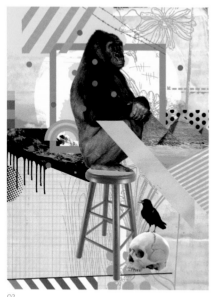

O2

O3

O4

05

06

TADAOMI SHIBUYA

b.1973

After studying product design at Tama
Art University in Tokyo, Tadaomi Shibuya
now lives and works in Yokohama, Japan.
Bold lines and sharp angles feature heavily
in his contemporary take on Cubism.
Influenced by graffiti, hip-hop culture and
Manga, he is in much demand and has been
commissioned by a host of clients including
Nike, Givenchy and The North Face.
www.tadaomishibuya.blogspot.co.uk

01 *Nike Air Jordan CP3 VI,*
Nike, Illustrator &
Photoshop, 2011

02 *Steve Jobs, Fortune*
magazine, acrylic/paper/
Photoshop, 2011

03 *Manchester International
Festival, The Guardian,*
acrylic/paper/Photoshop,
2011

04 *Darcus Howe Ex Black
Panther,* Channel 4,
acrylic & paper, 2002

01

02

03

04

YUKO SHIMIZU

A midlife crisis at the tender age of 22
resulted in Yuko Shimizu moving from
Tokyo – where she had studied advertising
and marketing – to New York to study
illustration at the School of Visual Arts.
Working from her studio in Manhattan,
she creates beautifully crafted work that
references her Japanese heritage while
remaining very much of the moment. Her
work has appeared extensively in magazines
and in ad campaigns commissioned by
clients including *Rolling Stone*, Microsoft
and MAC Cosmetics.
www.yukoart.com

01 *Flogfolio Calendar*,
calendar, Dellas Graphics,
ink & Photoshop, 2007
02 *Fall of a Superwoman*,
editorial illustration,
Der Spiegel, ink &
Photoshop, 2009
03 *The Beautiful and the
Grotesque*, book cover,
WW Norton & Rodrigo
Corral Design, ink
& Photoshop, 2010
04 *NYC SEX*, editorial
illustration, *New York*
magazine, ink &
Photoshop, 2005

01

02

03

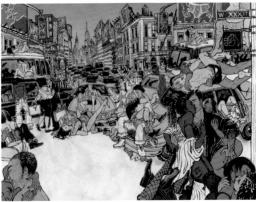

04

SHOUT (ALESSANDRO GOTTARDO)
b.1977

Born in Pordenone, Italy, Alessandro Gottardo studied at a specialist art high school in Venice and at the Istituto Europeo di Design in Milan, where he now lives and works. His beautifully drawn illustrations have won several awards, including the Gold Medal from the Society of Illustrators, which was presented to him in New York in 2009. Clients include American Express, *The Wall Street Journal* and Penguin Books.
www.alessandrogottardo.com

01

02

03

04

01 *Better Than Owning*, The Dallas Morning News, 2009
02 *Post Consumerism Society*, The New Republic, 2008
03 *Living and Dying with Dignity*, AARP, 2009
04 *The Perfect Joke*, Minimum Fax magazine, 2009

SKWAK

b.1977

Living in the north of France, the mysterious SKWAK started work as an illustrator after a spell at a design agency. He has created what he calls a 'maniac world', a distorted graphic reality swarming with bug-eyed, monster-like creatures that appear in his illustrations, as well as on T-shirts, toys and trainers. These have proved extremely popular and he has been commissioned by an impressive collection of clients including Microsoft, Google and Nike.
www.skwak.com

01

02

03

THE HEADS OF STATE

est.2002

Stella Elkins Tyler School of Art graduates Jason Kernevich and Dustin Summers comprise The Heads of State. They started out creating silk-screen posters for their local Philadelphia independent music scene, but their deceptively simple and witty graphics led to much critical acclaim. Commissions followed for clients such as R.E.M., Wilco, Penguin Books and *The New York Times*. Nowhere is their elegant approach more apparent than on their set of USA travel posters, which evoke the lost glamour of travel.

www.theheadsofstate.com

01 *Katrina City*, editorial illustration, *Brigham Young University Alumni Magazine*, 2006
02 *Global Health Care*, editorial illustration, *McKinsey Quarterly*, 2010
03 *Evan Bayh's OpEd*, editorial illustration, *The New York Times*, 2010
04 *The Newspaper Men*, editorial illustration, *Los Angeles Magazine*, 2008
05 *Washington, D.C.*, poster, personal project, 4-colour screen print, 2004

01

02

03

04

WASHINGTON D.C.

05

SHONAGH RAE

b.1967

A graduate of London's Royal College of Art, Shonagh Rae has worked for an extensive list of clients including Levi's, The Ritz and ESPN. Her bold printerly illustrations are created using digital techniques but retain a satisfyingly analogue feel. Rae's work lends itself perfectly to editorial pieces and has featured widely in the national and international press for such publications as *The New York Times*, *Esquire*, *New Statesman* and *The Financial Times*.
www.heartagency.com/artist/ShonaghRae

01 *Turntable*, promotional piece, 'In the City' Manchester Music Festival, 2000
02 *Doll*, editorial illustration, *The Independent: The Saturday Magazine*, 2000
03 *Robot*, editorial illustration, *New Scientist*, 2001
04 *Spanish Bar*, editorial cover, *Harper's Magazine*, 2000

02

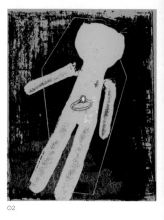

01

03

04

O2

KIMI KIMOKI

b.1978

French-born Kimi Kimoki studied
illustration at art school, first in her native
Avignon and then in Marseille. After four
years concentrating on artwork for children
she diversified and began working with
agents in Paris and Canada. Commissions
for high-profile clients such as Maybelline,
Paris Airports and Le Coq Sportif soon
followed. The excellent draughtsmanship
and meticulous attention to detail in
her illustrations give them an amazingly
lifelike feel.

kimikimoki.blogspot.co.uk

01 *Always Coca-Cola*, personal project, pencil & Photoshop,
2007
02 *Last Night*, personal project, pencil & Photoshop, 2008
03 *Diptyque*, personal project, pencil/felt/Photoshop, 2008

O1

OTTO DETTMER

b.1966

German-born illustrator, screen printer and artists' book maker, Otto Dettmer studied graphic design at Bristol Polytechnic and illustration at Kingston University, where he first started screen printing. His illustrations have appeared in magazines and newspapers around the world, and his screen-printed artists' books are exhibited at international artist book fairs in London, New York, and Germany. A keen advocate of print, in 2011 Dettmer set up Marshfield Print Studio, an open-access screen-printing workshop near Bath, UK.

http://www.ottographic.co.uk

01

THE ESSAY
ILLUSTRATIONS: DETTMER OTTO

The parent trap

Kids, who needs 'em? Certainly not Christopher Hawtree, who explains here why he has decided against parenthood. And why statistics show that more and more Britons are doing the same

'Cinema? I remember cinema ...' This was not a lament for the *nouvelle vague* era, when cinema was an adult concern rather than multiplex pap for the teen market. A friend was rueful that he could no longer afford to go, and, if he did, he would probably fall asleep during the trailers. "Do they still have that advert for Bacardi with a rough voice which leads you to believe that a glass of the stuff will turn Peckham High Street into the Bahamas?"

Across the nation, those with children voice such woes ("and the babysitter needs a taxi home, another fiver") to increasingly unsympathetic ears. Time was when any journalist, delivered of an infant, could find an outlet for a chronicle of the new-born's unremarkable activities. It was the vicarious equivalent of sending them up chimneys (Hunter Davies probably made as much from his offspring as he did from The Beatles). Read several such items, and one is close to echoing the *Fawlty Towers* scene in which a mother explains that her son is highly strung; to which comes the semi-aside of a reply, "he certainly should be".

The childless were once regarded as deficient, always subjected to that pressure known as cognitive dissonance: the process by which people urge others to do as they have done in order to convince themselves that they have made the correct decision. Those without children – so often made to feel, well, selfish – have now learnt to buck that sneer. This is not to make the matter black and white, to have or to have not.

Few cannot echo Jeffrey Masson's recent study of fatherhood and evolution, *The Emperor's Embrace*, which begins with an account of the way in which such a penguin spends untold hours in sitting on an egg, time in which the animal even denies himself food. From this Masson makes the leap to say, "these are the emotions that humans would feel in such circumstances; I can see no good reason

THE YOUNG WITH A BUGGY SO OFTEN EXUDE TIRED SURPRISE AT THE TURN WHICH LIFE HAS TAKEN

to deny them to penguins. When I visit the playground on a weekend and see all the fathers, many looking bored no doubt, but still there when they could be somewhere else, I am struck by how children come into our lives and simply demand that we give them immediate priority – and we respond. There are many pleasures more exciting than sitting in a sandbox with a three-year-old digging holes, or sitting at the seashore building castles. More exciting, but in some absolute sense, less fulfilling. There is nothing that feels more remarkably right than being with our children, attending to their small pleasures, observing with satisfaction their joy. We may not be emperor penguins, but our embrace of our children is not totally unlike theirs in these moments of parental devotion. We too feel a devotion to our young that makes us forgo ordinary pleasures to ensure that they survive and thrive."

And yet one turns to the box-sets of Miles Davis on the shelves, and reflects that, with the demand for innumerable rusks and nappies, these would have been an impossible purchase – and leisurely comparison of the alternate takes sure to be disrupted by an off-key squeal through another speaker, one wired to a cot. To determine the way in which to lead one's life is not easy, something ever-shifting with experience. To have children is often anything but considered. It remains a paradox that those wishing to adopt go through rigorous interrogation while those who shagged behind the bus-shelter are given all benefits of the doubt – literally so, payouts galore. The young with a buggy so often exude tired surprise at the turn which life has quickly taken; to watch, glass in hand, from a pavement café, is not only to feel relief at being spared this exertion but to reflect that these vehicles are almost as cumbersome as the pram in the hall which, for Cyril Connolly in the Thirties, was the very image of the economic pressure which thwarts creative endeavour. ✦

THE INDEPENDENT *magazine* 25

02

04

03

01 *What's in a Name?*, editorial illustration, *The Independent:*
 The Saturday Magazine, digital, 2001
02 *The Parent Trap*, editorial illustration, *The Independent:*
 The Saturday Magazine, digital, 2001
03 *The Hand of Fate*, editorial illustration, *The Independent:*
 The Saturday Magazine, digital, 2001
04 *Sodom and Gomorrah by the Sea*, editorial illustration,
 The Independent: The Saturday Magazine, digital, 2001

Further reading

Picture credits

In recent years there has been a proliferation of books about illustration. Many are very useful and insightful professional practice guides, others investigate the changing nature of a discipline in flux, while some may be considered merely showcases of current visual flavours and tastes. For this book, seeking out contextual information connecting illustration with its wider role has been achieved by using a range of publications: those with a specific focus on the communication industries and those with a broader remit covering historical changes in society.

The publications identified below are recommended reading for educators, students and those with an interest in the subject. There is still much to do in recording illustration's impact on art and design and on society too, but the process has started.

The authors and publisher would like to thank the following companies and individuals for permission to reproduce images in this book. In all cases, every effort has been made to credit the copyright holders, but should there be any omissions or errors the publisher would be pleased to insert the appropriate acknowledgement in any subsequent edition of this book. All images are courtesy of and copyright the individual illustrators unless otherwise stated below.

L = left; R = right; T = top; B = bottom; C = centre

Illustration titles

Arisman, Marshall and Steven Heller, *The Education of an Illustrator* (New York: Allworth Press, 2000)

Benaroya, Ana, *Illustration Next: Contemporary Creative Collaboration* (London: Thames & Hudson, 2013)

Brazell, Derek and Jo Davies, *Becoming a Successful Illustrator* (London: AVA Publishing, 2013)

Chwast, Seymour and Steven Heller, *Illustration: A Visual History* (New York: Harry N. Abrams, 2008)

de Bure, Gilles, *The Golden Age of Magazine Illustration: The Sixties and Seventies* (France: Vilo Publishing, 2001)

Hyland, Angus, ed., *The Picture Book: Contemporary Illustration* (London: Laurence King Publishing, 2010)

Male, Alan, *Illustration: A Theoretical & Contextual Perspective* (London: AVA Publishing, 2007)

Rees, Darrel, *How to be an Illustrator* (London: Laurence King Publishing, 2008)

Wiedemann, Julius, ed., *Illustration Now! v.3: 25 Years* (Cologne: Taschen, 2012)

Wigan, Mark, *The Visual Dictionary of Illustration* (London: AVA Publishing, 2009)

Zeegen, Lawrence, *Complete Digital Illustration* (Hove, East Sussex: Rotovision Books, 2010)

———, *Digital Illustration: A Master Class in Image-Making* (Hove, East Sussex: Rotovision Books, 2010)

———, *The Fundamentals of Illustration* (2nd ed., London: AVA Publishing, 2012)

———, *Secrets of Digital Illustration: A Master Class in Commercial Image-Making* (Hove, East Sussex: Rotovision Books, 2007)

———, *What is Illustration?* (London: AVA Publishing, 2009)

History titles

Children's History of the 20th Century (London: Dorling Kindersley Publishing, DK Millennium, 1999)

Gilbert, Martin, *A History of the Twentieth Century* (New York: William Morrow & Company, 2002)

Hopkinson, Christina, *The Usborne History of the Twentieth Century* (London: Usborne Publishing, 1995)

permission of the Estate of Maurice Sendak and HarperCollins Publishers
p.62 © Alex Gross
pp.64–65 © Washington University Libraries; Robert Weaver Collection, Modern Graphic History Library, Department of Special Collections, Washington University Libraries
p.66 © Ronald Searle/Punch Limited
p.67 © Williams College Oxford Programme; courtesy of Chapin Library, Williams College

Chapter 2

p.76 courtesy of the Museum of American Illustration at the Society of Illustrators
p.80 © The Fritz Eichenberg Trust/VAGA, NY/DACS, London 2013; Fritz Eichenberg, *The Donkey in the Lion Skin*, 1976, Wood engraving, 35.3 x 30.5cm (13 7/8 x 12in.), Harvard Art Museums/Fogg Museum, Gift of the Fritz Eichenberg Trust, M23106; Art: © Estate of Fritz Eichenberg/Licensed by VAGA, New York, NY; Photo: Imaging Department © President and Fellows of Harvard College
p.81L *ArtReview*, **TR** commissioned by Clive Crook, *The Sunday Times*
p.84 Robert Andrew Parker Collection, Modern Graphic History Library, Department of Special Collections, Washington University Libraries
p.85 © Teresa Starowieyska, poster from the collection of Piotr Dabrowski Poster Gallery, www.theartofposter.com
p.86BR art direction: David King
p.88T & B art direction: Louise Noble; **BR** art direction: Frank Metz
p.89 art direction: Alex Gottfried
pp.94–95 from *Roger Hane – Art, Times and Tragedy* by R.C. Hunsicker, publisher Vanguard Productions; © Janet Salerno;
p.94 art direction: Gordon Kibbee;
p.95TR art direction: Helen & Thomas Hahn; **BL** art direction: Shirley and Robert Hunsicker; **BR** art direction: Carol Macdonald
p.96 Jack Unruh Collection, Modern Graphic History Library, Department of Special Collections, Washington University Libraries
p.97 © Folon, ADAGP, Paris and DACS, London 2013
p.106T art direction: Milton Glaser & Walter Bernard; **CR** art direction: Bea Feitler, *Ms. Magazine*; **BL** art direction: Paula Scher; **BR** art direction: Louise Kollenbaum
p.107TL art direction: Milton Glaser & Walter Bernard; **TR & B** art direction: Ulrich Böege
pp.108–109 © The Estate of Guy Peellaert, all rights reserved
p.113 © Estate of Antonio Lopez and Juan Ramos
pp.116–117 © Brenda Lloyd
p.118 from *Father Christmas Goes on Holiday* by Raymond Briggs (Penguin Books, 1975, London), © Raymond Briggs, 1975, reproduced by permission of Penguin Books Limited
p.119 from *Fungus the Bogeyman* by Raymond Briggs (Hamish Hamilton, 1977, London), © Raymond Briggs, 1977, reproduced by permission of Penguin Books Limited
p.120T courtesy of Condé Nast
p.121 courtesy of Condé Nast
p.124 from *Meg and Mog* by Helen Nicoll & Jan Pienkowski (Puffin, 1975); text © 1975 by Helen Nicoll; illustrations © 1975 by Jan Pienkowski; story & characters © 1975 by Helen Nicoll & Jan Pienkowski

p.125 courtesy of the Museum of American Illustration at the Society of Illustrators

Chapter 3

p.127 Pernod Ricard
p.131T Design: Vaughan Oliver
p.131B from *The Witches* by Roald Dahl, published by Jonathan Cape, reprinted by permission of The Random House Group Limited
p.133 © *Time Out*, February 12–18 1982, no. 599
p.138TR photography: NASA; **CL** photography: David Buckland, design: Malcolm Garrett at AI; **CC** photography: Hugo Largo, art & design: Russell Mills & Dave Coppenhall; **BL** photography: David Buckland; **BC** photography: David Buckland; **BR** photography: Gregory Brooks
p.139TL art & design: Russell Mills & Dave Coppenhall; **TC** photography: Christina Birrer; **TR** art & design: Russell Mills & Dave Coppenhall; **CL** photography: David Buckland; **CC** art direction: Russell Mills, photography: Dave Buckland, art & design: Russell Mills & Dave Coppenhall; **BL** art & design: Russell Mills & Dave Coppenhall, photography: David Buckland
p.140TR Dr Feelgood/Barney Bubbles Estate; **L** Ian Dury/Barney Bubbles Estate; **BR** Psychedelic Furs/Barney Bubbles Estate
p.141 Riviera Global/Elvis Costello/Barney Bubbles Estate
p.146L reproduced with kind permission of *Radio Times*/Immediate Media Co.
p.148T art direction: Rina Migliaccio
p.149TL Graphis Inc.
p.150BL art direction: Steven Heller, *The New York Times*; **BR** art direction: Nicholas Blechman, *The New York Times*
p.152TL from *The Giraffe and the Pelly and Me* by Roald Dahl, published by Jonathan Cape, reprinted by permission of The Random House Group Limited; **BL** from *Matilda* by Roald Dahl, published by Jonathan Cape, reprinted by permission of The Random House Group Limited
p.155 cover art for *RAW no. 7* by Art Spiegelman; © 1985 by Art Spiegelman, used by permission of The Wylie Agency LLC
p.156 courtesy of Biblioteca Central, Sección Infantil (San Sebastián, Spain)
p.157BL *La llegenda de Sant Jordi* by Jordi Vinyes; **R** *Les Adventures de Pinotxo* by Carlo Collodi, translated by Albert Jané
p.158T art direction: Annedore Kern; **BL** art direction: Colline Faure-Poirée; **BC** art direction: Hans Troxsler
p.159BR © *The Architect's Journal*
p.162T commissioned by Alan Yentob
p.163T art direction: Henny van Varik
p.165 © DACS 2013; courtesy of Stasys Eidrigevicius
p.169 © Estate of Patrick Nagel/ARS, NY and DACS, London 2013; courtesy of Jennifer Dumas, Patrick Nagel Archive
pp.172–173TL Sue Coe:
Malcolm X Book: Cover Image, © 1986 Sue Coe, courtesy Galerie St. Etienne, New York; **TR** Sue Coe: *How to Commit Suicide in South Africa Book: Cover Image*, © 1983 Sue Coe, courtesy Galerie St. Etienne, New York; **BL** Sue Coe: *With Warm Regards to the Family*, excerpted from *How to Commit Suicide in South Africa Book*, pp.32–33, © 1983 Sue Coe, courtesy Galerie St. Etienne, New York; **BR** Sue Coe: *Backed by the Bomb and U.S. Corporations*, excerpted from

How to Commit Suicide in South Africa Book, pp.38–39, © 1983 Sue Coe, courtesy Galerie St. Etienne, New York
p.176L originally commissioned by the Royal Shakespeare Company; **R** commissioned by Chris Jones, *New Scientist*
p.177L/TR/BR commissioned by Derek Ungless, *Rolling Stone* magazine. Courtesy of *Rolling Stone*. All rights reserved. Used by permission.
p.181TR copyright © 1989 by Alfred A. Knopf, a division of Random House LLC; from *Pearl's Progress* by James Kaplan. Used by permission of Alfred A. Knopf, an imprint of the Knopf Doubleday Publishing Group, a division of Random House LLC. All rights reserved., **BR** courtesy American Booksellers Association
p.182 © 2012, 1983 Beltz & Gelberg in der Verlagsgruppe Beltz, Weinheim Basel
p.184T © Michael Foreman (from *Fairy Tales* by Terry Jones, 1981), **B** © Michael Foreman (*War Boy*, published by Pavilion Children's Books, 1989)
p.185 © Michael Foreman (from *Fairy Tales* by Terry Jones, 1981)
p.186 art direction: David Stuart, design: Pentagram, client: Watney Mann & Truman Brewers Limited
p.187T publisher: Shigeo Ogawa; **BL** art direction: Joanna Wenley, agency: Boase Massimi Pollitt Univas Partnership Limited, client: Greater London Council; **BR** art direction: Chris Baker, agency: Newton & Godin Limited

Chapter 4

p.190T art direction: Richard Koman
p.193B art direction: Matt Maitland, photography: Donald Milne
pp.196–197BL art direction: Richard Koman
p.199B art direction: GTF
pp.206–207 © Rian Hughes/Device
p.214 art direction: Markus RASP
p.215T art direction: Francesca Tongiorgi, agency: Swatch Lab (Milan, Italy); **BL** art direction: Richard Sheaff, agency: United States Postal Service (Washington, D.C., USA); **CR** art direction: Frank Viva, agency: Viva Dolan Communications & Design (Toronto, Canada); **BR** art direction: Martha Geering
p.216 from *Days in the Life: Voices from the English Underground 1961–1971* by Jonathon Green
p.217TR from *The Great American Novel* by Philip Roth, published by Vintage Books. Used by permission of The Random House Group Limited; **BL** from *Made in America* by Bill Bryson. Used by permission of The Random House Group Limited; **BR** from *Shopping in Space: Essays on America's Blank Generation Fiction* by Elizabeth Young & Graham Caveny
p.220TL commissioned by Deborah George, *New Scientist*; **BL** art direction: Ian Nuttall, *Traffic Technology International Magazine*
p.221TR © United States Postal Service, 1999
p.224BL art direction: Judy Garlan
pp.226–227 courtesy of Sara Fanelli/Walker Books Limited
p.228TL art direction: Wesla Weller, **TR** art direction: Fred Woodward & Gail Anderson
p.229TR photography: Dillon Kerekes
p.238BL *Captain Correlli's Mandolin* by Louis de Bernières, published by Minerva Books. Used by permission of The Random House Group Limited.
p.243CR & BR *The Guardian*

p.245 courtesy of Patinae, Inc., www.patinae. com, © Rafal Olbinski

Chapter 5

p.264L creative direction: MTV World Design Studio (Milan, Italy), motion studio & production: Physalia (Barcelona, Spain)
p.265BL © Fila Global
p.266TR cover art copyright © 2005 by Vintage Books, an imprint of Random House LLC; from *Men and Cartoons* by Jonathan Lethem. Used by permission of Vintage Books, an imprint of the Knopf Doubleday Publishing Group, a division of Random House LLC. All rights reserved.
p.271TL London Underground logo reproduced by permission of Transport for London
p.276TL Marion Deuchars/Vince Frost; **TR** Cass Art; **BL** Marion Deuchars/ Fernando Gutierrez
p.277 reproduced by permission from Penguin Books
pp.284–285 art direction: Achim Matschiner
p.286T Craig Mackie, deputy art editor, *New Scientist* magazine; **L** art direction: Annette Trivette, *Harvard Business Review*; **CR** Kevin Fischer, design direction, *Audubon Magazine*; **BR** art direction: John Gall, Vintage Books, author: Dave Eggers
p.293BR originally commissioned for *Wallpaper**
p.295TR photography: Astrid Solomon
p.295B photography: Sixtysix Visual
p.298BL from 'Monstruos Modernos' by Jordi Costa; **BR** from *Réformisme et esclavage à Cuba (1835–1845)* by Karim Ghorbal
p.307TR art direction: Julia Menassa, agency: TBWA/Chiat/Day; **BR** art direction: Stephanie Pesakoff
p.308 art direction: Matt Hexemer
p.310TR *Eye* magazine
p.320B commissioning & art direction: Hawaii Design, event: DesignersBlock Illustrate
p.321CL Gitune.com/Github
p.326T art direction: Tatsuro Kiuchi; **BR** art direction and design: Eleanor Crow
p.327 art direction: Masato Takayanagi
p.343 letter illustration by Jeffrey Bowman (Berlin, Germany)
p.345TL *Vogue* (Japan); **TR** EMI Music Japan Inc.; **B** Sportswear International
p.346B Pernod Ricard
p.351BL FSG Books/QuickHoney; **BR** Nana Rausch
p.352T Middle East editorial direction: Andrew Humphreys, editor: Matthew Lee, art direction: Gary Cook, **B** editor: Patrick de Saint-Exupéry, art direction: Quintin Leeds & Sara Deux
p.353 art direction: Roger Browning
p.354T & BR *The Independent Magazine*; **BL** *Stylist* magazine
p.355 *Elle* magazine
pp.356T & B commissioned by BBH for Vodaphone; **C** commissioned by TDA Advertising (Denver, CO, USA) for First Bank
p.360C commissioned by Nicholas Blechman, *The New York Times*
p.366TL art direction: Michael Hogue; **TR** art direction: Christine Carr; **BL** Jessica Salas; **BR** art direction: Riccardo Falcinelli
pp.372–373 art direction: Stephen Petch, *The Independent on Saturday*

Index

Page numbers in italics refer to illustrations

Acknowledgements

This book exists because of the extraordinary input from a great number of people.

I would like to thank the following for their support, patience and tireless work: Jo Lightfoot at Laurence King Publishing, Catherine Hooper and Caroline Roberts.

I would like to thank my colleagues at the School of Design at London College of Communication, University of the Arts London, and my former colleagues at Kingston University and the University of Brighton for their support and enthusiasm for the project.

This book would not have been possible without the talented illustrators who kindly contributed their work and their time. Thank you all.

My final thanks are to my family: Louie, Jake and Felix Zeegen, Ann and Matthew Lee and Rebecca Wright for love, wisdom and guidance especially when things got a little dark at times. Thank you.

Published in 2014 by Laurence King Publishing Ltd
361–373 City Road
London EC1V 1LR
United Kingdom
Tel: + 44 (0)20 7841 6900
Fax: + 44 (0)20 7841 6910
e-mail: enquiries@laurenceking.com
www.laurenceking.com

This book was produced by Laurence King Publishing
Ltd, London

ISBN: 978-1-78067-279-3

Cover artwork and chapter openers: Jeff Fisher
Design: Zoë Bather, www.zoebather.co.uk
Picture research: Caroline Roberts, Catherine Hooper,
Sophia Gibb and Alice Graham
Senior editor: Catherine Hooper, www.hoopdesign.co.uk

Printed in China